H2

from multimedia to virtual reality

from multimedia to virtual reality

designed by malcolm garret

from multimedia to virtual reality

from multimedia to virtual reality

from multimedia to virtual reality

understanding
hypermedia

from multimedia to virtual reality

bob cotton & richard oliver

introduction 7

Media Fusion
when technologies collide 11

media chronofile 14
multimedia arts 20
hypermedia innovators 22
cyberspace visionaries 26
virtual media 30

The Next Media Revolution 32
hypermedia on the S curve

inventing the media 35
bricolage 36
managing complexity 38
developing a new rhetoric 40

Media Matrix 42
components of hypermedia

interface 44
image 48
text and typography 52
graphics 56
audio 60
video 64
animation 68
virtual space 72

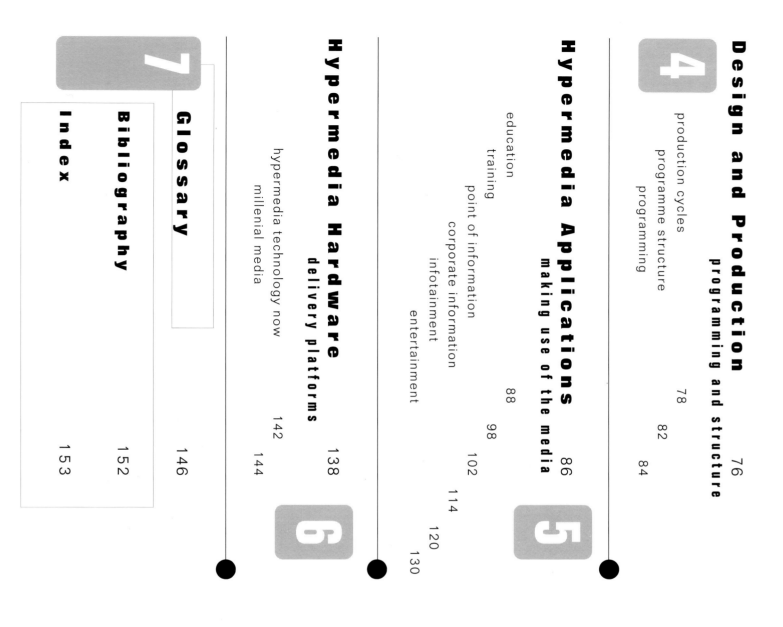

Design and Production
programming and structure 76

production cycles 78
programme structure 82
programming 84

Hypermedia Applications
making use of the media 86

education 88
training 98
point of information 102
corporate information 114
infotainment 120
entertainment 130

Hypermedia Hardware
delivery platforms 138

hypermedia technology now 142
millenial media 144

7 Glossary 146

Bibliography 152

Index 153

understanding
hypermedia

contents

1

This book is intended as an explanation of the hybrid interactive media that we believe will dominate mass culture in the twenty-first century, and equally, an exploration of its potential. We have tried to keep the text as non-technical as possible, but in a period of such rapid technological innovation and cross-fertilization of media there is bound to be a correspondingly rapid development in the terminology and language needed to describe what is happening. Where key technical terms or acronyms have to be used, they are explained on their first occurrence in the text. A glossary has been included towards the end of the book. The terms "hypermedia", "interactive media", and "interactive multimedia" have been employed interchangeably. It should also be made clear that "programme" describes a finished hypermedia production, while "program" refers to a software application that may be used to design one. Phaidon Press are also the publishers of a companion dictionary of hypermedia terms.

We have tried to feature a comprehensive range of pictorial examples but some important contributors to the development of hypermedia may need to be added in future editions. The authors are always pleased to hear from hypermedia producers, publishers, artists and designers; correspondence should be addressed care of Phaidon Press, London.

intro duction

0

about this book

ypermedia is an entirely new kind of media experience born from the marriage of TV and computer technologies. Its raw ingredients are images, sound, text, animation and video, which can be brought together in any combination. It is a medium that offers "random access"; it has no physical beginning, middle or end. It is this combination of random access with multiple media that opens up such exciting possibilities for radically new ways to communicate ideas, information and entertainment.

Perhaps the analogy we would find most familiar is with the video recorder. Like a video system, any hypermedia system has to have some form of display. This may be a TV set, a special high-resolution monitor and speakers, or a headset with stereoscopic viewers and binaural headphones to provide a "world" of virtual reality. Like the video tape that goes into a VCR any hypermedia system has to have some form of storage medium. This may be a computer disc, a CD carrying images, text, animation and video as well as sound, or, in the not too distant future, massive information banks that can be accessed through a fibre-optic network. Finally, any hypermedia system has to have some means of interacting with and controlling the material displayed. This may be something very like the remote control of a VCR, or a computer mouse, a touchscreen, or even a body suit covered with sensors that would allow the user to act in a computer generated virtual world.

Only a small part of this book is about the technology that makes hypermedia possible. Far more intriguing and considerably more relevant to what most of us do is the potential of hypermedia as an expressive medium unlike any other we have experienced before: an expressive and ubiquitous medium giving sensory form and human meaning to the ever growing, invisible world of digital electronics which increasingly permeates every aspect of our lives.

In writing this book we have taken a very broad view of what constitutes hypermedia, drawing on

examples that could be classified as computer games, interactive video or interactive multimedia rather than pure hypermedia. The idea behind this wide approach is to unleash our imaginations and to dissolve our preconceptions so that as communicators, media professionals, educators, trainers, designers, entrepreneurs, or whatever our sphere of professional interest, we can begin to seize the unique opportunities generated by the birth of a new medium to do things we have never been able to do before.

The book is designed to be read in a variety of ways. Like a hypermedia programme it offers different ways of access. It can be scanned as a picture book picking up points of interest on the way, so that if you have a particular area of interest such as entertainment or education you can go straight to the relevant section. Or you can begin at the beginning and read through until the end.

The first section of the book, "Media Fusion", looks at the origins of the medium: the convergence of technologies that have made the medium possible; the ideas of artists and designers that have laid the ground for some of the concepts and aesthetics that will find their full expression in hypermedia; and the work of the pioneers and visionaries of hypermedia and cyberspace. The second section, "The Next Media Revolution", investigates some of the key concepts and issues that will have to be addressed by anyone trying to develop practical hypermedia applications.

In the third part, "Media Matrix", the role and function of each of the media components are analysed: interface, image, text, graphics, audio, video, animation and virtual space are the elements that make up this new medium.

The book then expands on the practical issues and processes involved in the design and production of hypermedia applications, while the fifth section draws on examples from all over the world to show how hypermedia is being applied now in education, training, corporate information, point of sale and information, entertainment and "infotainment". It also makes suggestions about further development in the future.

The final section deals with the technology of the medium both current and foreseeable, and discusses how this affects the nature and possibilities of the medium.

To be present at the birth of a new medium is a rare privilege filled with boundless possibilities. While celebrating this new-found potential, this book is also intended to stimulate an understanding and involvement with what is going to be the key medium of the twenty-first century, affecting how we work, play, learn, think and communicate.

intro duction

how to use this book

W

hat is now interactive multimedia grew out of a very wide range of parallel developments in fields as diverse as art, film, television, telecommunications, digital optical storage, psychology and computer science. Over the period 1945-1985 a number of visionary thinkers, artists and writers (a list headed by Vannevar Bush, Ted Nelson, Alan Kay and Douglas Engelbart) had mapped out the possibilities of a singular medium that combined all the other media in such a way that people could control it using natural language and gesture.

The major stepping stones in these "mediatech" developments were the introduction of telegraph and telephone networks and cinematography in the nineteenth century, the invention of television in the 1930s, the digital computer in the 40s and 50s and the emergence of the personal computer in the 70s. It was the convergence of these technologies in the late 70s and 80s that finally provided the framework for consumer interactive multimedia.

media
fusion

1

when technologies collide

media fusion

telegraph and telephone

The development of the electronic telegraph in the 1830s signalled the very beginnings of a "cyberspace" infrastructure. Networks of telegraph wires, carrying their simple binary signals of dots and dashes, spread through Britain, Europe and the United States, and by the 1870s had spanned the Atlantic. Telegraphy initiated the era of electronic communications, and began a process that is now rapidly becoming a world-wide integrated digital network. But the telegraph was a form of "distance writing" not "distance speaking". The transmission of Morse code along telegraph wires required trained operators, and communications were only possible through special telegraph offices. It was the invention of the telephone that provided live voice communications that were available to everyone. By 1900 over two billion telephone conversations a year were being transmitted through the Bell telephone system alone.

cinematography

The first films encapsulated the theatrical experience and made it available to an audience massively wider than that of the theatre. Film was (in the terminology of the late twentieth century) the first audio-visual medium that involved "storage and delivery". It stored the theatrical experience while at the same time extending that experience beyond the physical boundary of the stage. The cinema could encompass the real world, and provided a vicarious experience of people and places distant in both space and time - all for the cost of a cinema ticket. The early film-makers immediately realized that film could convey experiences that live theatre could not, allowing film stories to juxtapose incidents in time and space, take their audiences to the moon, or into the world of hand-drawn comics, or back in time to the American Civil War. And for little more expense than that of a theatrical performance, these experiences could be delivered to an audience that was literally millions of times larger.

The photo-mechanical technology of film was a natural extension of three nineteenth century developments: the time-lapse "chrono photograph" (such as those by Marey and Muybridge), the "magic lantern" projector, and the kinetoscope, a parlour novelty that enabled the viewer to see moving pictures by spinning a disc of drawings through a simple viewfinder. In the 20s, spurred on by the enormous popular success of radio, movies incorporated the sound-track and thus became an even more potent multiple medium.

television

At about the same time, early experiments in television broadcasting signalled another major breakthrough, extending the possibilities of radio by incorporating pictures, and taking the power of the cinema right into the home. The audience could turn the television on and off at will, and select the kind of entertainment and information they wanted from an ever increasing number of channels. As a medium, television delivered most of what film could offer, but added the instantaneity of radio news coverage, magazine programmes and chat and game shows, all of which it did electronically, invisibly, and with greater and greater technological sophistication. After the interruption of World War Two, television rapidly overtook the cinema as the preferred entertainment medium. It integrated radio, film, theatre, dime novel, magazine, advertising hoarding, comic strip and newspaper, providing a multiple-media magazine of all these forms. Unlike film, which with its high-definition large- scale images required the audience to do no more than just sit back and watch, the low-definition, small-size television image demanded additional attention. The audience had to fill out the television image with their own imagination, interpreting the mosaic of phosphorescence that they were watching. Early television, with its dials, control buttons and low-resolution pictures, was an active medium that required participation.

New technologies have already changed the nature of "publishing". With videotape, on-line databases, teletext, electronic mail, desktop

computers

The final step towards the fusion of media technologies began with the development of digital computer technologies in the late 40s and 50s. During and immediately after the War the conceptual and technical framework for modern computers was put in place. The essential components, including Claude Shannon's Theory of Information, Norbert Weiner's work on cybernetics, John von Neumann's work in digital computing, the transistor, electromagnetic memory and Grace Hopper's work in programming were all in place by the mid 50s. The astonishingly rapid progress in micro-electronics, from transistor (1948) to integrated circuit (1959) to the microprocessor "computer on a chip" (1971), spanned only 23 years. The first personal computers appeared on the market in the early 70s, and commercially available software designed specially for hypermedia followed just ten years later.

The enabling technologies for hypermedia included many that can only be mentioned here: TV-style displays; the computer graphics and videographics that followed; the videodisc and its spin-off, the hugely successful audio compact disc, and the resulting laser-read digital-optical memory discs - CDROM, CDI, WORM, CDTV, CDROMXA; the engineering of the user-friendly "graphical interface", and presentation, animation, graphics, three-dimensional modelling, hypertext and hypermedia software; the development of the Musical Instrument Digital Interface (MIDI), low-cost digital audio tape and mixing software, digital video, data compression hardware and software - all these were essential components in the development of a desktop hypermedia machine, and all were available by the late 80s.

media fusion

publishing, floppy disks and compact data discs such as CDROM, distribution is no longer limited to printed words on paper. Hypermedia changes the means of production as well; a single artist or designer can now sit at a single workstation and on that one machine orchestrate the complete span of media. It is possible to move seamlessly from typography to animation to illustration to image scanning to video editing to sound mixing, and at the same machine produce an entire interactive programme ready to be mastered and stamped on to CDROM, or networked to other machines.

First we'll look at the chronological development of media, and see how all the separate strands of media (computers and telecommunications, television and video, radio and records, photography and film, and print) have, in the last ten years or so, begun to converge into the digital domain of hypermedia.

But these technological developments are only half of the equation - what of the structure, language and contents of hypermedia? Now we've got the tools, how do we write, design and orchestrate for multimedia? How do we adapt to the shift of emphasis from author to user? Later in this section we will begin to answer these questions by surveying the approaches made by artists working in non-linear forms of multiple media, and by introducing the theorists, designers and programmers involved in the development of hypermedia software.

media chronofile

This "chronofile" charts the development of the main forms of media over the last two hundred years or so. Entries have been colour-coded to show the changes from conventional "analogue" forms to electronic analogues, and finally into the digital forms we have now. It is only in the last decade and a half of the twentieth century that the ingredients for hypermedia have entered the digital domain, sparking the beginnings of the next media revolution. [Note that this chronofile is a selective illustration, with entries chosen to show the principle events on the route to hypermedia, and is not meant to be an exhaustive history.]

Key: electronic | digital

telecommunications & computers

1777 • Stanhope Logic Demonstrator
1793 • Mechanical Semaphore network
1793 • Stanhope Arithmetic Machine
1805 • Jacquard Programmable Loom

television & video

photography & film

1798 • Phantasmagoria projector

Caslon

Bodoni

1702 • *Daily Courant:* London's 1st Daily Newspaper
1704 • *The Boston News-Letter:* America's 1st regular weekly
1706 • *The Evening Post:* London's 1st afternoon daily
1710 • Le Blon: Three-colour engraving
1725 • Stereotypy
1734 • Caslon typeface
1750 • Baskerville typeface
1755 • Dr Johnson's *A Dictionary of the English Language*
1764 • Fournier: point system
1768 • Encyclopaedia Brittanica
1770 • Didot typeface
1788 • Bodoni typeface
1796 • Senefelder: Lithography
1798 • Nicholas-Louis Robert: Papermaking machine
1814 • The London *Times* operates 1st Steam press

1700 1725 1750 1760 1770 1780 1790 1800 1810

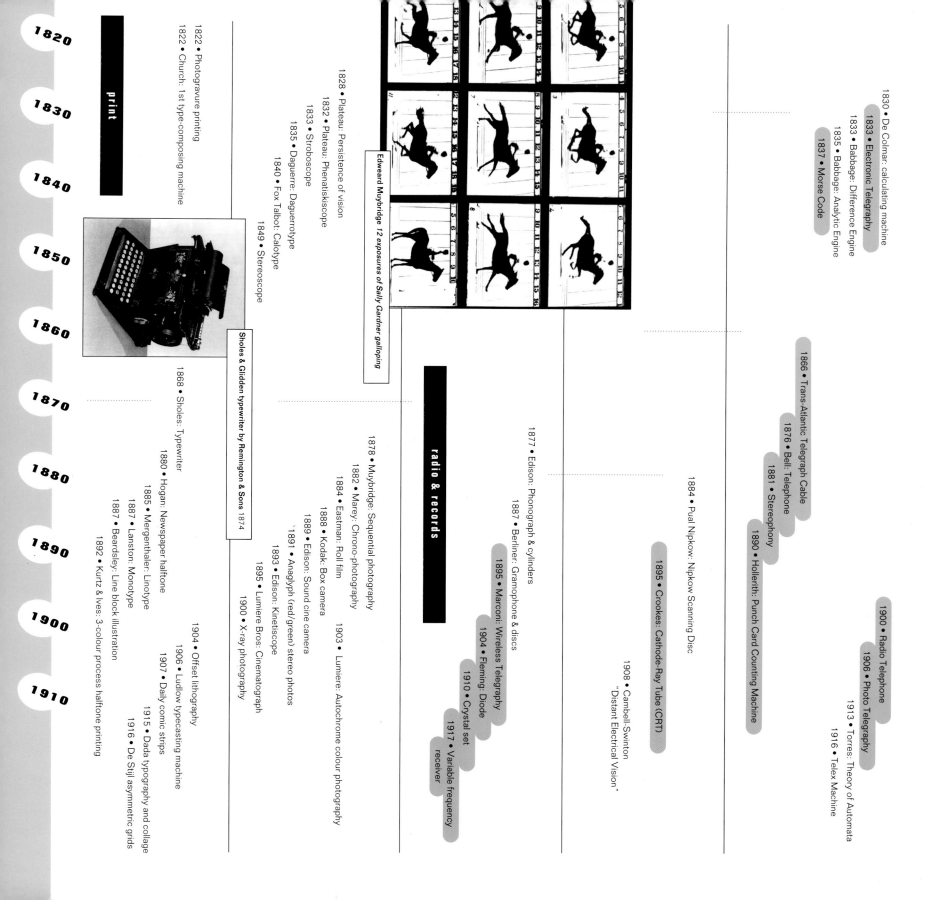

print

1820
1830
1840
1850
1860
1870
1880
1890
1900
1910

1822 • Photogravure printing
1822 • Church: 1st type-composing machine

1828 • Plateau: Persistence of vision
1832 • Plateau: Phenatiskiscope
1833 • Stroboscope
1835 • Daguerre: Daguerrotype
1840 • Fox Talbot: Calotype
1849 • Stereoscope

1830 • De Colmar: calculating machine
1833 • Electronic Telegraphy
1835 • Babbage: Difference Engine
1835 • Babbage: Analytic Engine
1837 • Morse Code

Edweard Muybridge 12 exposures of Sally Gardner galloping

Sholes & Glidden typewriter by Remington & Sons 1874

1868 • Sholes: Typewriter

1878 • Muybridge: Sequential photography
1880 • Hogan: Newspaper halftone
1882 • Marey: Chrono-photography
1884 • Eastman: Roll film
1885 • Mergenthaler: Linotype
1887 • Lanston: Monotype
1887 • Beardsley: Line block illustration
1888 • Kodak: Box camera
1889 • Edison: Sound cine camera
1891 • Anaglyph (red/green) stereo photos
1892 • Kurtz & Ives: 3-colour process halftone printing
1893 • Edison: Kinetiscope
1895 • Lumiere Bros: Cinematograph

1904 • Offset lithography
1906 • Ludlow typecasting machine
1907 • Daily comic strips
1900 • X-ray photography
1915 • Dada typography and collage
1916 • De Stijl asymmetric grids

radio & records

1877 • Edison: Phonograph & cylinders
1887 • Berliner: Gramophone & discs
1895 • Marconi: Wireless Telegraphy
1904 • Fleming: Diode
1910 • Crystal set
1917 • Variable frequency receiver

1866 • Trans-Atlantic Telegraph Cable
1876 • Bell: Telephone
1881 • Stereophony
1890 • Hollerith: Punch Card Counting Machine
1895 • Crookes: Cathode-Ray Tube (CRT)

1884 • Pual Nipkow: Nipkow Scanning Disc

1908 • Cambell-Swinton "Distant Electrical Vision"

1900 • Radio Telephone
1906 • Photo Telegraphy
1903 • Lumiere: Autochrome colour photography
1913 • Torres: Theory of Automata
1916 • Telex Machine

Futura

media chronofile

telecommunications & computers

1927 • Trans-Atlantic Telephone Service
1930 • Vannevar Bush: Differential Analyser
1931 • Zuze: Z1 Computer
1936 • Turing: *On Computable Numbers*
1937 • Claude Shannon: *Information Theory*
1943 • ENIGMA computer
1943 • Colossus electro-mechanical computer
1944 • Aiken: ASCC general purpose digital calculator

1923 • Iconoscope/linescope television system
1926 • Baird: Electro-mechanical TV
1929 • Zworykin/Farnsworth: TV
1932 • BBC Television Broadcasting

Marconiphone popular TV

1940 • Radar
1941 • Regular TV broadcasts in USA

Lumiere Cabinet Grand Model c1924

London Underground typeface by Edward Johnston

radio & records

1920s • Widespread radio broadcasting
1922 • Portable radio
1922 • Car radio
1926 • Pulse Code Modulation (PCM)
1928 • Magnetic recording tape
1933 • EMI: Stereo recording

HMV Radio

photography & film

1926 • Sound movies (music only)
1927 • Sound movies ("Talkies")
1935 • Technicolor films
1935 • Kodachrome 35mm film
1937 • 3-d stereoscopic (anaglyph) movies

print

1920 • Bauhaus typography
1924 • Otto Neurath: Isotypes
ISOTYPE: International System Of TYpographic Picture Education
1927 • Paul Renner: Futura typeface
1930 • Four-colour offset press
1933 • Henry Beck: Schematic London Underground map
1935 • Modern paperbacks

Haas Helvetica

1945 1950 1955 1960 1965

OCR-A 1968

Typesetting & typography

- 1945 • Photon photographic typesetting
- 1946 • Intertype Fotosetter
- 1953 • Computer printer
- 1957 • Letraset dry transfer lettering
- 1957 • Dot-matrix printer
- 1958 • Magnetic character recognition typeface
- 1959 • Xerox photocopiers
- 1959 • Helvetica typeface
- 1961 • Golfball typewriter
- 1966 • Thermal printer
- 1968 • Linotron 1010 digital typesetter

Hasselblad Camera

photography & film

- 1948 • Polaroid: instant photography
- 1952 • 3-d stereo Polaroid movies
- 1955 • Blue screen optical matting
- 1956 • Panavision Camera
- 1956 • Cinerama
- 1958 • Heilig: Sensorama
- 1963 • Colour Polaroid film
- 1966 • Kodak Carousel projector

sound & music

- 1947 • LP records
- 1947 • Modern electric guitar
- 1954 • Transistor radio
- 1956 • Stockhausen: Electronic music
- 1958 • Consumer "hi-fi" stereo records
- 1958 • 45 rpm singles
- 1958 • Electric piano
- 1961 • Philips: Compact cassette
- 1965 • Moog: Synthesiser
- 1967 • Dolby noise reduction system

computers & television & video

- 1945 • ENIAC computer
- 1946 • Vannevar Bush: "As we may think" MEMEX article
- 1946 • Von Neumann: stored program computer
- 1947 • Stibetz: 1st electronic program-controlled digital computer
- 1947 • Bardeen, Brattain, Shockley: Transistor
- 1948 • Norbert Weiner: Cybernetics
- 1949 • 1st cable TV narrowcasts
- 1951 • Mincom monochrome videotape recorder (VTR)
- 1951 • UNIVAC 1st commercial mainframe computer
- 1951 • Computer flight simulation/air traffic control
- 1953 • Colour TV broadcasting
- 1953 • Ampex VTR
- 1958 • Ampex hiband colour VTR
- 1959 • Closed Circuit TV (CCTV)
- 1958 • 1st high level programming language: Fortran
- 1959 • Kilby/Noyce (independently): Integrated Circuit
- 1960 • Computer Aided Design
- 1962 • Telstar telecommunications satellite
- 1962 • Satellite TV
- 1962 • Ivan Sutherland: Sketchpad
- 1963 • Teletext
- 1964 • Satellite TV broadcasting
- 1964 • Sony: Consumer VTR
- 1965 • Engelbart: Mouse
- 1968 • Intel: RAM chips
- 1968 • Engelbart: "Augment" hypertext system
- 1960s • Cable TV networks

television & video

media chronofile

1980 **1975** **1970**

telecommunications & computers 1

- 1971 • Intel 4004 Microprocessor
- 1972 • Xerox Alto Personal Computer
- 1972 • Nolan Bushnell : 1st videogame
- 1973 • Modern Fax Machines
- 1974 • Ted Nelson: *Computer Lib/Dream Machines*
- 1975 • Microsoft Corporation founded
- 1976 • Cray 1 Supercomputer
- 1976 • 16 kbyte RAM chips
- 1977 • Apple II Computer
- 1978 • 64 kbyte RAM chips
- 1978 • Intel: 8086 Microprocessor
- 1979 • Cell telephones
- 1979 • Visicalc: 1st spreadsheet software
- 1979 • Wordstar Word Processor
- 1979 • Motorola 68000 Microprocessor
- 1980 • Dbase II database management software
- 1981 • IBM personal computer
- 1983 • Inmos: Transputer

television & video 3

- 1971 • Sony U-Matic VTR
- 1972 • Philips: 1st consumer video cassette recorder (VCR)
- 1974 • Sony: Mavica still-video camera
- 1975 • Sony: Betamax VCR
- 1976 • JVC: VHS VCR
- 1978 • Philips: Laserdisc
- 1979 • MIT: Interactive Video (IV)
- 1982 • Sony: Betamovie camcorder

radio & records 6

- 1979 • Sony: Walkman
- 1979 • Philips announce Compact Disc Audio
- 1980 • Digital sampling
- 1981 • MIDI interface
- 1983 • Compact Disc Audio launched

photography & film 7

- 1970 • Steadycam mount
- 1971 • Omnimax Cinema
- 1973 • Canon colour photocopier
- 1981 • Sony: Mavica electromagnetic camera
- 1982 • Kodak: Disc film
- 1983 • Motion Control
- 1983 • Showscan process

print 4

- 1977 • Laser typesetting
- 1978 • Daisywheel printer
- 1980 • Laserprinter

Apple Laserprinter

media chronofile

1985
1990
1995

print

- 1985 • Adobe: Postscript page description language (PDL)
- 1985 • Aldus: Pagemaker software
- 1986 • Apple Desktop Publishing (DTP)
- 1986 • Canon colour laser photocopier
- 1988 • Colour laserprinter
- 1989 • Desktop Reprographics
- 1991 • Canon digital scanner/printer/copier
- 1992 • Adobe: Multiple Master digital fonts

photography & film

- 1984 • Kodak DX coding
- 1985 • Holographic film
- 1985 • Digital film editing suites
- 1992 • Kodak: Photo CD

radio & records

- 1987 • Digital Audio Tape (DAT) recorders
- 1989 • Sony: CD Walkman
- 1989 • CD-MIDI
- 1991 • Sony: Minidisc
- 1992 • Philips Digital Compact Cassette (DCC)

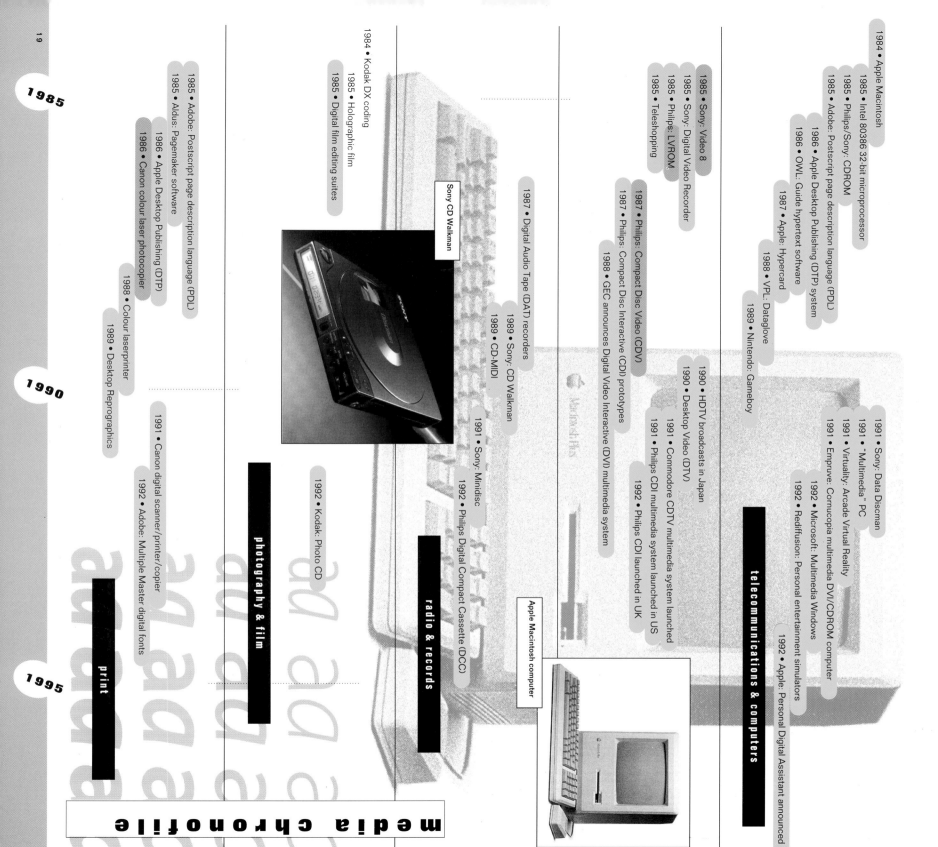

Sony CD Walkman

Apple Macintosh computer

telecommunications & computers

- 1984 • Apple Macintosh
- 1985 • Intel 80386 32-bit microprocessor
- 1985 • Philips/Sony: CDROM
- 1985 • Adobe: Postscript page description language (PDL)
- 1986 • Apple Desktop Publishing (DTP) system
- 1986 • Adobe: Postscript page description language (PDL)
- 1986 • OWL: Guide hypertext software
- 1987 • Apple: Hypercard
- 1988 • VPL: Dataglove
- 1989 • Nintendo: Gameboy
- 1985 • Sony: Video 8
- 1985 • Sony: Digital Video Recorder
- 1985 • Philips: LVROM
- 1985 • Teleshopping
- 1987 • Philips: Compact Disc Video (CDV)
- 1987 • Philips: Compact Disc Interactive (CDI) prototypes
- 1988 • GEC announces Digital Video Interactive (DVI) multimedia system
- 1990 • HDTV broadcasts in Japan
- 1990 • Desktop Video (DTV)
- 1991 • Commodore CDTV multimedia system launched
- 1991 • Philips CDI multimedia system launched in US
- 1992 • Philips CDI launched in UK
- 1991 • Sony: Data Discman
- 1991 • "Multimedia" PC
- 1991 • Virtuality: Arcade Virtual Reality
- 1991 • Empruve: Cornucopia multimedia DVI/CDROM computer
- 1992 • Microsoft: Multimedia Windows
- 1992 • Rediffusion: Personal entertainment simulators
- 1992 • Apple: Personal Digital Assistant announced

multimedia arts

Artists have been crucial to the exploration of the language of the new media technologies since the American painter Samuel Morse devised the electric telegraph and the code named after him. Throughout the nineteenth century, science and technology forced the pace of change in art, with photography, optical theory, electric light, X-ray photography, the cinematograph, colour photography, line block, halftone; as soon as new media technologies emerged, artists and designers seized upon the opportunities they afforded to experiment with ever more adventurous art forms.

At any time of rapid technological and social change, the nature of the Zeitgeist is apprehended most readily by artists, who often succeed in inventing a new form, or combination of forms, with which to express their insight. The most famous example of this "parallelism" between science and art (cited by John Berger in *The Success and Failure of Picasso*) is Cubism. For several years (between 1907 and 1914), Picasso, Braque and the other Cubist painters

Dada Typography

In their typographic experiments, the Dadaists and Futurists explored the presentation of information in "non-linear" formats, using montage and the juxtaposition of type and image.

explored a new kind of painting that broke with vanishing point perspective and the singular view of the world that this implied. Their new vision was multifaceted. Berger, Bronowski and others have noted the similarities between Cubism and the "phase shift" in physics signalled by Plank and Einstein between 1900 and 1905: a shift away from the Newtonian single, universal frame of reference towards a new conception of space time as relative to the observer.

Berger does not suggest that the Cubists understood, or even knew about, the new physics. But they did develop a response to the spirit of the age as they perceived it, a response

that was an expressive counterpoint to these revolutionary shifts of thinking in the sciences.

Although it has taken some time to emerge, it seems that a similar parallelism is developing in the last decade of the twentieth century. In hypermedia artists and designers are creating a new art and communications medium that perfectly expresses the non-linear "field" nature of electronic technology. As Marshall McLuhan pointed out in 1963 in *Understanding Media*, the

El Lissitsky: exhibition design for Pressa, 1928

One of the most influential Modernist designers, Lissitsky understood the transformations in media heralded by electricity. In the 20s he described the possibility of electronic books, and his exhibition designs demonstrate the multimedia approach to problem solving that is a recurring theme in twentieth-century design.

Tom Phillips: page from *A Humument*

In his method of superimposing alternative readings within an established text, Tom Phillips suggests the linking mechanisms of hypertext, and the different perspectives available to the users of hypermedia systems.

Peter Phillips: *Select-o-mat Variation no.13*

In his Selectomat series, Peter Phillips provided a collection of imagery and encouraged his clients to choose the images they wanted for their own customized painting. This method, derived from the technique of customizing cars popular in the US in the 50s, prefigures an important aspect of hypermedia programmes.

instant communication offered by electronic media leads to fragmentation. Sequence is replaced by montage. As it emerged from the convergence of the two dominant electronic technologies, television and computing, hypermedia is indeed designed to be fragmented. Blake's poetic vision of perceiving the universe in a grain of sand is given concrete expression in hypermedia. Whatever the starting point, it is possible to end up exploring the universe.

Fragmentation and synaesthesia have been two recurrent themes in Modernism. From Wagner's *Gesamptkunstwerk*, Whistler's *Nocturnes* and Kandinsky's correspondences between colour and music, to the Futurists' *Art of Noise*, to Dadaist Anti-Lectures and Cabaret, to the layering of media in Bolshevik Agitprop propaganda, to *Finnegan's Wake*, to Vertov's *Man with a Movie Camera*, to the explorations of Oscar Schlemmer and László Moholy-Nagy at the Bauhaus, and on through the work of John Cage, through the light/sound shows of USCO, Warhol and Expo 67, through "happenings", and the performance art of Laurie Anderson, artists have given expression to the "invisible revolution" that is occurring as our senses reorientate to accommodate media that are instant, global and multi-sensory.

Sergei Eisenstein: *diagram from The Film Sense*

Eisenstein's meticulous working diagrams show the correlation between image, camera movement, music and script, and anticipate many of the issues faced by the hypermedia programme director. *The Film Sense* includes Eisenstein's theory of montage.

Vannevar Bush

The vision that brought about the genesis of hypermedia was elaborated by the American computer scientist Vannevar Bush in an article entitled "As we may think", published in the *Atlantic Review* in July 1945. Bush's credentials were impeccable. From as early as 1912 he had patented a series of devices that were key steps on the road to the modern computer - and by 1941 Bush had been appointed by the Roosevelt administration to coordinate scientific research.

"As we may think" was a prescient article. In it Bush elaborated a most complete vision of a "memory extension" system he named "Memex" - a system that allowed the operator to input text, drawings and notes through an early form of dry photocopier or through head-mounted stereo camera

spectacles; to store this information in a microfiche filing system; to display several such microfilm files simultaneously, and to link related files together with a simple code. Bush envisaged a photographic (microfilm) data compression system; a method of exchanging information with other Memex users; the use of voice-transcription by means of voice recognition technologies; automatic character recognition, and much else that characterizes the desktop hypermedia systems that were to emerge fully fledged some 40 years later. Bush defined the Memex system in terms of the photo-mechanical technologies available in the mid 40s, with his informed guess as to how these technologies could be extended and optimized. He also mentioned the possibilities of electromagnetic memory cards, and hinted at the potential of

using television to provide network links between several Memex users.

The essence of the Memex system was "associative indexing": the ability to link the microfilm information together in ways that were meaningful to the user. In his official capacity, Bush was in a unique position to foresee the consequences of the information explosion. He realized that contemporary indexing techniques were imposing artificial constraints on the retrieval of information, forcing researchers to trace their requirements by following rigid alphabetical or numerical classifications. He noted: "The human mind does not work that way. It operates by association. With one item in its grasp, it snaps instantly to the next that is suggested by the association of thoughts, in

Bush was the first to realise the potential of storing items of information with built-in associative links to other data. He never actually built a real Memex, but the idea of such a system was a driving force in the development of hypermedia.

Vannevar Bush

The Memex system: desktop hypermedia in 1945

Bush envisaged Memex ("Memory Extension") in 1945 (three years before the transistor was invented, and 30 years before personal computers), and thought of it in terms of extrapolations from 1940s technology. Some 40 years later Apple launched Hypercard for the Mac, added a scanner, laserprinter and modem, finally creating a hypermedia system like Memex.

Back projection screen - several images displayed simultaneously. Images can be enlarged and reduced.

Joystick for browsing. Single frame, 10 frame and 100 frame jumps

Glass platen for photocopying books onto microfilm

Input copy button

Index button - projects Memex index file

Keyboard for adding text

Storage unit for microfilm Memex files, with automatic feed to projector

hypermedia innovators

accordance with some intricate web of trails carried by the cells of the brain." Bush talked about the possibilities of mechanizing this process of "selection by association", and went on to elaborate the system illustrated here.

In Memex, microfilm "files" are retrievable in three distinct ways: they can be called to the screen by means of a conventional index (which is itself a microfilm file that can be projected on demand); they can be displayed sequentially, (using a "joystick" to control the frame rate), slowly for browsing, and fast for speedy location of an item; and most importantly they can be viewed by following the "trails of association" that the user or author has established by linking together one card with another. The resulting trails can be followed by other users and they too can make annotations, or create further links. Leaping ahead in his imagination to the 1990s, Bush commented: "Wholly new forms of encyclopedias will appear, ready made with a mesh of associative trails running through them, ready to be dropped into the Memex and there amplified."

The Memex system was never implemented using the technologies that Bush envisaged, but the idea of an interactive, desktop "hypermedia" system was to resonate through the next 40 years, inspiring several of the individuals who were to make important contributions to the hypermedia revolution of the 90s.

Douglas Engelbart

"Augmentation of the Human Intellect"

Douglas Engelbart read Bush's article "As we may think" towards the end of the War while he was still an army radar technician. Within 20 years or so, at this laboratory at the Stanford Institute, he had developed his own contributions to hypermedia: the idea of the mouse and windows, electronic mail and teleconferencing. All these components formed part of Engelbart's "Augmentation" project - a project that provided much of the framework for both the development of the personal computer and for hypermedia. Engelbart conceived the idea of a computer-based system for the "augmentation of man's intellect" in the early 60s:

When I first heard about computers, I understood from my radar experience during the war that if these machines can show you information on printouts, they could show that information on a screen. When I saw the connection between a television-like screen, an information processor, and a medium for representing symbols to a person it all tumbled together in about half an hour. I went home and sketched a system in which computers would draw symbols on the screen and I could steer through different information spaces with knobs and levers and look at words and data and graphics in different ways. I imagined ways you could expand it to a theatre-like environment where you could sit with colleagues and exchange information on many levels simultaneously. God! Think of how that would let you cut loose in solving problems!

By 1968 Engelbart had produced the NLS (oN Line System), which embodied features that were to become prototypes for all the hypermedia systems we have now. These features, ranging from the mouse, windows and electronic mail to word processing and hypertext, were all steps on the road towards an "Augmentation" system that would marry contributions from a human user (the ability to organise, a knowledge of procedures, customs, methods and language, and skills, knowledge and training) with a "tool system". This would include

Douglas Engelbart

Engelbart was a pioneer in office automation. During the 1950s and 60s he invented the mouse, multiple-window screens and many other of the now familiar components of desktop computing and hypermedia.

hypermedia innovators

capabilities for communicating with other users, for "travelling" through an information space, for viewing information in a variety of ways, and for the retrieval and processing of information in a number of different media. Today, Engelbart believes that such a system creates a synergy between the user and the computer that will amplify the user's intellectual capabilities. As a graphic demonstration of what happens when tools handicap our thinking, instead of augmenting it, Engelbart has suggested that we try to write with a pencil tied to a brick. Such a poor tool "disaugments" our intellect.

Ted Nelson

Ted Nelson coined the expression "hypermedia" in the 70s in order to describe a new media form that utilised the power of the computer to store, retrieve and display information in the form of pictures, text, animations and sound. He had already used the prefix "hyper" to describe a system of non-sequential writing: "text that branches and allows choices to the reader". In "hypertext" textual material could be interlinked, providing a system which would break down traditional subject classifications and allow non-computer-literate users to follow their own lines of enquiry across the whole field of knowledge. The principles of hypertext have since been embodied in several software products aimed at the general public. Nelson's own Xanadu project is the most ambitious of these, aiming to integrate the entire library collections of the world into a seamless electronic system, where for example the hypertext reader might start by consulting a modern edition of Shakespeare's *Macbeth*, diverge sideways to explore medieval witchcraft, look at the original "first folio" or access any of the thousands of critical essays on the play, all by simply selecting different keywords from the texts displayed on a computer monitor.

Echoing Vannevar Bush's comments on Memex, Nelson points out that the value of hypertext is that (compared with normal "sequential" reading) it more closely models the way we think, allowing us to explore a subject area from many different perspectives until we find an approach that is useful for us. Using hypertext, authors would no longer have to write for a specific "average" reader. They could include any level of detail, and allow the reader to decide how deep into the subject matter they wanted to go.

dream machines

In a series of seminal articles and books, including *Computer Lib* and *Dream Machines*, Nelson develops the idea of "fantics" (the "showmanship of ideas"), "thinkertoys" (computer systems for helping to visualise "complex alternatives"), and "super virtualities" (the conceptual space of hypermedia). These ideas encapsulate his vision of hypertext and hypermedia, and explore the nature of how these media could be used for both education and entertainment. Nelson has mapped out much of the theoretical territory that is now being explored by practising hypermedia designers, and has stressed the point that "Learning to program has no more to do with designing interactive software than learning to touch-type has to do with writing poetry." Creating successful hypermedia, like making feature movies, depends on applying the arts of communication design to both the content and the structure of the programme.

By the time the first desktop computers were produced in the late 60s, much of the theoretical and practical infrastructure of hypermedia was in place. But Engelbart's NLS system had been designed for use on workstations attached to large mainframe computers, and the arrival of the small "personal" computer opened up an entirely new possibility - portable hypermedia systems more like "super books" than computers.

Ted Nelson

Nelson invented the term "hypermedia" and developed many innovative ideas for the application of hypertext (linked text). He has always championed the idea of hypermedia as two-way, read/write media, available to everyone.

Alan Kay

the Dynabook

In 1968 Alan Kay built a cardboard model of a portable hypermedia system he called the "Dynabook". This prototype was designed to have a flat screen display (a technology then in its very earliest stages) and a graphic interface, and would be capable of handling large quantities of text. It would be a read/write medium for children, with an easy to use "development environment" (or programming language) called "Paintbrush", that children could use to create and animate pictures. Kay proposed that the Dynabook would link (via phone lines and wireless) to other Dynabooks and to library resources, and should be produced for under $500, so that it could be made available to every schoolchild. Over 20 years later, the Dynabook has still to be implemented as it was originally conceived.

Much of Kay's subsequent work at the Xerox Palo Alto Research Centre (PARC) was driven by the Dynabook vision. The spin-offs were considerable: in particular, the development of software that allowed users to control the Dynabook by means of a "graphical user interface", that included many of the features later developed by Apple for their Macintosh computer, such as menus and icons. They also included a new kind of programming language (Smalltalk, the precursor of Apple's Hypertalk, the most popular hypermedia "scripting" language); and an expansion of the Dynabook idea to include intelligent "software agents" which are specialised computer programs to which mundane or time consuming tasks can be delegated, and which have enough "intelligence" to learn about us (our tastes, requirements, priorities and plans), in order to help us deal with the ever increasing "information overload" that characterises the late twentieth century.

Kay sees the emergence of the Dynabook as a culmination of the process that began with Gutenberg's invention of printing, progressed with the idea of the portable, legibly printed book (such as those designed by Aldus Manutius in the late fifteenth century), and gave us the modern paperback. Just as books went from desktop-size with Gothic typefaces to pocket size and Roman (modern) faces, so the Dynabook will make the computer into a personal (and individualized) information resource, as easy to use as reading a book. And just as the availability of mass-produced books helped create the individualism and personal perspective that spurred the Renaissance, so the Dynabook and "intimate computing" will initiate profound social changes that will make a serious impact on the next century.

hypermedia innovators

The Dynabook idea is so attractive that already several manufacturers have used the name to describe their laptop and "notebook" computers. Some of these machines incorporate CDROM (laserdiscs the size of CDs that store data and pictures as well as sound) disc drives, and modem connections, but so far, most of them use software and interfaces originally designed for desktop computers.

"Interface" is an abbreviation of "human-computer interface". There are many ways of "interfacing" with computers. The first interfaces were plug boards; the computer was literally rewired in order to run a particular program. Later, programs were prepared in batches of punch cards. When television-style monitors were introduced, a more "interactive" interface became possible, with the computer providing a set of prompts to which the user responded by typing in various commands (which of course had to be learned in advance). The success of the "graphical" interface (with its now familiar windows, mouse and menus) lay in the fact that it was so easy to learn. The interface software for future Dynabook-style intimate computers will owe far more to the kind of interface that is now evolving for hypermedia than to the style of software we associate with most desktop computers. As Ted Nelson says: "To see tomorrow's computer systems, go to the military flight simulators! Go to the videogame parlours! Look there to see true responsiveness, true interaction."

Alan Kay

Kay's idea of the "Dynabook" (a portable, personal hypermedia computer) is a continual inspiration for the developers of portable, easy-to-use notepad computers that incorporate telecoms with hypermedia access to information sources.

cyberspace visionaries

Since 1984, when William Gibson used the term in his novel *Neuromancer*, the word "cyberspace" has become the most useful catch-all to describe the composite new "space" that encompasses both extremes of scale: the vast "global village" network of telecommunications, and the minuscule quantum space of the microchip, with its ever increasing capacity to store and manipulate data. Somewhere between these two extremes there is a space that architects and animators who use three-dimensional computer graphics will be familiar with: the strange "virtual" space that only materializes as glowing red, green and blue phosphors on the monitor screen, yet seems to be as real as perspective geometry, ray tracing, depth cueing, texture mapping and other computer graphic devices can make it.

First time users of such computer-graphic systems experience a peculiar vertigo or agoraphobia as they begin to explore the vast spaces that can be encapsulated in the microchip. Being able to define a preferred viewpoint from within an extensive architectural model, getting lost within that model, or piloting a "virtual" aircraft in a landscape that apparently stretches

William Gibson: *Neuromancer*, 1984

In this seminal "cyberpunk" novel, Gibson elaborates his idea of "cyberspace" as a global media/telecommunications network.

for miles and miles; all these are "transforming" experiences, and provide the basis for Gibson's elaborate vision of cyberspace.

Gibson's vision is of a multi-dimensional space inhabited by vast "data structures", where glowing and pulsing representations of data flow within the ubiquitous computer/telecommunications networks of military and corporate processing power. In such a space, the hackers of the future ("cyberspace jockeys") wheel and deal raw data by breaking the complex security protection of the corporate memory banks. The scale of Gibson's cyberspace is hinted at in the following passage from Neuromancer:

Program a map to display frequency of data exchange, every 1000 megabytes a single pixel on a very large screen… Manhattan and Atlanta burn a solid white. Then they start to pulse, the rate of traffic threatening to overload your simulation. Your map is about to go nova. Cool

it down. Up your scale. Each pixel a million megabytes. At 100 million megabytes/sec you begin to make out certain blocks in midtown Manhattan, outlines of 100 year-old industrial parks fringing the old core of Atlanta…

Using McLuhan's metaphor of computing as an extension of the human sensory system, Gibson describes the cyberspace matrix as "a drastic simplification of the human sensorium", and "a consensual hallucination experienced daily by billions (of people)… a graphic representation of data abstracted from the banks of every computer in the human system." Other science fiction writers of the "cyberpunk" genre such as Bruce

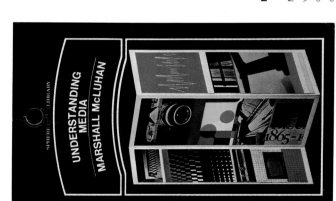

Jascia Reichardt: *Cybernetic Serendipity*, 1968

This special edition of *Studio International* magazine served as a catalogue to the first major exhibition of cybernetic art, held at the Institute of Contemporary Arts (ICA) in London in 1968, some six years before microcomputers were widely available.

Marshall McLuhan: *Understanding Media*, 1964

McLuhan was the first to realise that electronic media would create a "global village", simultaneously shrinking the world down to village size while extending our central nervous system to give us electronic "eyes" and "ears" wherever the TV camera, radio microphone or satellite imager is used.

W Industries: Virtuality console

With a "Visette" visor to provide a stereoscopic view of a computer-generated environment, this virtual reality system from W Industries moves the user through cyberspace by means of dual joysticks. The Virtuality system tracks users' positions and generates high-resolution images in response to their head movements.

NASA : Exploring Virtual Reality

The technologies of real-time 3d computer animation, position-sensing and stereoscopic viewing have been integrated within "Virtual Reality" systems. VR allows users to participate interactively within three-dimensional computer-modelled environments. Users can explore DNA molecules, practise space walks, walk through architectural models

cyberspace visionaries

Ted Nelson: *Computer Lib/Dream Machines,* **1987**

This is Nelson's "manifesto", mapping out the future of hypermedia in a collage of articles, features and sketches. Nelson thought it all through in the 60s and 70s, and this book is the best evidence of his vision.

Sterling and Rudy Rucker have also explored the notion of cyberspace, extending a tradition that includes John Brunner's *Stand on Zanzibar* and *Shockwave Rider* and Larry Niven's *Ringworld* and many others. Outside fiction, this accretion of cyberspace perspectives has been variously informed by philosophers, critics, artists and architects, including McLuhan, Norbert Weiner (*Cybernetics*), Jean Baudrillard (*The Ecstasy of Communication*), Buckminster Fuller (*Education Automation*), Myron Krueger (*Artificial Reality*), Gene Youngblood (*Expanded Cinema*) and the work of Nam June Paik, Stan Van der Beek, the Whitney brothers and the other artists featured in Jascia Reichardt's seminal *Cybernetic Serendipity* exhibition at London's Institute of Contemporary Art in 1968. The psychologist/guru Timothy Leary, interviewed by David Gale in 1991, is most eloquent about cyberspace:

What we're talking about is electronic real estate, a whole electronic reality. The problem we have is to organise the great continents of data that will soon become available. All the movies, all the TV, all libraries, all recordable knowledge.... These are the vast natural crude oil reserves waiting to be tapped. In the 15th century we explored the planet, now we must prepare once more to chart, colonise and open up a whole new world of data. Software becomes the maps and guides into that terrain.

During the 80s, the cyberspace vision was being fleshed out in the workshops and laboratories of MIT and NASA. Different ways of engaging with silicon space, of seeing it, being in it, touching and feeling it, flying through it and hearing it, were being developed. The inter-relationship between the vision and the practical engineering of cyberspace during these last few years is complex. But practical, working "virtual reality" machines (such as W Industries' Virtuality and VPL's Reality Built for 2) were on sale in both the US and Britain by 1990.

Eugene Youngblood:
Expanded Cinema, 1970

Youngblood's collation of essays and interviews surveys the range of cybernetic art developments up to 1970, and covers all the pioneers of computer graphics and experimental film and video work.

Richard Buckminster Fuller:
I Seem to Be a Verb, 1970

Fuller is an architect, engineer, poet and philosopher with engaging insights into the condition of the arts and sciences in the late twentieth century. This book is designed in a very "multimedia" style, with graphics, typography, quotes, new articles, images and content acting together to present a montage of his ideas. Like hypermedia programmes, this book has no beginning or end – it can be read back to front and upside down, since the page layouts work in both orientations.

cyberspace visionaries

exploring cyberspace

virtual media

The roots of virtual reality lie way back in the 30s when the first flight simulator, the Link Trainer was introduced. This was the first in a long line of training simulators for aircraft pilots. A simplified full-scale model of a fuselage and cockpit, mounted on a platform that could rotate and move up and down, and with the bare minimum of audio and visual cues (or "feedback") helped the trainee pilot suspend disbelief in the "reality" of the experience. From this early stage simulators have grown into immensely sophisticated machines employing hydraulics, wrap-around video screens and powerful computers using state of the art real-time modelling software.

Early machines used back-projected film to give the trainee the illusion that he was airborne. The current generation of flight simulators, such as those made by Hughes, Evans and Sutherland, and Rediffusion, employ computers to generate the images, which are projected on to 200°-wide screens (using the latest monitor and videobeam technology). The illusion of reality in these machines is so successful that it is only in the smallest details, such as the lack of tyre skid marks on runways, that pilots can tell the difference.

The idea of simulating reality with wide screens and stereoscopic effects became very attractive to the motion picture industry during the 50s, a decade when cinema audiences were switching to television as the preferred entertainment medium. The attempts to provide cinema audiences with experiences that were impossible to achieve on television resulted in a wave of technological innovation, including Cinerama (with three synchronized films projected simultaneously on to a wide, concave screen), CinemaScope and other wide screen formats, stereo sound, and the pseudo-stereoscopic effect of anaglyph (red/green) or Polaroid three-dimensional movies.

It was during the 50s that the inventor and cinematographer Morton Heilig decided to take the Cinerama effect to its logical conclusion and develop a projection system for images that would extend to completely fill the viewer's peripheral vision, both horizontally and vertically. Despite commercial setbacks with this cinema system, Heilig went on to patent an arcade console for individual users, which he called "Sensorama". This was the first simulator designed for entertainment, and Heilig planned to put Sensorama "Experience Theatres" in every coin-op arcade in the United States. Sensorama used back-projection, vibration, wind fans, stereo sound and even smells to create a realistic simulation, but the photo-mechanical technologies it used could not cope with the physical rigours of continual use in an arcade, and the system was never mass-produced. Sensorama was a mechanical cul-de-sac. Heilig's system ignored the two most powerful technical developments of the time, television and the computer.

These technologies are harnessed together perfectly in large-scale flight simulators. But they can also be used in another way to achieve the effect that Heilig was seeking. Instead of using larger screen images, the screens are made smaller, and mounted right in front of the viewer's eyes. Heilig had thought of this idea, and Ivan Sutherland had demonstrated the possibilities of head-mounted binocular television displays in the late 60s. Linking these head-mounted displays to computers (into which have been programmed high-definition computer models of buildings and landscapes) is the first step in making a virtual reality (VR) simulator.

For the next step, which allows interaction with the three-dimensional models, stereoscopic goggles fitted with position sensors are needed. The computer has to "know" where the viewer is

Dimension International: Superscape VR toolkit

Sophisticated software for people to create their own three-dimensional environments: digital "movie lots" for VR games designers, models that architects can "walk" through, molecular models for scientists, virtual anatomies for surgeons. This is one of the first generation of VR toolkits; according to Dimension, it is possible to create virtual worlds up to the size of the British Isles...

Domark: 3d Construction kit

This software combines 3d modelling software with an arcade game developed using the same kit. The game is not only fun: it demonstrates the modelling and animation that can be created with the construction kit.

Virtual media

in relation to the software model, and in which direction he or she is looking. It must then generate two images (one for each eye) of the view from that point, producing about 25 of these frames every second and recomputing instantly the new viewpoints as the user moves his or her head, and to redraw the new stereo images of the model.

Flight simulators promote interaction with the virtual world through physically real hardware: the joystick and controls in the simulator's cockpit or flight deck. Virtual reality systems carry this a stage further. By means of position-sensing gloves, such as VPL's Dataglove or W Industries' Space Glove, the user can put his or her hand "into" the computer model, take hold of objects and move them about. With clever programming, VR systems can supply "force feedback", so that the object has weight and inertia.

Virtual reality and flight simulation technology have much in common, and the two industries are

in competition to provide machines that allow us to explore cyberspace. What we find there will be up to us. We shall be able to choose VR environments that allow us to drive a racing car, ski in the Alps, sail the oceans, fly a plane, or alternatively travel through the solar system, explore the genetic code, or wander through the neolithic landscape of Britain. Simulation is already a successful training tool; how much it will be used as a powerful educational tool, and how much as merely an escapist entertainment, remains to be seen.

W Industries: Virtuality

The British company W Industries were the first to market successful VR systems for arcades and theme-park installations. Current software includes flight and driving simulators, but VR systems like this will eventually allow us to "travel" to the stars, explore the rings of Saturn, climb Mount Everest, travel on a "Fantastic Voyage" through the human body; in other words, VR will be used to give us a wide variety of real-time educational environments.

Morton Heilig: Sensorama

The first multi-sensory "virtual reality" engine invented back in the 50s, used film loops, stereo sound, smells, wind and other effects to create the illusion of motorbiking through downtown Brooklyn.

NASA: Designing within a virtual windtunnel

Virtual Reality is not limited to flight simulators. Here, using VR techniques, the designer can experience first-hand the aerodynamic consequences of design decisions. Virtual Reality extends the notion of computer-aided design (CAD) by putting the designer back in touch with the designed artefact.

Everything we have learned about how change and innovation take place suggests that there is a common underlying pattern. Plotting the adoption of a new technology against time always seems to produce an "S" shaped curve. In the early stages the curve is almost flat: promoting an innovation from the start seems to involve pouring in energy and effort with very little return, a frustrating period when nothing seems to be happening.

Until about 1990 hypermedia occupied this flat part of the curve. People were producing some very interesting work; the technology was improving at a breathtaking rate, and there was some stimulating thinking and writing about the potential of the medium. But all this was very much the concern of a small bunch of enthusiasts. Designers and developers of hypermedia products found this period particularly difficult. The possibilities of the medium could be clearly seen and generated considerable excitement. But ideas for amazing hypermedia products tumbled out of discussions only to hit the wall of "Where is the market?", "Who is going to fund it?", and a range of other hard realities.

In 1991 there were indications that the direction of the curve was changing. Articles about

hypermedia began to appear in the non-specialist press; Commodore launched their CDTV (an interactive multimedia system) as a consumer product; some galleries and museums installed interactive multimedia information systems, to a very positive response from their visitors. And, perhaps most interestingly, there was a flurry of general interest in virtual reality, which can be seen as the far reaches of hypermedia.

These hints of change are important to hypermedia designers, but they are still more significant to people with a wider professional interest in the media and communication industries. A characteristic of the S curve of innovation is that while the initial stage is almost flat, the second stage moves very quickly to the near vertical. For this reason change often seems virtually instantaneous. Suddenly every business seems to have a fax machine. Suddenly everyone seems to be using a computer. The earlier stage of slow research and development, when the innovation was the province of a small minority is forgotten.

h y p e r m e d i a o n t h e S c u r v e

It looks as if we will very shortly be at the stage when "suddenly everyone is using hypermedia." We cannot know exactly where we are on the innovation curve. What is evident from looking at other innovations is that when the curve begins to move sharply upwards things start to happen very fast. When this happens, imaginative foresight is required. No one can predict the future, and the record of forecasters on specific detail is inevitably rather poor. However, hypermedia has now been around long enough for us to identify some of the issues, potentials and characteristics which will allow us to begin the process of intelligent anticipation.

This section of the book explores some of these issues, potentials and characteristics. Combined with the concrete examples featured in subsequent chapters, this analysis will provide some tools for thinking about the implications of this medium.

hypermedia

2

the next media revolution

what makes hypermedia new ?

A n analogy is often drawn between film and hypermedia. Those involved in hypermedia face problems similar to those confronting the early pioneers of cinema. People actually had to invent the close-up, the fade, the dissolve. And when sound came along they had to reinvent the medium to incorporate that. The same is true for hypermedia. We have the technology, but we are still very much in the process of inventing the language and conventions of this new communications medium. Many of the examples that now look exciting and interesting will no doubt seem primitive in a few years' time.

But the analogy with film is misleading, for two reasons: hypermedia is likely to be more widespread in its applications than film has ever been; and as a medium it may represent a more radical break with the past than all the other new media of the twentieth century, apart from

computing. Hypermedia is of interest to information technology (IT) specialists because it represents IT's human face. Loosely defined as "computing plus telecommunications", IT is very rapidly becoming the prime technology in the world of work. As Shoshana Zubof has pointed out in her seminal book *In the Age of the Smart Machine*, this presents serious problems in terms of the "disembodiment" of work. Instead of working with real items, bits of metal, pieces of paper, stuff with real weight and substance, most people are dealing with abstract representations of those things, which have been reduced to alphanumeric characters on a computer screen. Through a range of concrete examples, from workers in pulp mills to clerical workers in insurance companies and banks, Zubof graphically describes the sense of alienation and powerlessness that can result from this "abstraction" of the work process. And as the engineer Mike Cooley has pointed out, this abstraction can lead to "the spectacular separation of theory and practice whereby some of those who have been weaned on CAD (computer-aided design) are unable to recognise the object that they have designed".

Hypermedia, with its rich sensory mix of media promises a solution to some of these problems. We are very likely to see hypermedia becoming the "front end" (the part the user deals with) for IT systems of all kinds, whether they be design systems, cash machines at the bank, control systems in a factory or databases in an office.

This book's major focus is on professionally generated hypermedia products, and implicit in much of what is said is the notion that the creation of hypermedia products is the business of media professionals. This view is reinforced by the fact that the overwhelming majority of examples are carried on compact discs - the same CDs that have come to dominate recorded music, but carrying images, text, animations and video as well as sound. These compact discs are described as "read only": the user cannot add anything after

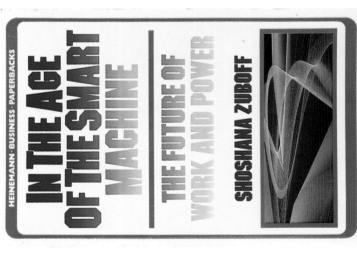

Shoshana Zuboff: *In the Age of the Smart Machine*, 1988

A key text for anyone who wants to understand the impact of information technology on the world of work, Zuboff's book is, by implication, an argument for the development of hypermedia as the "human face" of IT.

the next media revolution

which was among the first practical introductions to hypermedia, was conceived and promoted as an easy to use hypermedia construction kit for anyone to use. One of the great strengths of Hypercard is that it allows novices to create their own applications by "copying" and "pasting" elements from existing applications. Everything, from images, text and sounds to the programs that make things happen, can be reused or modified to create new applications.

Today Hypercard and its close relative Supercard are used by professionals to create very sophisticated hypermedia products. Although many Apple Macintosh owners have discovered the joy of programming through Hypercard, the majority probably only use it to run Hypercard applications ("stacks") produced by professionals or very knowledgeable amateurs. Only a small minority construct applications for their own use.

The professional adoption of programmes such as Hypercard, and the ever increasing promotion of CD-based multimedia systems which reinforce the professional, "one way" image of Hypermedia, tends to disguise its capacity as a two-way, "read/write" medium. But just as desktop publishing (DTP) introduced the skills of graphic

design to a much wider range of people, including secretaries, executives and managers of small businesses, so Hypercard encourages the "hands on" experience of the wide range of skills associated with hypermedia.

they have been pressed. This emphasis on hypermedia as a "read only" product is typical of the attitude being taken by the major electronics companies who are developing the hardware (the equipment to play hypermedia products), and by the media-based companies who are developing hypermedia programmes (the software) that will be played on that equipment.

If this were the only approach, the development of hypermedia would be much closer to that of film, television and radio than it actually is. Media professionals would have the responsibility for learning to "write" in the new medium, and all that learning to "write" it - much as they learned to "read" film, TV and radio, the earlier media of the twentieth century. But hypermedia has the capacity to be more "democratic" and "personal" than these, which were all mass media, largely defining their success in terms of audiences counted in millions.

When Ted Nelson coined the word "hypermedia" he was certainly imagining a medium more like writing, a medium in which we are all users and creators rather than simply consumers. Apple, who have done much to make hypermedia a practical reality, have consistently promoted it in these terms. Indeed, their Hypercard programme,

Westminster Cable: Westscan channel multi-choice screen

A visual "menu" for cable TV subscribers that shows what programmes are available on twelve channels, with local ads in the central window.

S Curve diagram

bricolage

D igital media makes copying extremely easy. We have already seen how electronic and electromechanical media such as photocopiers, tape recorders and video cassettes have allowed wholesale copying, depriving the intellectual property holders of their legitimate revenue. In the computing world the use of pirated software by otherwise law-abiding, honest people is extremely high. The actual ratio of pirated to legitimate software actually is not known, but might well be five to one.

With a digital medium such as hypermedia, not only is copying very easy, but once it has been copied, material can be very easily adapted, modified, changed or merged with other copied material. In 20 years' time, one definition of "literacy" may be the ability to put together an interactive communication (using sound, images, animation and live action video as well as text). If this is the case, it will be largely because hypermedia is the supreme medium for bricolage. This, the bringing together of existing elements to create something new, has been one of the characteristics of many of the arts heralded as precursors of hypermedia. At a deeper level, bricolage can be seen as a fundamental aspect of human creativity. Nothing that any of us creates is totally new. Everyone, including the most brilliant and original, draws on existing elements of the culture. What makes something new and original is the organization of those existing elements into new and original relationships, combined with the detail of their expression.

This book is a very clear and concrete example of bricolage. The pictures that illustrate it are in the main the work of independent individuals, while the text is, except where credited, the authors' own work. The ideas too are largely theirs, unless their origin is specifically identified. But the words and ideas are mostly built on encounters and interactions with the works of hundreds if not thousands of others. A book making very similar arguments to this one could have been

constructed entirely from quotes, and still been legitimately claimed as an original work. Had we altered or modified those quotations to suit our line of argument that task would have been much easier.

It is hardly surprising if ideas like this fill people with a sense of unease. It is part of our common heritage. Even though most of us know that one of the characteristics of legitimate, respectable and original academic works is that they consist of direct and indirect quotes linked by by the author's commentary, most of us still carry the notion that copying is wrong. Copying and then modifying to suit our own ends seems a still greater violation.

In hypermedia the nature of the "quotes" that can be copied and modified is far greater. As well as text, sound, images and moving images can be sampled and assembled in new forms. Some sense of the legal and commercial issues this presents can be gleaned by looking at what has happened in recorded music in recent years. The practice of sampling (lifting a musical phrase or a drumbeat from an existing recording and placing it within a new work) has become commonplace and only in a tiny handful of cases do the original musicians or artists receive any recognition or payment for their unwitting contribution.

This issue will be made still more acute by a development of which the effort that is going into inventing and promoting hypermedia can be seen as a symptom. Information is becoming a valuable commodity in its own right. Large corporations

are spending billions on the acquisition of intellectual and creative property rights and the means of generating intellectual and creative property, whether it be books, films or recorded music, or publishing companies, film studios or record labels. Companies that have been storing large backlists of material have suddenly found that their archives are very valuable assets.

Hypermedia's ability to integrate material of many different forms, and to allow reorganization of the relationships within that material in a multitude of different patterns, offers new ways of communicating and new tools to operate with. New communications and "knowledge processing" tools, are desperately needed, but for them to become a reality it is crucial that the mass of cultural, creative and technical material that now exists be freely available.

Information can be expensive, however. No one would argue with the idea that original authors and creators should be recognized and rewarded for their work. But as has been shown with software piracy and music sampling, the practical problems of monitoring royalties and protecting copyright are immense. Robert Kerr of the Alexandria Institute summarizes the problem:

"A copyright system based on the publication, distribution and compensation for a printed copy of a book may not be a viable model for the protection of intellectual property rights when the "copy" is a single disc with the full text of 500 books representing more than 1000 proprietary interests" (quoted in Michael Fraase, *Macintosh Hypermedia Vol 1*). Kerr suggests a "pay for use" model in which copyright fees are based on the actual use of the information. Through this method, simply viewing the information on a

semantic compression

A crucial aspect of the work that needs to be done is what Nicolas Negroponte calls "semantic compression". An example he gives is of a wink across the dinner-party table. That one simple action, the equivalent of the smallest unit recognized by a computer (the binary "on off"), would require a lengthy explanation if put into words, and still might not convey the same depth of meaning. Hypermedia, with its multi-sensory capabilities, offers us the opportunity to develop a similar "economy of means" with which to express and compress large amounts of information.

Semantic compression is necessary because it is only by using simple, elegant means of expressing complexity without violating variety and diversity that workable solutions will be found to the problems that confront society. If we are to manage complexity successfully we will need to remember the words of Maynard Keynes in his preface to his *General Theory*: "The difficulty lies not in the new ideas, but in escaping from the old ones, which ramify, for those of us brought up as most of us have been, into every corner of our minds."

screen would incur a lower fee than, for example, copying the text or pictures into another application for editing. The *Whole Earth Review* editor, Kevin Kelly, has suggested a "share-right" scheme, by which publishers of electronic media can label their work with an ⑤ sign meaning that: "You may reproduce this material if your recipients may also reproduce it".

But since the great bulk of copyright material is now owned and controlled by very large corporations who have both the resources and the motive to enforce their rights zealously and restrictively, an immensely complex copyright problem arises, involving many conflicting interests.

The early pioneers of hypermedia, Bush, Engelbart, and Nelson, were all acutely aware of the problems of handling complexity, and their conceptual and practical work in this area was, and in the case of Engelbart and Nelson still is, very much concerned with developing systems that allow us to manage complexity. So we can think of the long-term goal of hypermedia both as being a communications medium, enabling us to communicate ideas about complex situations with elegance and simplicity using most if not all of our senses, and as a tool for managing complexity by allowing us to assemble and manipulate a mass of disparate multi-sensory information elements until they fall into patterns that make sense.

managing complexity

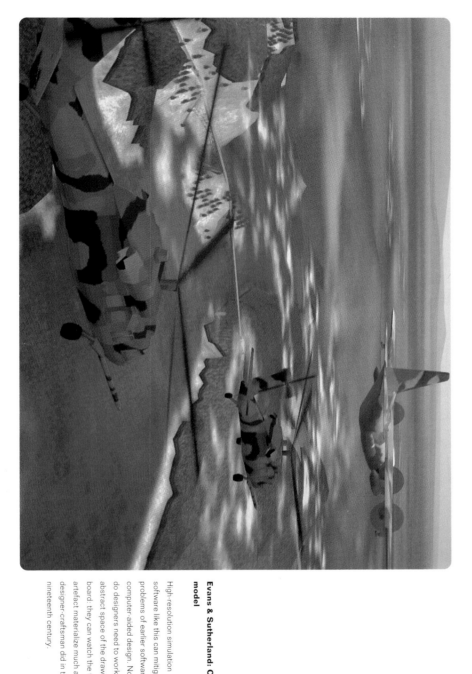

Evans & Sutherland: CAD model

High-resolution simulation software like this can mitigate the problems of earlier software for computer-aided design. No longer do designers need to work in the abstract space of the drawing board; they can watch the final artefact materialize much as a designer-craftsman did in the nineteenth century.

Commodore: CDTV Player

Commodore Dynamic Total Vision is the first multimedia system designed specifically for the general consumer market. Launched in 1991, with a range of software programmes that included videogames, quiz programmes such as "Trivial Pursuits", sports simulators, encyclopedias and interactive cartoons, CDTV began to set the pace for home multimedia products.

a.b. Section plate 3.

c.d. Section plate 2.

Sir Robert Smirke: Covent Garden Theatre plan

The architect's plan as a metaphor for cyberspace. Navigating your way through hypermedia programmes is easier if you have the kind of spatial cues you expect in real life. Following the metaphor of a building (and knowing which parts of the programme can be found in the different rooms in that building) simplifies the user's task.

RAM/La Mancha Productions: WW2 Interactive

Interactive "encyclopedias" like this use hypermedia techniques to make linear film or video programmes become interactive. Users can quickly access the programme segments they need, and extra levels of text, graphics and pictures are available.

developing a new rhetoric

What constitutes a communication, an argument, a medium, must be developed in a new rhetoric in order to escape convention. There is so much that is familiar about the elements that make up hypermedia, and yet so much that is strange and confusing to minds that have been deeply programmed to think in conventional terms of a beginning, a middle and an end.

Almost inevitably hypermedia programmes are thought of as having the structure and form of earlier media, albeit with some extras. Whole categories of interactive products (including Interactive Encyclopedias, Music Plus and Film Plus) are emerging that are based on familiar media. Perhaps this is just as well: we need to move through a period where hypermedia is made as familiar as possible in order to develop the confidence, concepts and skills in this new medium that allow us to escape from the conceptual tyranny of the past. Marshall McLuhan identified this phase as necessary to the adoption of any new technology, and reminds us of "horseless carriages" and the "wireless" as examples of

"looking at the future as though through a rear view mirror".

Nevertheless experience suggests that structural metaphors drawn from serial media such as books are real obstacles to hypermedia's attainment of its full potential as a communications medium and as a medium for managing complexity. Structural metaphors drawn from landscape gardening, sculpture or architecture seem a far more fruitful way of exploiting the "random access" (start anywhere, go anywhere) nature of this new medium.

The words of the design theorist Christopher Jones in his *Essays in Design*, come to mind:

...using and inhabiting...a building as a process, a physical process differing only in scale from the physical process of constructing the building. In both processes materials and people move about over the site changing the positions and form of what is there. So in this view, building is a form of living, and living a form of building. That's one way of realising that there are no products, no fixities, only continuous flux. And that designing, making and using are all processes that are added to, and interact with, the natural processes of the place where these activities occur.

Hypermedia marks the beginning of the adoption and exploitation of the computer as a medium, rather than simply as a tool. The "computer" as its

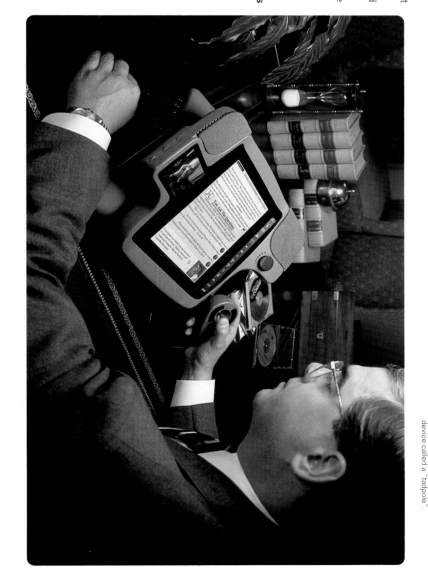

name suggests, was originally designed just to process numbers. While we have known right from the beginning that the digital computer is a general-purpose machine, it is only in the last few years that its capabilities as a carrier of pictures, video and sound have begun to be exploited. The computer is no longer just a computer, it is a "hypermedium", generating a revolution in media that is happening at this minute. Hypermedia is likely to have profound implications affecting every aspect of our lives. For the interactions of people from all over the world, both as users and creators of hypermedia applications and networks, will be a major force in redefining our knowledge of ourselves and the world we live in.

Since hypermedia is a very young medium, claims for it are largely based on intuition and imaginative projection. While the technology seems certain to continue to develop at a breakneck pace, hypermedia's development as a medium, on the other hand, is going to rest on the

imagination and creativity of commissioners, artists, designers and publishers. Its success will depend on their capacity to seize the opportunities offered and their ability to escape from the preconceptions and dead conventions of the past.

Empruve: Cornucopia System

Advanced multimedia systems will become as much an integral part of our lives as the telephone, the television, the typewriter and the book. "Cornucopia" demonstrates how ergonomic a multimedia system can be. The system uses DVI technology and a CDROM drive, and combines an A4 paper white screen and a colour screen (for stills and motion video) with a new control device called a "tadpole".

ne of the most powerful characteristics of hypermedia is that it is a multiple medium. One way of visualizing this is to think of hypermedia as having the diversity of a magazine that, as well as using text, illustrations and photographs, also includes film and sound, videogames and databases.

But while a printed magazine's art director and graphic designer are thoroughly familiar with the effect of type and image combinations, and know precisely how to create a stylistically consistent look through the use of layout grids, choice of typefaces and use of colour, the hypermedia designer is venturing into relatively new territory, and must learn how to orchestrate these extra audio-visual and computer media within an integrated and interactive whole.

This territory is not entirely unexplored. The fairly continuous Modernist tradition of artists prepared to grapple with multiple media has generated exploration of various non-linear ways of communicating ideas and emotions. But it is only recently that all these component media have been made accessible at a professional level through single, multi-purpose workstations (such as the Apple Macintosh) that also ran the first popular and accessible hypermedia software. It was only in the late 80s

and early 90s that all the tools for hypermedia development were finally subsumed within a desktop creative environment.

The tasks involved in creating hypermedia programmes are fourfold. First, forms of multiple media have to be utilized in such a way that they optimize the communication characteristics of particular media, for example using text for what it does best, using animation where that is the best way to encapsulate an idea, and so forth. Secondly, a hypermedia equivalent of the magazine layout grid has to be

produced by means of which different media can be seamlessly integrated into a consistent programme style. Thirdly, it is necessary to develop coherent, easy to use "control and feedback" interfaces between man and machine, by which the user can control the programme and navigate successfully through it. Finally, it is important to gain enough knowledge of hypermedia software and hardware to produce programmes that work functionally and aesthetically, and that optimize the use of the intended hypermedia technology.

The first three of these tasks involves drawing upon aspects of communications design that practitioners in all the component media will already be familiar with. There are established conventions within the practice of film and video, animation, radio and sound recording, and especially graphic design (the oldest mass media art), but as yet, there are very few ground rules for the integration of all these media

within a single structure, let alone within a structure that is placed under the direct control of the user. There are also a number of conventions (such as "windows" and "menus") that have been developed to provide an easy-to-use interface for microcomputers, but which are still being redefined for multimedia use. The ways in which different designers have tackled these problems in a wide variety of applications are examined later in the book; here the component media themselves (interface, image, text, graphics, audio, video, animation and virtual space) are discussed. This section looks at how these individual media may be used within an integrated hypermedia programme.

media
matrix
3

components of hypermedia

ntil the nineteenth century, very few humans had to learn how to operate a machine any more complex than a winch, but since the invention of the telegraph, the typewriter, the phonograph, the car, and later the radio, television, washing machines, video cassette players and the like, most of us have experienced the act of "interfacing" with sometimes very complex equipment. By interface we mean "control and communication": being able to control machines by communicating with them, and receiving feedback from them. Watching the speedo on a car dashboard and easing up on the throttle, or choosing the correct washing machine programme, are good examples. We are used to turning knobs, pushing buttons and toggling switches, following directional arrows, stopping at red lights or changing gear, so it is natural that metaphors of all these familiar varieties of interface are used in hypermedia. We can control volume as well by turning a knob, as by pulling a slider up or down, whether the knob is real ("hard") or virtual ("soft"). The video cassette control-panel buttons for "play" (an arrow pointing from left to right), "fast forward", "stop" and so on, are being adopted to create "friendly" control devices for hypermedia.

These metaphors, or "user illusions" are embodied as still and animated graphics on the monitor screen, and provide the user with a control panel or "console" through which the programme can be controlled. Interface design does not just concern the look of the control panel (although this obviously determines how effectively the user will suspend disbelief in the metaphor); it also encompasses the ergonomics of the user's control of the programme. If, for instance, the "navigational" controls for the programme are placed together in one part of the screen, the user can easily select between them without having to make unreasonable physical efforts. The interface metaphor may also

Art of Memory: Shakespeare's *Twelfth Night or What You Will*

Sophisticated educational programmes such as Art of Memory's Shakespeare CDROM incorporate a variety of user controls and ways of interfacing with the wide range of information stored on the disc.

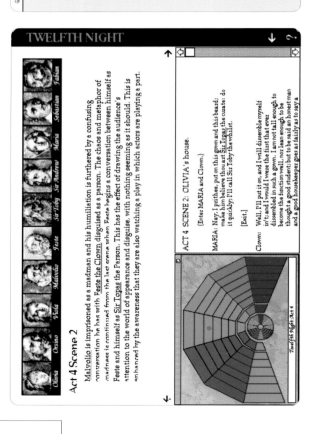

determine the overall "house style" of the programme. Details from a "virtual jukebox" control panel in a "music plus" programme might be used, for example, as decorative components within all the content frames.

There are a variety of ways in which these control devices and the interface metaphors can be extended to accommodate the idea of "navigating" around a hypermedia programme. For example, arrows may be clicked on to indicate the direction the user wishes to

take from street to street in a surrogate travel programme. Or the user might click on a location in a street map and the screen would display the view from this location. The console metaphor is extended still further in arcade flight and driving simulators, where the dashboard controls and steering wheel, or even the entire cockpit, are available to bolster the relevant illusion.

Currently, most hypermedia control devices are presented as "soft" tools on screen, and supplemented by some general-purpose pointing device such as a "mouse" or infra-red controller, though an increasing variety of interface

technologies are now available, each one gradually extending the physical possibilities of interaction with computer systems, and the range of human senses that are engaged in the hypermedia experience. These hardware devices include digit pads, touchscreen monitors,

datagloves, eyephones and complete datasuits. These use a variety of "gesture-sensitive", telematic, force-feedback, eyeball-tracking and position-sensing devices to foster a "one to one" relationship between man and machine.

Hypermedia ... simulators ... virtual reality ... we are moving further and further along the road towards a physically enveloping, multi-sensual illusion of telematic control. What is now called the "interface" between man and machine will be gradually subsumed within an ever more real illusion that we are actually "inside" the machine itself, interacting at first hand with what Timothy Leary calls "vast continents of unexplored data".

Button samples

Graphic buttons are used for a number of purposes in hypermedia programmes, including navigating through the information base, accessing different points of the programme including "help" and "information" frames. The buttons control "active" screen areas that respond to a mouseclick by calling up the next screen in the programme.

Artwork · Tutors · Glossary · A Z · Thumbs · Contents · 5, 30, 33 · bles, 96

Twelfth Night Act 4

NEXT PAGE · SEE ALSO · INDEX

主要建設 · 地形 · 人口

Macintosh

Entry Level Macintosh Features Comparison

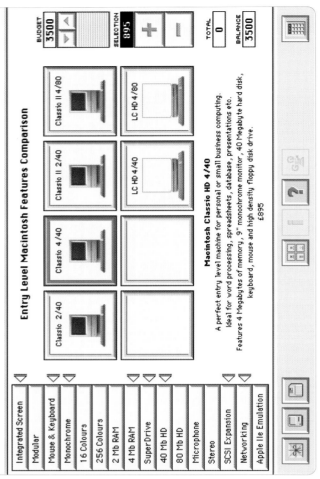

Classic 2/40 | Classic 4/40 | Classic II 2/40 | Classic II 4/80
LC HD 4/40 | LC HD 4/80

Integrated Screen	▽
Modular	▽
Mouse & Keyboard	▽
Monochrome	
16 Colours	
256 Colours	
2 Mb RAM	▽
4 Mb RAM	▽
SuperDrive	▽
40 Mb HD	
80 Mb HD	
Microphone	
Stereo	
SCSI Expansion	▽
Networking	▽
Apple IIe Emulation	

BUDGET 3500 SELECTION 895 TOTAL 0 BALANCE 3500

Macintosh Classic HD 4/40

A perfect entry level machine for personal or small business computing. Ideal for word processing, spreadsheets, database, presentations etc.

Features 4 Megabytes of memory, 9" monochrome monitor, 40 Megabyte hard disk, keyboard, mouse and high density floppy disk drive.

£895

Joe Gillespie: Focus

Joe Gillespie has produced some very successful graphical interfaces for corporate clients such as Apple Computers. The effectiveness of programmes like these (designed for point of information use in dealers' showrooms) demonstrates how complex databases can be made "user friendly".

Zaum of Babel Noise Opera

How many noises are locked deep within the unmentionable recesses of your psyche? The noisiest anthem imaginable is the sound of all sounds....

500

[OK] [Cancel]

HARD DISK:AUTOCEPTOR 2::Zaum Gadget (Hype 1.2)

Each Letter has its own Fate, its own Song, its own life, its color, its personality, its path, its odor, its heart, its purpose.
A Letter—this is a completely separate planet of the universe (words are concepts).
A Letter has its own sketch, sound, flight, spirit, its solidity, its rotation.
The born Word is a divine wedding of several pairs or threes of Letters.
The vowel is the wife.
The consonant—the husband.
Consonants are roots of Letters; fathers.
Vowels are movements, growth, motherhood.
Each Letter is a strictly individual world, a symbolic concentration which gives us an exact definition of internal and external essence.

[Quit] [What is Zaum?] [About this stack] [Restart]

Autoceptor Experimedia: Zaumgadgets

A freeform interface that is full of surprises – you explore with the mouse, sparking off animations, digital music and sound effects as you travel through the conceptual space of artist Amendant Hardiker's imagination.

media matrix - **interface**

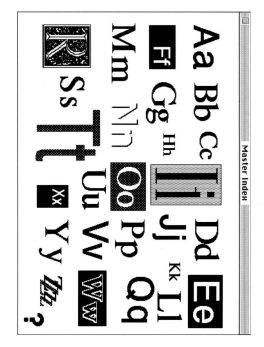

Broderbund: Kid Pix

An interface can be more than just visual. "Kid Pix" looks like a simple computer painting program. It is just that, but Broderbund have extended the act of painting by incorporating sounds to accompany each of the painting tools. Further to this, extensive use is made of randomizing techniques and dynamic animation effects. Kid Pix is a pointer to the future for children's educational software. (Illustration by Tiger Savage for XYZ Magazine.)

Empruve: Cornucopia

Interface design for personal "dynabook" style coputers/CDROM readers such as this elegant example from Empruve, feature easy-to-use icons and other graphic components. The DVI-equiped Cornucopia features an A4-size paper-white screen (for text and graphics) alongside a smaller full-colour LCD screen for the display of colour stills and motion video.

Computer Graphics Workshop: DTP Graphic Design Index

A simple, functional interface from one of the first generation of Hypercard programmes by the Computer Graphics Workshop, the DTP Index is a glossary of graphic design and printing terms. Version 1 of Hypercard limited developers to a 7x5-inch black-and-white card, but within these restrictions could be created very powerful audio-visual databases. Each card in the Index contains a text definition, and many cards contain illustrations and animations. The question mark delivers more information; the exclamation mark triggers an animation.

Tab Index	Transparency
Tabulation	Tri-chromatic
Templates	Trim/marks
TextText type	Twice up
Thermographic Embossing	Type/Typeface
Thick/Thin	Type area
Thumb Index	Type high
Thumbnail	Type mark-up
Tint	Type specimen/sheet
Tip-in	Typescale
Title page	Typescript
Tone	Typography

Typescale

or 'Pica Rule': rule marked in pica ems and points, as well as millimetres and inches, for use in layout.

PICA TYPE SCALE

POINT SIZE

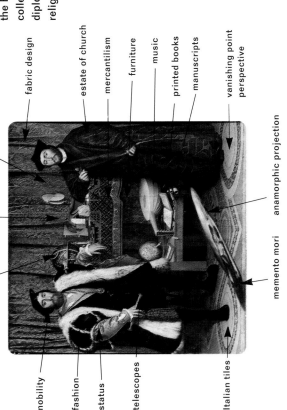

mages are used in a multiplicity of ways: to entice, inform, appeal, communicate and enrich. They can excite passions, express feelings, communicate ideas, explain complex relationships, become objects of aesthetic pleasure, meditation and contemplation, and even tell stories.

In hypermedia, images can be used in all these ways, and they can also be linked together with text and other images to create new kinds of relationships that can be explored interactively by the user. Just as a film poster, a stained glass window or a painting can tell us a "story" in an iconic, "all-at-once", non-linear way, so images in hypermedia programmes can be devices for providing a variety of different ways of looking at a particular subject or theme. For example, Holbein's painting *The Ambassadors* can be seen as a visual menu for an information base that may include not only astronomy, navigation, cartography, exploration, music, *memento mori*, mercantilism, fashion and anamorphic perspective; but also Renaissance art, Holbein himself, his relationship with the English Royal Court, his colleagues and friends, and the diplomatic, political and religious climate of the

sixteenth century. Starting by selecting an object within the painting, the user can explore the context and content of the image from a variety of different perspectives, developing a personal understanding by selecting from a "menu" of juxtaposed viewpoints. In response to the user clicking on the anamorphic *memento mori* that spans the bottom of the painting, the system would offer a choice of "information trails", to explore the iconography of death in medieval and Renaissance painting, or to examine the geometry of anamorphic projection. These "trails" might include several different art-historical, critical, anthropological and mathematical perspectives, suggested by individual experts. The user would have the freedom to follow these trails, gradually building up a more complete understanding of many aspects of the painting.

Innovative hypermedia producers will use a variety of such image-based techniques to offer the user a choice of "approaches" to the information content of the programme. These range from pictorial "menus" and catalogues through interactive illustrations and diagrams, to providing sets of image creation, manipulation and processing tools. Still images can be programmed to gradually reveal themselves in whole or in part according to the user's actions; the image, or components of the image, can be

Hans Holbein: *The Ambassadors*

A painting such as Holbein's *Ambassadors* can provide a pictorial "menu" of options for users. Navigational buttons would be included to survey other paintings and to take the user back to the beginning of the programme, but otherwise the picture does all the talking. Small text labels appear as the mouse pointer is passed over the picture, signalling the options available.

Thorn EMI: Ray Base

Computer-graphic image processing techniques are used in many applications, such as remote sensing and medical imaging. DVI (Digital Video Interactive) enables large quantities of high-resolution images to be stored on a hard disc or CDROM and manipulated freely on the host computer.

nobility

fashion

status

telescopes

Italian tiles

exploration navigation astronomy

fabric design

estate of church

mercantilism

furniture

music

printed books

manuscripts

vanishing point perspective

memento mori anamorphic projection

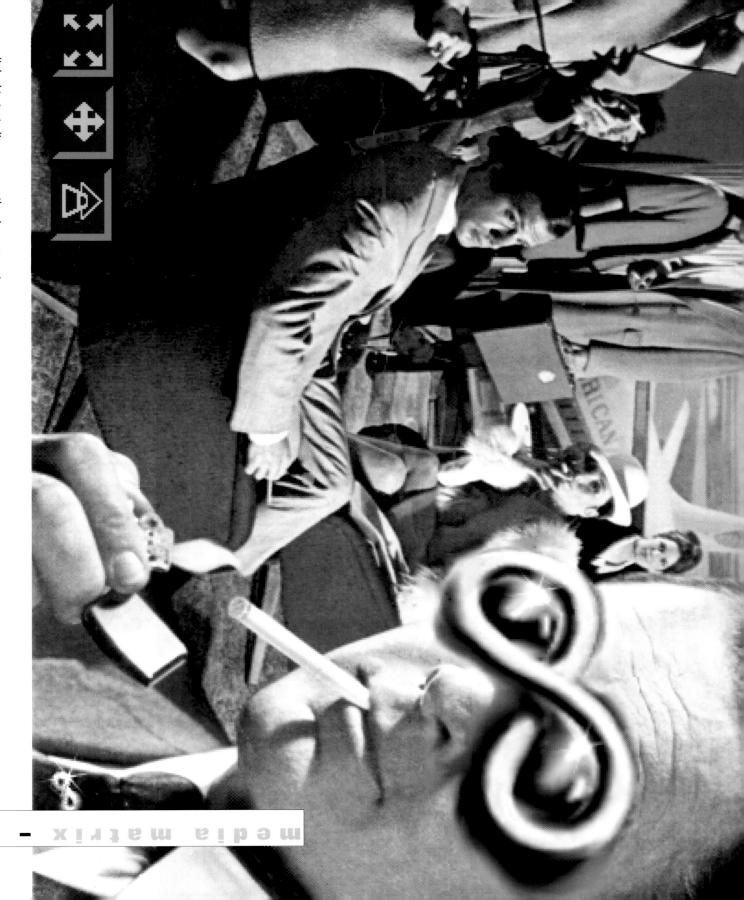

linked to text, diagrams or other images, or to animations, video or audio sequences; or the user can create an image by finding and juxtaposing a set of component parts just as a jigsaw puzzle, a montage or a collage is assembled.

It was Sergei Eisenstein who identified "montage" as a basic principle used by all artists in the

Bob Cotton & Peter Burnell: The Event Horizon

The development of interactive "faction" (programmes that combine fiction with scientific fact, and use a variety of "graphic novel", hypertext, computer models, interactive video and surrogate travel techniques) is one of the most interesting tasks for hypermedia artists. Here the image is itself a menu, different options are signalled to the user by the mouse pointer, which changes shape to form symbols representative of the option available in that screen location.

media matrix – **image**

Cornell University: A Field Guide to Insects and Culture

This CDROM disc is designed to be used in personal computers fitted with DVI expansion boards, allowing full-motion video. Images are used extensively as interactive menus, with button areas being marked with tiny insect icons.

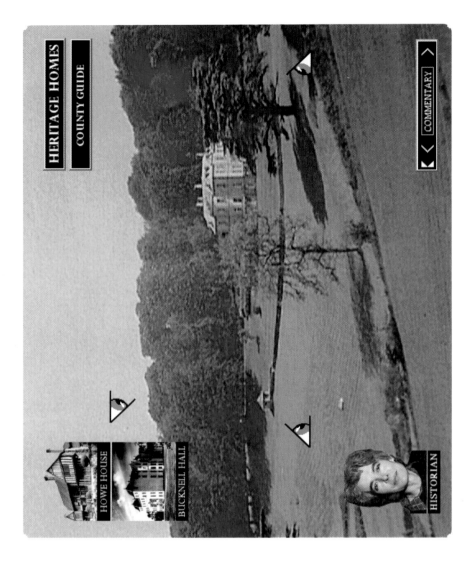

Bob Cotton/Random Access Media: Heritage Homes (prototype)

"Heritage Homes" features several different approaches to interactive images, including the "eye spy" icons shown here. Each icon accesses the view of the main house from that perspective. This view may be a photograph or painting, etching, watercolour, architect's plan or elevation, an illustrated map, video sequence or aerial photograph.

media matrix – image

exposition of a theme, pointing out that when two images (or sequences of images) are placed together they inevitably combine "to create a new concept, a new quality, arising out of that juxtaposition". In other words, the act of perceiving two or more images (or sounds, or words) in juxtaposition is in itself "interactive": it is the observer who is creating the "new concept" in the space "between" the different stimuli. In hypermedia, artists and designers have a communications tool that offers a multiplicity of means by which this principle may be applied. From simple sequences of still images (effectively a "digital slide show") through the visual kaleidoscopes of multi-image screens, to the complex matting and collage of images within other images, all these techniques can be put under the direct control of the user, so that physical interaction can supplement the

"perceptual" interaction of montage. In this way the user will have access to a wide variety of ways through which to approach the subject matter. It will be possible for users to "browse" through these approaches, select the most appropriate, and "fine tune" them to optimize their own understanding.

In any interactive production, the images must first be acquired or produced, and then processed into the appropriate digital or analogue format for the medium of delivery. This entails not only picture research and copyright clearance (or the commissioning of custom images from artists and illustrators), but also the photography, copying or digitizing of these images, and finally their cropping, scaling and retouching to produce the best quality for the intended medium.

DESKTOP PLUS: Text Input

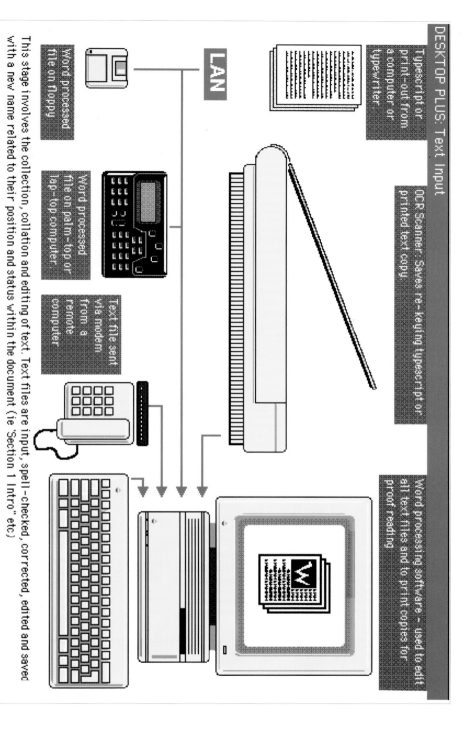

Typescript or print-out from a computer or typewriter

OCR Scanner: Saves re-keying typescript or printed text copy

LAN

Word processed file on floppy

Word processed file on palm-top or lap-top computer

Text file sent via a modem from a remote computer

Word processing software – used to edit all text files and to print copies for proof reading

This stage involves the collection, collation and editing of text. Text files are input, spell-checked, corrected, edited and saved with a new name related to their position and status within the document (ie 'Section 1 Intro' etc)

Computer Graphics Workshop: Graphic Design Mentor/Desktop Plus

Schematic illustrations like these can respond to mouse clicks by presenting the user with more detailed information. Here the text panels pop up when the appropriate image is selected. Hypermedia allows lots of information to be "hidden" until the user needs it.

The Life of Sir Henry Unton

This anonymous sixteenth-century English painting uses techniques familiar to us equally through the modern film poster, and the medieval church stained-glass window to encapsulate an entire story in a single image. The Russian film director Sergei Eisenstein noted that images like this hark back to the "simultaneous" theatre of the Middle Ages, and are also reflections of the multiple stage settings of sixteenth-century theatre. Such images are a model for hypermedia "image interfaces", visual menus that provide instant access to the different "episodes" in the picture.

The sheer inventiveness shown by Gill in figure and letter form interaction, for the illuminated chapter headings for the Golden Cockerel Press edition of "The Four Gospels" in 1931, and the elegance and beauty of his type designs for the Press would possibly, for a less gifted artist, have proved to be the summit of achievements in this field. But not Gill. By the completion of work with the Golden Cockerel Press, he had already embarked on a historic collaboration with Monotype, at the invitation of his friend Stanley Morrison. However, as well as the work on Perpetua, Gill was also producing drawings for Gerald Meynell of the Westminster Press.

W e use language as our main method of communicating, and we use the visible language of writing as our main method of storing and transmitting our knowledge and ideas. We have developed the arts of calligraphy and typography to allow us to modify the visible word, to clothe it with additional qualities that are expressive (brand names), personal (the signature), authoritative (legal documents), informative (road signs), funny (comic book mastheads), ephemeral (dot matrix alphanumerics on tickets and receipts), and so forth. Over the last five hundred years several thousand typefaces have been designed that offer designers a broad spectrum of these modes. Typefaces are a typographer's "palette", and can be selected and combined to compress additional meaning into the words they are representing.

Typographers have developed a range of conventions for the treatment of printed matter, some of which are directly transferable to the display screen format of hypermedia. In addition to these basic devices hypermedia adds other more dynamic possibilities, the most significant of which are hypertext and animation.

We are all familiar with "text" as printed or typed words, and even words displayed on a television screen and computer monitor, but "hypertext" is a more sophisticated concept.

When Ted Nelson invented the term in the 70s he was imagining an extension of the idea of the cross-reference, a means of creating meaningful links between information that is stored in text form. In the "ideal" hypertext system (such as Ted Nelson's Xanadu - see Hypermedia Innovators) readers would be able to follow their own enquiries through an interconnected database of all the world's books, making annotations and linking passages of literature with relevant items from critical essays, research papers, specialist dictionaries, bibliographies and the like. A literature student, for example, reading a

"hyperbiography" of Edgar Allan Poe, might come across a reference to a poem. "Clicking" on the title of the poem calls up a window with the complete poem in it. Reading the poem, the student finds an unfamiliar word, clicks on it, and the relevant dictionary definition pops up on the screen. Similarly, critical essays on the poem can be called up, or a digital copy of the original manuscript can be viewed, all without moving from one workstation. Ted Nelson envisaged a global hypertext network linking individuals to databases created by libraries and museums, in effect giving the scholar "on-line" immediate access to all the world's literature. The Xanadu system would give the user a set of tools, both for

navigating through this enormous "information space", and for creating associative links between texts.

Nelson's concept of "chunk" hypertext (such as extra notes, marginalia or references linked to the main text via "asterisk" buttons and only visible if required) and "collateral" hypertext (where two related passages of text are linked together with perhaps some mediating explanation of the link) are the two main ways in which most hypermedia programmes use hypertext. The central idea is to provide the reader with a variety of different perspectives on to a body of information that can be explored interactively.

Mark Bowey: Gill: The Genesis of Perpetua

Hypermedia can combine some of the qualities of print media with the dynamics of animation, interlinking "hypertext" and transitional special effects that are possible using programs like "Director" and "Supercard".

In 1918, Edward Johnston completed the first of the twentieth century sans serifs.

...case characters suffer from—as a result of Johnston's efforts to maintain an even mono-line throughout. In Gill Sans, the line weights vary by as much as three to one.

Edward Johnston was virtually responsible alone for the revival of lettering and fine calligraphy, and his ...scribes. He began teaching a class in calligraphy at the Central School of Arts and Crafts in 1899, and in 1901 Eric Gill joined his class. The effect on the young Gill was so great, that in his "Autobiography" he recollects how he almost physically trembled in his master's presence—and compares their...

click on any of the five buttons to the right of this panel. If you wish to start straight away then click anywhere in this text

Colin Taylor and Mike Worthington/Dm Studio: Oriane

This coloured and anti-aliased version of "Oriane" was developed by Dm studio especially for the "Halliwell's Interactive Film Guide", a Random Access Media project. The demand was for a display face that would work well with the text face Din Mittelschrift and would be clearly legible on screen. The font also had to include a large number of special and foreign language characters, accents and cedillas. Anti-aliasing ensures that oblique and curved strokes within the letterforms do not appear jagged when presented on screen.

Mark Bowey: Ectropy hypertypeface

Bowey's work on Ectropy takes the notion of user-customizable fonts to its logical conclusion. Adobe Systems are developing their "Multiple Masters" concept for font outlines that can be customized by the user. These so-called "chameleon" fonts can be expanded, condensed, or made light, bold, italic or shadowed with great precision.

media matrix – text and typography

Of course, not all text in a hypermedia programme is hypertext. The writer and typographic designer have also to consider the infrastructure of the programme: titles, menus, help messages, credits and other textual elements. These components, and the textual contents of the programme, can be prepared by the typographer using a combination of graphic skills and techniques derived from both print and television production. Good typography and layout are as important in hypermedia as they are in magazines and television news broadcasts. Unlike print, hypermedia places no restrictions on the use of colour or texture for both type and background, and like television, hypermedia can accommodate animated and even three-dimensional typography.

NCC WORM 1:Hypercard:BANDWIDTH:Bandwidth Panic

A uthori

"the neuron either."

'Theatre of Memory.'

'Hardware systems'

'There's a direct relationship between the non-linear, allusive, interconnected...'

Computer Graphics Workshop: High Bandwidth Panning

Abbreviated headlines, titles, or first lines are used as iconic devices to represent a text available elsewhere in the programme. This technique is similar in essence to the outliner facilities in many word processors, where texts can be written by expanding progressively upon sets of sub-titles.

NCC WORM 1:Hypercard:BANDWIDTH:Bandwidth Text

There's a direct relationship between the non-linear, allusive, interconnected network of an interactive program and the continuum of mythologies that constitute dream-time - the proto fable, pre-literate, iconic nature magic of the UR man. A dreamtime programme would be a molecular environment where the travels of the user are guided by a simple set of rules (some overt, some implicit, some arcane). The user is encouraged to develop an appropriate 'world view' in his navigation through the dreamtime environment. It is populated with myths and oracles...

NCC WORM 1:Hypercard:BANDWIDTH:Bandwidth Text

Henceforth it is the map that precedes the territory - PRECESSION OF SIMULACRA - , it is the map that engenders the territory and if we were to revive the fable today, it would be the territory whose shreds are slowly rotting across the map. It is the real not the map, whose vestiges subsist here and there, in the deserts which are no longer those of the empire, but our own. The DESERT of the REAL itself.
Jean Baudrillard

The 'Dynabook' concept, expanded 'to read CD-I as well as CDROM discs, serves as an illustration of the type of portable 'readers' or 'players' we expect to emerge as a consumer and industrial standard during the coming decade.

The original Dynabook idea was developed at Xerox PARC by Alan Kay, during the '60's and '70's. This illustration & of Scenario's 'Dynabook' - (1989) an LCD touch screen CDROM reader with onboard micro processor.

malcolm garrett
ulterior motifs

ver the last five centuries typographers have developed a number of ways of making information more accessible to readers. Alongside appropriate legible and readable typefaces, there are conventions for the very organization of information itself: tables of contents, glossaries and indices, the arrangement of text as headline, subhead, main text, footnotes, marginalia and captions. Further conventions govern the use of the subtle "body language" of visual communications, the colours, textures, graphic elements and layout that modify the information content. Graphic designers working in advertising have extended the language of print to produce hybrid image-text juxtapositions that are powerful communications tools.

Hypermedia accommodates most of these conventions from the printed page, and adds other graphic features such as animation (of both words and pictures); context-sensitive fonts that change size and style in response to user's actions; variable "page" sizes (pages 30-foot square); text notes, glosses, captions and cross references that can pop up on demand; automatic book marks, and of course, the powerful linking features of hypertext.

The "hypergraphic" designer faces some very interesting problems. In addition to considering the actual two-dimensional space of the screen, and of windows within the screen (which can be windows on to much larger virtual spaces), the designer also has to accommodate the "latent" two-dimensional space of, for instance, "invisible" images, graphics and text fields: items that become visible as a result of the user's interaction. How these latent components fit into or overlay the current display, and how efficiently the designer can employ programming techniques to display text in real-time, as the user is watching, make hypermedia graphics an art quite different from designing for print. Like television graphics, hypergraphics are always "soft", and the graphic designer must consider screen resolution, viewing distance, colour saturation and contrast, indeed all the physical constraints of video display systems.

We control the television set by means of "hard" switches: buttons that we press on the set itself. Hypermedia programmes are controlled by "soft" switches: "buttons" that we metaphorically "press" by using a pointer and a single remote switch, such as a mouse. How these soft switches look, and how they signal their function to the user, is the responsibility of the graphic designer, who, together with the hypermedia designer and

programmer, will have the key roles of interpreting and developing a suitable "graphical user interface" (GUI). GUIs have their own conventions, such as windows, menus, and pointing devices, that have evolved in the continuing effort to make personal computers more responsive and easy to use.

So hypermedia graphics involves a combination of print, desktop computing and videographic conventions. The method by which the screen or window graphics change from one "page" to the next requires the graphic designer to make decisions more familiar to the television director; whether, for instance, to use partial or full dissolves, cuts, wipes and zooms. Designers must consider how effectively these techniques can be used in differentiating parts of the programme, while at the same time supporting and cohering to whatever interface metaphor is used.

Early desktop publishing software has grown into a suite of sophisticated graphic design tools. Designers of television graphics also use desktop computers, but mainly as "animatic" sketchpads for work to be produced on expensive digital video paintboxes, such as the Quantel system. Hypergraphic artists use both desktop print and videographic tools.

In the "cyberspace" of virtual reality, programme-makers must solve the problem of presenting two-dimensional hypermedia information within a three-dimensional virtual environment. Current hypermedia programmes demonstrate some of the ways this could be done. The art of information design is entering a period of radical transformation. Regardless of whether the interface is two-dimensional or three-dimensional, the graphic designer will continue to play a key role.

Malcolm Garrett: Interactive catalogue for an exhibition at the Design Museum, London

This interactive exhibition catalogue encapsulates a very wide range of work, contextualizing the pieces actually on display. Users can navigate through a graphical information space, exploring one designer's output. Designing for hypermedia involves dealing with type, images, layout and colour in ways that have become familiar through five centuries of print. In addition, random access, animation and "hyperlinks" are used to produce dynamic hybrid imagery.

Joe Gillespie: Astrostack

Here the "control panel" metaphor for graphical user interfaces is treated in an exemplary fashion by Joe Gillespie of Pixel Productions. The clean, simple layout echoes the push-button panels of consumer electronics products. Dealing with software as though it were hardware is one of the most common approaches to software design.

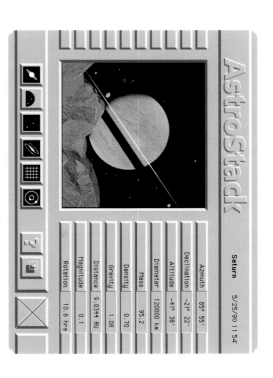

AstroStack

The Moon 5/25/90 11:54'

Azimuth	85° 04'
Declination	23° 43'
Altitude	26° 56'
Diameter	3480 km
Mass	0.012
Density	3.34
Gravity	0.17
Distance	368900 km
Magnitude	-10.6
Rotation	27.3 days

AstroStack

Saturn 5/25/90 11:54'

Azimuth	85° 55'
Declination	-21° 22'
Altitude	-4° 38'
Diameter	120000 km
Mass	95.2
Density	0.70
Gravity	1.08
Distance	9.0344 AU
Magnitude	0.1
Rotation	10.6 hrs

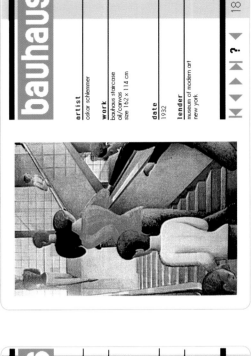

bauhaus 18

artist
oskar schlemmer

work
bauhaus staircase
oil/canvas
size 162 x 114 cm

date
1932

lender
museum of modern art
new york

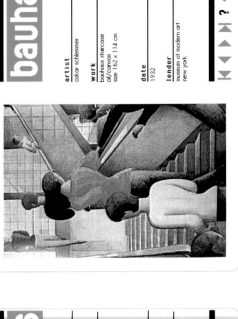

bauhaus 17

artist
gunta stadler-stölzl

work
slit gobelin wall hanging
warp linen, wool cotton
size 142 x 110 cm

date
1927 - 1928

lender
teppichgemeinschaft ev.
stuttgart

Joe Gillespie/Pixel Productions: Bauhaus

Graphics for print provide the metaphor here. The screen is laid out as though for a printed exhibition catalogue, and the titles are "active" links to further information.

media matrix - graphics

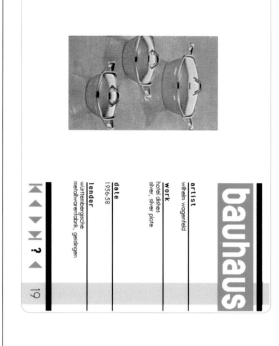

bauhaus

artist
wilhelm wagenfeld

work
hotel dishes
silver, silver plate

date
1956-58

lender
württembergische
metallwarenfabrik, geislingen

19

Videogame Graphics

Although the restricted storage space of videogames produced for floppydisk distribution militates against high-resolution graphics, what can be achieved is impressive. Videogame graphics share with comic strip images the ability to engage the reader, literally inviting the user to participate in "rounding out" the minimal perceptual clues created by the artist, so that the gaps are filled in with the user's own imagination.

Studio DM Hypermedia Initiatives: Diablo

Diablo is a "mini-application" for the Mac, designed to run alongside any design-oriented software, and acts as a "familiar", prompting the user with suggestions of direction and decision. Diablo helps solve the user's design dilemmas by dealing one or several cards at random when the Diablo icon is clicked. The cards contain illustrations and text with comments, suggestions and "lateral thinking" strategies for the solution of design problems.

Q. If it works,
should I fix it?
A. Only if you
break it first

media matrix – audio

C

onversation is our most natural way of exchanging ideas. When two strangers converse at a party, they will start by proposing themes to each other, gauging feedback from these proposals, then developing a theme in which they have a mutual interest. The initial theme will provide a starting point from which other themes can be proposed and developed, so the conversation proceeds by a process of interpersonal interaction. This natural form of discourse, with its possibilities for branching out into a myriad of associated subjects, makes human conversation an ideal model for designers of human-computer interfaces.

The idea of being able to converse with a computer system using a natural, spoken language is one of the attractive areas being explored by researchers of artificial intelligence. For example, computers with "speech recognition" software and microphone inputs can now be "trained" to recognize a limited vocabulary of spoken commands from a specific individual, as long as these commands use a pre-established protocol, such as the linked commands "Select", "File", "New", "Now". While there is little doubt that these techniques will eventually be developed into a general-purpose "automatic speech recognition" system, and that such a facility will have important specific uses (such as enabling the visually disabled to use computers, or providing a more efficient "hands off" control mechanism for air traffic controllers) it is more likely to supplement, rather than replace, a graphical user interface.

But if interaction by sound is still some way off, techniques for interactions with sound are being used right now. On a basic level, these include ways in which the computer/hypermedia system provides audio feedback to the user, by making a noise, for example, that warns the user of an improper

Virgin Games: Musicolor

Designing a music tuition programme to optimize the qualities of CDTV, Steve Clark and Tony Green drew upon their videogame programming expertise to produce a very friendly interface with a graphic style suited to the younger user.

Joe Gillespie/Pixel Productions: Grooves

"Grooves" allows CD audio discs to be controlled from a Mac. The Wurlitzer juke box provides the metaphor: the user inserts some virtual coins (which clink into the cash box), and then selects tracks as on a conventional juke box. Once the selection has been made, the disc is loaded in an animated sequence, and the track starts playing from the CD. Users can create their own CD track catalogues for the juke box.

action: the use of recorded "voice-overs" for help, guidance and training sessions; providing "voice annotation" facilities, where the user can add audio memos to an existing information base; and providing tools for the user to choose, edit and mix audio tracks, and to control volume and tone.

We know that sound can be a powerful stimulus to the imagination. The radio play provides us with all the audio cues we need to recreate the drama in our imagination. Orson Welles proved how effective radio drama can be with his Mercury Theatre production of War of the Worlds, which caused mass panic when it was broadcast to a US population already made jumpy by the prospect of war in Europe. (The shower sequence in Hitchcock's Psycho with the sound turned off is a counter example: without the repeated shrieking of the orchestra's string section, the scene loses much of its heart-thumping urgency).

In hypermedia, sound re-establishes the audio space of conversation, and presents the possibilities of parallel and branching narrative soundtracks, which can be presented graphically so the user can choose between them, switching from one sound-track to another. It then becomes possible to participate in choosing the direction for the evolution of a story, or to access different viewpoints on a particular subject or body of knowledge, or even to choose a preferred language from several foreign language commentaries.

"Interactive audio" techniques like these are used within the context of a graphical interface that provides special screen buttons or "icons" on which the user has to click to trigger the audio sequences - so that, for example, clicking on an icon featuring the French tricolour might call up a spoken commentary in French. Such "audio"

icons" can be called "Earcons", and provide a valuable method for accessing audio sequences in the non-linear environment of hypermedia, giving the user the choice of what they listen to, and when and how they hear it.

Some hypermedia programmes include lengthy "linear" sequences like a television programme with a narrator, or a slide show with spoken commentary, which can be interrupted by the user in order to find out more about the content. These decision points can be signalled by a flashing icon, mnemonic label, keyword or bullet point, so the user knows when interruptions are possible. Interactive programmes that feature music ("music plus" programmes) have to make use of such signalling devices, which are often supplemented by "soft" (on-screen) controls for "volume", "play", "stop" and so on, and scrolling text for the lyrics or libretto, or sheet music.

RAM: Retros

A format for interactive music documentary programmes. "Retros" allows the user to examine the entire career of a recording artist, sampling audio tracks, recorded interviews and promotional videos, as well as text and graphic artefacts such as album sleeves, tour posters and publicity stills.

RAM: Pavarotti CDI prototype

The Retros format, when applied to classical performers, combines the attributes of "coffee-table" book and CD audio disc. Hypermedia can combine text, graphics, animation and motion video to extend the hybrid of information that TV viewers have become used to.

RAM: Aaron Copland/The Tenderland CDI prototype

Designing an interactive documentary and sampler of Copland's only opera, RAM have created a format that can be applied to other operatic works. Hypermedia programmes can supply much more contextual information than the traditional album sleeve or CD insert and, what is more, the information can be dynamically linked, allowing users to explore the composer's work in many different ways.

media matrix - **audio**

Autoceptor Experimedia: ZaumGadget and Noise House

Amandent Hardiker is a hypermedia artist working in Wisconsin. "Noise House" is described as "short vignettes of deconstructed, surgically manipulated rap sounds as typoglyphic stick figures break the dance." It provides chaotic fun in the tradition of the Futurists' "Art of Noise". Hardiker's creative vision draws on Dada, Constructivism and Surrealism. "ZaumGadget" is introduced by a 1923 quote from El Lissitsky describing the new possibilities of the "electrolibrary".

Warner New Media: Audio Notes

This CDROM series uses Hypercard to provide the contextual information and interface to CD audio tracks. Warner New media have been originators of innovative approaches to classical music, combining graphics, text and animation in their Mac CDROM packages.

STORY • SYNOPSIS

Papageno's Major Songs

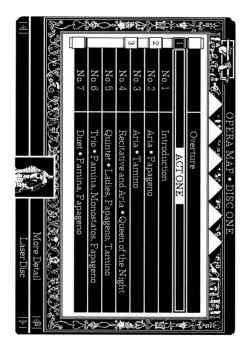

OPERA MAP • DISC ONE

Overture		ACT ONE
No. 1	Introduction	
No. 2	Aria • Papageno	
No. 3	Aria • Tamino	
No. 4	Recitative and Aria • Queen of the Night	
No. 5	Quintet • Ladies, Papageno, Tamino	
No. 6	Trio • Pamina, Monostatos, Papageno	
No. 7	Duet • Pamina, Papageno	

More Detail LaserDisc

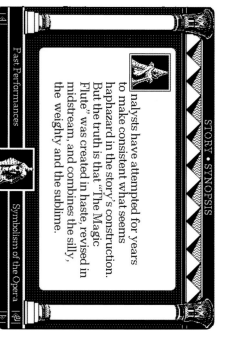

STORY • SYNOPSIS

Past Performances

nalysts have attempted for years to make consistent what seems haphazard in the story's construction. But the truth is that "The Magic Flute" was created in haste, revised in midstream, and combines the silly, the weighty and the sublime.

Symbolism of the Opera

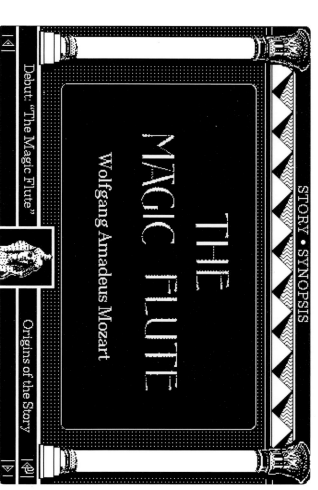

STORY • SYNOPSIS

Debut: "The Magic Flute"

THE MAGIC FLUTE
Wolfgang Amadeus Mozart

Origins of the Story

GIESECKE & THE LIBRETTO • 1 OF 6

"Magic Flute" Stage Manager

In his book "The Complete Operas of Mozart," Charles Osborne notes that Schikaneder may have given himself more credit for writing the story and dialogue (libretto) of "The Magic Flute" than was true.

Giesecke

Emanuel Schikaneder Origins of the Story

otion video, like sound, is a time-based medium. Designers are only just beginning to explore the potential of combining linear, time-based media into the random access (non-linear) structure of hypermedia programmes. In educational programmes this is a reiteration of the continuing debate over whether students acquire knowledge better in a structured environment, where they are rigorously guided through the subject matter by the teacher; or in an unstructured situation, where the subject material is made available to students, who are free to explore this material for themselves. Happily, hypermedia provides the means for integrating both approaches, providing structured guidance for those who feel they need it, and methods that encourage the freeform exploration of a body of knowledge for those who find they learn better that way.

In entertainment programmes, the integration of linear and non-linear content material raises another important issue: how can programmes be designed to encourage the suspension of disbelief in a narrative while at the same time offering the user control over that narrative?

The nature of storytelling changed fundamentally with the invention of print technology in the fifteenth century. From being a group activity, with the story-teller in direct contact with the audience, and able to use gesture, song, mime and dramatic devices to elaborate the tale to listeners who could interrupt and ask questions, storytelling became a solitary, one-way communication between the author and the reader. The tradition of dramatized storytelling lived on in the theatre, and later in film and television. Common to these "linear" media developments is the notion of the audience as passive consumers. Hypermedia, however, offers a return to the idea of an audience of active participators. It challenges the whole notion of the author-reader relationship that we have grown used to, and creates the opportunity for another form of dialogue. Without diminishing the role of

SCREENPLAY LIVE

Apple Computers: Quicktime Movie

Using sophisticated data compression/decompression algorithms, Apple have developed a means of showing motion video in a window on the Mac screen, with no extra hardware required. Quicktime movies can be cut and pasted through a range of graphic, word-processing and presentation software to create really dynamic communications.

File Edit Project Clip Windows

Project: ZAPfactor – Offline Edit

Alasdair [1]
Still Image
Duration : 0:00:01:00
320 × 240

Dede [1]
Still Image
Duration : 0:00:01:00
320 × 240

John [1]
Still Image
Duration : 0:00:01:00
320 × 240

Luca [1]
Still Image
Duration : 0:00:01:00
320 × 240

Rosie the Dog [1]
Still Image
Duration : 0:00:01:00
320 × 240

Construction Window

Preview

Eight Frames

Special Effects

Dither Dissolve
Image A Dissolves into Image B.

Funnel
Image A is pulled through a funnel, revealing Image B.

Inset
A corner wipe reveals Image B under Image A.

Iris Round
A circular wipe opens to reveal Image B under Image A.

Iris Square
A rectangular wipe opens to reveal Image B under Image A.

Page Turn
Image A curls to reveal Image B underneath.

the author/director, it fundamentally changes it, establishing the new role of "information architect", whose task is the orchestration of the components of a story or a body of knowledge, so that an environment is created in which the user will take an active part.

Like all the other components of the media matrix, film and video become building blocks by means of which the information architect can construct a rich media landscape for the user. Much as an architect works with a town planner in designing the infrastructure of a new town, and deciding where resources such as shopping centres, post offices, museums, galleries and libraries should be situated, so the media architect will plan an infrastructure for the exploration of a body of knowledge. Film, video and audio will be used to provide narrative and instructional guidance at various stages of the user's exploration of the time/space environment of the hypermedia programme.

While full motion video has only recently become a viable option in the compact disc-based media, it has been used in interactive programmes since 1978, when Philips launched the 12-inch video laserdisc. The best of these "interactive video" programmes used motion video sequences and audio voice-over as narrative components in a seamless media matrix of stills, computer graphics, text and animations. With the new image-compression methods perfected by Intel (for DVI-CDROM), Apple (Quicktime), and C-

Cube and Philips (for CDI), motion video can be incorporated within all the major multimedia platforms.

Throughout the twentieth century, motion pictures have been the vehicle for much of our art, information and entertainment. In the twenty-first century, it will be the way we view those motion pictures, and how we choose to view them that will further extend their scope as communications media. New levels of stereoscopic realism will be offered by virtual reality systems, new interactions of sight and sound will be discovered; and we will develop new kinds of critical awareness as we begin to take personal control of the balance between film and still, "fast forward" and "stop-motion", "close-up" and "longshot".

DVI Motion Video

The Intel Digital Video Interactive system uses a mainframe computer to compress motion-video frames onto CDROM or hard disk. Video is decompressed in real-time in the desktop computer by means of a combination of software and add-in boards. DVI has made the personal computer into a truly multimedia machine, with applications in point of information, publishing, video-editing and many other areas.

media matrix - video

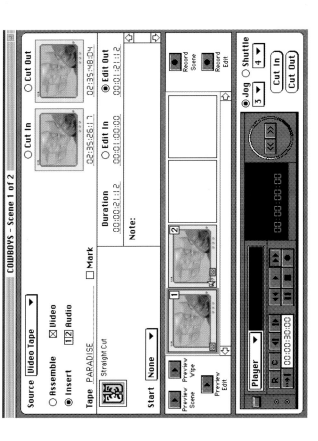

NuVista: Studio Master professional

This video-editing software can be used with Macintosh computers fitted with the NuVista video board. This sophisticated circuit board can display and digitize video signals.

FitVision/RAM: Sight & Sound Exhibition Catalogue for Thorn EMI.

Running on Macintosh computers connected to laserdisc players by means of a videoboard (a special-purpose processor that slots into the computer), the "Sight and Sound" programme allows users to investigate the history of Thorn EMI's contributions to the development of stereo audio, radar, computer-assisted tomography (body scanning), television, lighting, and record, film and video entertainments. Laserdisc is still the best way of integrating broadcast-quality full-motion video into hypermedia programmes.

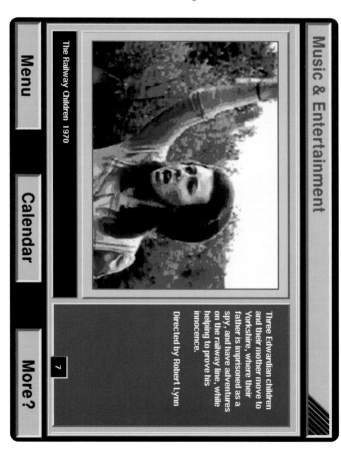

Joe Gillespie/Pixel Productions: Videologic control software

Making complicated technology easy to use relies heavily on the skills of the interface designer. Videologic produces powerful videoboards that link to laserdiscs and videotape recorders, allowing high-quality motion video to be presented on the desktop. This interface uses the metaphor of a familiar video-edit suite console to simplify control. Users spend less time thinking about how to use the equipment and more time developing their creative work.

media matrix - video

Macromind: MediaMaker

Developed by the MultiMedia Corporation, MediaMaker is a visually based editing system for assembling and synchronizing video with Apple Mac graphics, sound and animations created in Macromind's "Director" software. MediaMaker works with a wide range of video boards to link to videotape recorders, laserdisc players, audio tape recorders and CDROM drives, allowing complete multimedia presentations to be created on the desktop.

media matrix – animation

A t projection speeds of around 15 frames per second, still images appear to us as a continuous representation of motion. After viewing an image there is some small amount of time in which that image is retained on the eye's retina, a fact first exploited commercially in the nineteenth century. Edison's "Kinetoscope" and other devices used round cards on which were pictured animals and human figures in different stages of activity. When these cards were rotated, and viewed through a peephole, the images appeared to move. Later, "flip books" and film-animated cartoons used the same principle.

There are several ways in which animation can be used in hypermedia programmes. As "animation bites" for instance, short sequences of full- or part-screen linear animation that illustrate or explain processes and are progressively or automatically played in response to the user's interaction. In longer sequences, the user has to make branching choices. Animation can also be used for attention-seeking devices, for expressive or decorative effects or as transitional effects, as feedback, and as an "autoplay" or "default" condition, which occupies the screen if the user decides not to interact with the programme.

Animation bites are used wherever the special informational, explanatory or expressive qualities of animation are required, such as in the illustration of systems and processes that are too large, small, fast or slow to be perceived, or that can best be apprehended in abstract form: plant or cell growth, for example, or manufacturing processes, the digestive system or an internal combustion engine. Animations may be linked together in longer sequences, so that an overall animation of, say, the circulation of blood in a body may serve as a "menu" through which progressively more detailed animations of the workings of the heart and lungs may be viewed.

Animations are effective attention-attractors when presented within an otherwise static information frame or menu. They can take the form of small, looped (repeating) animations that act as "self advertising" buttons and are known as motion icons or "Micons"; it is also possible to include animated typography and graphics in a titles sequence, dynamic headline or subtitle; or as instructional or help messages to explain a diagram or a software tool, or to draw the user's attention to programme sections that have not been accessed.

Animations can also be used as mood setters, providing abstract, pictorial or expressive accompaniments to music tracks, monologues or sound effects. Looped animations, fractal generators (computer programs that produce intricate graphic displays), colour "look-up table" animations (where a still image is "animated" by progressively altering its component colours) and animations derived from mathematical formulae and random number generation (such as the "screen savers" used on personal computers) can all be used to create mood.

Transitional effects include digital versions of those developed by film and video-makers: dissolves, wipes, cuts, flash pans and the like, as well as various familiar television effects such as zooms, tumbles, peel-offs, wraps and pop-ups, and the multiscreen effects derived from graphical user interfaces and digital video paintboxes. These effects are programmable, and the computer code to drive them can be stored as part of the programme's software, or stored in read-only memory (ROM) in the delivery hardware, so that they are performed by the playback system itself.

An important consideration in hypermedia design is what happens when the user chooses *not to* interact. What does the programme do? It could just display the frame where the user left off, but there are advantages in designing a "default" or

Macromind Director

Director is one of the key tools for animators working on the Macintosh. It is really three programmes in one, providing painting and drawing tools for the creation of graphics and text; a scripting mechanism based on the traditional animation "dope-sheet" for arranging all the components of an animation and structuring their motion through time; and a presentation programme. Further to this, Director supports a hypermedia scripting language (called "Lingo"), so that complete hypermedia programmes can be produced in this single, versatile platform. Three-dimensional animations can be imported into Director, and digitized sound tracks added. Outside the hypermedia field, Director is also used to produce animatics (presentation animations) for clients of advertising agencies.

Tiger Media: Production Sketches for "Murder makes strange Deadfellows"

Tiger Media are in the vanguard of companies developing hypermedia programmes that utilize the work of top-grade illustrators and animators.

Cartoon-style animations use only a restricted number of colours and this makes them ideal for systems with a limited capacity for data transfer as images can be compressed without loss of quality.

"autoplay" condition, where a specific animation is looped as a "trailer" or come-on for the programme if no user interaction has taken place for some minutes. This default condition can be driven by software that selects parts of the programme at random, providing an ever-changing montage of features, or more simply a sequence of slow "dissolves" between graphic frames, or even a specially designed screen saver. The default condition instantly responds to any new action taken by the user, with some sort of "Continue?" or "Start again?" prompt.

Transitional effects are a form of feedback, letting users know that the system is responding to a command such as selecting the required section of the programme, or progressing forward through that section. Most hypermedia

programmes, for example, involve some sort of information hierarchy. The user selects the required section, then the sub-section and eventually the frame that is of interest. This frame may link to other frames in other parts of the programme. The transitional effects that signal these frame changes can identify which level of the programme is currently in use, and can give the user a sense of "place" within the programme. Simple animations can also give important feedback to the user in "wait states", where the action taken by the user cannot be performed within the time it takes for the system to display a new screen. The conventional options here are a ticking clock, emptying egg timer, moving bar chart, flashing "alert" icon, animated cursor or highlight changing colour.

Video Games

Videogames use a variety of animation techniques to provide both 2d and 3d moving images. Typically, 2d games use animated "sprites", small graphics which are manipulated by the user and move around over a 2d backdrop. Animations in 3d can involve constructing complete environments using vector graphics, or using variable-size sprites on top of drawn backgrounds.

Flight simulators

Videogame flight simulators use vector models, computer graphic models from which images are computed in realtime in response to the user's actions. The user is in direct control of the animations, moving a joystick or mouse to determine the flight path of the aircraft through the virtual space of the game.

A ten-second essay on "hypertypography" in the Computer Graphics Workshop's hypermagazine. Words are flashed staccato fashion at a speed that borders on the subliminal, synchronized with a digital-audio metronome and punctuated with distinct spoken words. The sense of the essay is only acquired through time. This technique was first explored by Michael Snow, the Canadian avant garde film-maker in the 70s.

HARD DISK:HBP:hypertypo2

take a LETTER

HARD DISK:HBP:hypertypo2

EXTRUDE

it into Hyperspace

HARD DISK:HBP:hypertypo2

PIXELLATED

and it becomes a

HARD DISK:HBP:hypertypo2

and d' i p a r t e set of s a

HARD DISK:HBP:hypertypo2

FRAGMENTED

HARD DISK:HBP:hypertypo2

RANDOM RANDOM RANDOM DATA.

Computer Graphics Workshop: High Bandwidth Panning

Even within the restricted format of Hypercard 1.0, it is possible to produce lively animation sequences, either by displaying illustrated cards in quick succession (as though they were frames of a film,) or by scripting actions to take place on the card itself, such as moving objects around, resizing them or instructing Hypercard to use its painting tools, and specifying the necessary X, Y coordinates to create an image that appears to draw itself.

HARD DISK:HBP:Bandwidth Panic

"Music Plus is now the

HyperTypography

"in a
vision

Authoring Mixmaster

media matrix – animation

Domark: Mig29 SuperFulcrum

Simulating futuristic aircraft with advanced aerodynamic features gives the user joystick control over machines that only military pilots actually fly. Flight simulations such as "Mig 29" come complete with terrain maps and landscapes covering huge virtual volumes of space.

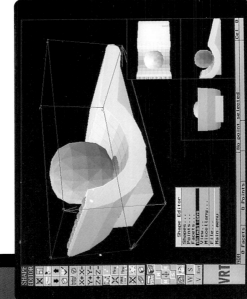

Dimension: Virtuality Modeller

It was the professional users of computer-aided design software who were the first non-programmers to become aware of the vast scope of cyberspace. Creating three-dimensional models of buildings and industrial products with computer-aided design software, architects and designers started delving into the mysteries of X,Y,Z coordinate space. Now such tools can be used to create entire virtual environments for users to explore through data visors and digital gloves.

media matrix – virtual space

Because the technology of hypermedia is capable of subsuming all previous media, the wide range of spatial illusions offered by paintings, photographs, perspective systems and dioramas, film, video and sound recordings can now all be represented on the monitor screen.

Currently these screens are relatively small, with a typical television screen viewed from across the room occupying only a tiny fraction of our cone of vision. Because they are so small, we perceive these screen images as objects "out there" in the environment, rather like looking through a small window onto the outside world. The bigger the window, and the larger the proportion of our visual field that is filled by the screen, the more it actually becomes the environment. The new generation of high definition television (HDTV) screens will be flat, and will be available in much larger sizes, even wall size. They will perform a function in our living rooms that will heighten their similarities with real windows. All the signs indicate that we will be living in an increasingly "soft" environment, with decor, information, entertainment and recreation programmes displayed on large screens and orchestrating the actual space we inhabit. A click will create a gymnasium, another a disco, another an art gallery or museum, another a mountain ski slope, or a multiscreen news room. From being a small window on to a variety of real world scenes, the television will become an architectural space that we will inhabit. These soft "hyper environments" will be controlled through the kind of interfaces that are currently being developed.

The metaphor of media images as "windows" on to the external world, or on to the internal world of the imagination, is still the most common way of describing the sensation we get when looking at a photograph or watching a film. Now, the "windows" metaphor is applied to computer software, where each window provides a view into a software program, giving us access to word processors, graphic packages, spreadsheets and the like. So, for example, when we use a graphic design program, we metaphorically enter a space that has "soft" equivalents of all the tools a designer would need in a real studio. Recent personal computer interfaces from Xerox PARC extend this notion into a "rooms" metaphor, a three-dimensional environment that more accurately creates the illusion of the different work and leisure "spaces" that we occupy at different times during the day.

This idea of passing through a window (and not merely looking through it) is taken to its logical conclusion in virtual reality systems. By placing stereo viewing screens where they completely fill our visual field – right in front of the eyes – and by providing images of a three-dimensional environment which is not just a static representation, but which is computed afresh several times a second to take account of our movements and shifting viewpoint, virtual reality practitioners invite us into a "real" graphic design studio, not simply a two-dimensional, symbolic system representation. As in paintings and films, these virtual worlds can be both real and imaginary, and can transcend human physical and perceptual limitations, taking us right down into the smallest molecule of the DNA helix, or allowing us to travel through the solar system or into the abstract worlds of fractals.

Currently hypermedia programmes bridge the gap between the "window onto" of traditional pictorial media such as painting and film and the "door into" of virtual reality. Hypermedia is the method by which information will be accessed and processed in the multisensorial media of the future. In the "cyberspace" of virtual reality systems, or in the soft environments possible with HDTV, we will communicate, learn, have fun, meet people, do business, and negotiate for information in a world-wide network of video telecoms, databases, simulations, information and entertainment programmes, all through the hypermedia interface.

media matrix – virtual space

Gremlin: Lotus Turbo Challenge 2

Flight simulators and driving simulators were the first videogame programs really to give the user some notion of the scale of the virtual environments that it is possible to create in "cyberspace". In this driving game, two or more players can road-race right across a virtual America. through night and day and different weather conditions.

NASA: Virtual Interface Environments

NASA have been developing techniques for the exploration of virtual space since the early 1980s. Their systems include control and feedback mechanisms for voice input and output, position-tracking, stereo imaging and stereo sound cueing, all through head-mounted display systems. Gesture tracking and tactile input and feedback are facilitated through digital gloves. Systems like this provide tools for interfacing with Virtual Reality environments, simulating space exploration (telepresence), industrial processes (telerobotics), and many other scientific, entertainment and educational experiences.

Computer Graphics Workshop: High Bandwidth Maze

The maze has proven to be a rich metaphor for navigating through the virtual space of hypermedia programmes. The Computer Graphics Workshop used this wire-frame "rooms" model back in 1986. The maze is full of surprises, as random elements have been built in to reinforce the Escher-like feel of cyberspace, and to provide a high degree of replayability. Articles and features within the "hypermagazine" can be retrieved through the "cuecon" headlines along the bottom of the frame, or the user can click on one of the three "doors" into other rooms containing further cuecons, animations and "hypertypographical" essays and sounds.

SPACE HUMAN FACTORS
VIRTUAL INTERFACE ENVIRONMENTS

AUTONOMOUS AUTOMATION INTERFACE

TELEROBOT SUPERVISORY CONTROL INTERFACE

HELMET-MOUNTED, HEAD-TRACKED STEREO DISPLAY

3D AUDITORY CUEING AND VOICE I/O

GESTURE, HAND POSITION TRACKING

NCC WORM 1:Hypercard:BANDWIDTH:Bandwidth Panic

The students

'Barefoot doctor expert systems......

The Condition of Muzak

The Art of

Everyday the observable universe

media matrix - virtual space

P roducing a hypermedia programme has much in common with producing a book or a video. Just as in these forms of publishing, an idea will be analysed in terms of its uniqueness, intrinsic merit, market potential, cost of production and the like. The idea will be fleshed out, developed into script form, a schedule established and a budget set. The production team will be assembled which will, with careful management, produce the book or video within both budget and deadline.

Both print publishing and video production now rely heavily on electronic tools: computers for word processing, graphics, page makeup and typesetting; paintboxes for video image manipulation, and computers for generating, processing and mixing sound. These are the very same tools that are required in hypermedia. While obviously some new and different skills are involved in hypermedia production, these are differences in kind rather than substance. Programming for hypermedia need be no more difficult than programming for video effects or operating a MIDI (digital audio) sequencer. Graphic designers working in television, or in a desktop print environment, will have no problem adapting to hypermedia graphics, and nor will video and audio producers. So, what is new in the production of hypermedia?

The simple answer is "interaction". Books and videos are linear media. Most books, such as novels and textbooks, are meant to be read through from the first page to the last. Hypermedia programmes, on the other hand, are described as "random access". They have something in common with reference works such as encyclopedias and dictionaries: books that are designed to be dipped into or used to find a particular piece of information.

Imagine an "electronic" encyclopedia containing all the words and pictures that you would find in a book. Add to this information animations of animal and plant growth, planetary motions, chronological maps and the like. Then add video sequences and movie clips. Then add bird calls, animal cries, the sounds of musical instruments, excerpts from symphonies and folk songs, samples of foreign languages Then add dynamic simulations, so that users can see the population curves of different countries, and

continued from book

can change the parameters that produce these curves and see the results for themselves. Let them compare the air flows across the wing of a bird and an airplane, and then change the design of the wing to see how they can affect lift and drag in a simulated wind tunnel.

Now we are getting closer to hypermedia: we have a multimedia encyclopedia. The next stage is to add an index, and some special software with which we can search the index to quickly find all the entries that relate to "education" for example, or to "music". Now we have a multimedia database. We can search the contents of this database by any number of means, including name, subject and date, and use the power of the computer to do all this hard work for us.

The final step is to imagine that we have added a system of links between related items in the encyclopedia. These links would enable the user to move effortlessly through all the encyclopedia entries, following up an interesting reference in one entry simply by clicking on a keyword and going to the linked entry; then perhaps returning to the original item, or following a link to another entry. We can still "browse" through the encyclopedia as though we were reading a book, but now we have all the added power of database searching and hyperlinks.

We can add other components, such as expert guides, who will talk us through a difficult subject in language that we can understand, or guide us through established "knowledge trails". Or we can add graded quizzes, puzzles and games.

The process of thinking interactively is not difficult, but different. The user or reader has to know where he or she is and how to retrace the path to an item seen ten minutes (or ten entries) ago. The various pictures, films, text and data have to be accommodated on a delivery medium that is of a finite size, and the programme has to be as easy to use as a book or a radio. Exactly how all this is achieved is the subject of this section of the book.

4

design and production

programming and structure

W

hatever "delivery" medium is chosen, whether it is Hypercard and CDROM, CDI, DVI, Laserdisc or CDTV, the production cycles will have several stages in common, including design, prototyping and data acquisition. The structural design and prototyping of hypermedia product will take into account the technical characteristics of the chosen medium as well as the ergonomic factors of viewing distance, user control, where and how the programme will be used, and so on. Prototyping is the preparation of a hypermedia programme that demonstrates how it will work, both in terms of structure and user interface. Data acquisition is the preparation of all the constituent media that are required for the programme. What follows is an overview of the typical stages in the production of an interactive multimedia programme.

Concept and target audience

This is the first stage of work for the designer, who will initially develop an idea in response to either a stated or a perceived requirement of a client, or for a speculative programme that is to

be presented to possible financiers and/or publishers. The programme concept will have emerged from the identification of a service, product or publication that addresses the perceived needs of a particular group of people or, on the larger scale, a particular market sector. The more accurately this target audience can be defined (in terms of, for instance, viewing and reading habits, lifestyle, taste, level of education and media preferences), the more precisely the designer can gauge the interface design, editorial style and functionality of the proposed programme.

The only hardware the designer needs at this stage is a pencil and paper. The "software" required is however rather formidable: it is no less than the sum total of the designer's experience of all the component media, and his or her knowledge of how to integrate them into a coherent idea for an interactive programme suitable for the defined target audience. Effectively, this means that the designer will develop ideas, and test these ideas with the production team (the producer, programmers and

CDI Developer's Workstation

In order to simplify the production of programmes . for complex technologies such as CDI, Philips have put together a range of developers' workstations to provide all the facilities a designer needs to assemble prepared multimedia components into a CDI programme.

CDROM Developer's Workstation

CDROM is much simpler than CDI. Workstations like this allow programme developers to compile all the data files for text, images and audio, assemble them, and then test the finished programme as though it was running from a CDROM disc.

audio, animation, graphics and video specialists), to assess their effectiveness, verify that they are technically possible, and to ascertain their logistical implications such as probable production requirements, time and costs. Once the idea is established, preliminary approaches are made to the copyright holders of any visual, textual or audio material that may be required from archive sources.

At this stage, the client will see a written description of the programme, perhaps illustrated with sketches and flowcharts. How much of this material needs to be presented to the client depends largely on the experience of the producer, and the nature of his relationship with the client or financiers. Client presentations may also include colour graphic visuals to give an indication of the proposed titles, interface and general graphic style of the programme.

Bob Cotton: Sketches and Presentation Graphics

Every aspect of the programme is worked out in sketch form before simplified schematics are produced using DTP software. These ideas do not necessarily reflect the graphics style of the finished programme; rather, they are used as 'briefing' guides for the graphic designer, and show the functional requirements of the various screens.

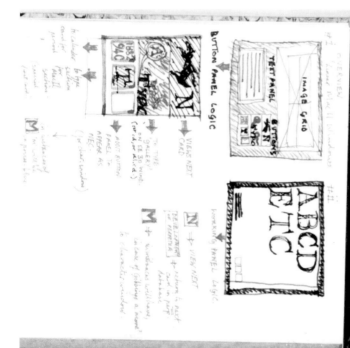

Mark Bowey: Sketches

From the functional schematics produced by the programme designer, the graphic designer can work up suitable graphic treatments. Design is a process of trial and error, the finished design emerging out of a long period of discussion and testing of different approaches.

Jeanne Verdoux: Sketches

Sketches like these are used by the designer to work up ideas for screen graphics and interface icons. Verdoux was trained at the Royal College of Art, London, and designs interactive programmes for a number of multimedia production companies.

production cycles

the brief

When the client or financiers have reached an agreement in principle a detailed brief is prepared, not only listing the functional objectives of the programme, but also attempting to define the target audience. The brief is really a specification for the design of the programme, forming part of the contract between the producer and the client.

detailed design

Based on the specification of the brief and the original ideas, the design has to be worked out in every detail, from title sequence, default condition and credits to all the programme contents. The result of this stage is a complete interactive storyboard, showing the relationship between programme components and indicating the range and possible style of the graphics, video and animation components. From this detailed design will emerge a list of all the visual and audio material required. The storyboard and lists will form the basis of briefings for all the individual members of the production team.

prototype

At this stage a prototype is often developed. This need not be a complete model of the programme, but it should test all the different types of functions expected in the finished production. This gives the designers an opportunity to evolve a suitable graphic style and interface, the programmers an opportunity to test various programming solutions, and the producer and client a chance to assess the programme's style and structure.

pre-production planning

While the design is being finalized through the prototyping stage, the production budgets and schedules are prepared by the production manager. He or she is also responsible for coordinating any necessary picture research and rights clearances for video and other material required for the programme, and for employing a production team for video, animation, graphics, audio and programming.

data acquisition

As soon as archive, library and other source material is assembled, it can be edited, scanned or "frame-grabbed" (through a video camera) into suitable digital file formats, and retouched, scaled or cropped to the required sizes. Scanning is the first major production expense, and processed files are immediately backed-up on to a large-capacity storage medium. At this stage video and audio recordings are edited and converted into tape formats.

video and film

There may be a requirement for live action, studio or location shoots, or for the rostrum shooting of material that is too large to be scanned, or that is three-dimensional. Motion and stop-frame material can be shot on film (and then telecined to video) or on any professional quality video format. Within the limits of the budget, the designer is free to consider the entire range of animation processes and film and video special effects offered by production companies.

computer animation

Computer animations can be produced in many ways, and range from simple scripted graphics or cell animations, through two-dimensional colour animations, right up to broadcast-quality three-dimensional model animations produced on supercomputers. Whether produced in-house, or sub-contracted to specialist production houses, the time taken to develop animated sequences -especially if these sequences are to be interleaved to produce highly interactive "surrogate travel" or simulator sequences - should not be underestimated.

audio

A number of desktop tools exist for digitizing and mixing audio. More sophisticated material can be commissioned from professional musicians or audio engineers and delivered in pulse code modulated (PCM) form on digital compact cassette (DCC), digital audio tape (DAT) or Betacam tape.

graphic design

While scanning is in progress, the graphic designer can start work developing the "house style" of the programme, and producing finished graphics for all the different types of frames, windows and icons needed for the production. These are all produced digitally, using software such as Pixelpaint Professional, Photoshop, Studio 32 and Image Studio.

formatting

This stage involves the formatting of all required images and sounds into suitable file formats for the medium of distribution.

programme construction

When all the necessary components are correctly formatted, the programme is constructed to the initial design, and the graphics and control buttons linked together with all the video, animations and audio sequences. The authoring and programming for this stage is often intensive, as there are always improvements and adjustments that suggest themselves as the finished programme materializes. Different programme development hardware is required for this stage, depending upon whether the programme is for distribution on CDROM, CDI, CDTV or laserdisc. This stage usually gives the first opportunity for the designer to see the programme approaching its finished form.

testing and debugging

The final stage in the production is the thorough testing, troubleshooting and debugging of the programme. This stage may incorporate user-trials with typical users, and will certainly result in some programming revision.

delivery to client

The finished programme is delivered as a mastertape or disc ready for replication, or in the case of limited editions of interactive laserdisc or CDROMs, as finished pressings, together with any necessary hypermedia software for the controlling microcomputer.

post-production servicing and re-versioning

Extra production work will be entailed for the regular updating and re-editioning of the programme, for the conversion to other interactive media formats, and for the preparation of different language versions.

contextual information. A variety of "overviews" from expert travellers and explorers in the subject domain will be on offer, and the system itself will provide the inertial navigation that will keep a constant dead reckoning of where you are, and of what directions are possible or desirable from that location.

The hypermedia designer is an "information architect", responsible for coordinating all the components of the media matrix into a media environment that the user can explore at will. The designer's job is to develop a structure that shows in schematic form the relationships between every part of the programme. There are several ways of doing this, but perhaps the easiest is to use the flowcharting conventions similar to those developed for computer-based training (CBT) and computer assisted instruction (CAI) some twenty years ago. Flowcharts work well for programmes where the number of links between items in the programme is limited. The idea is to produce a structural model of the programme that can be rigorously tested for logic and consistency. All the possible "routes" through the programme can be traced, and the model refined using an iterative process of "test/refine" until the most efficient structure is arrived at. This model will then serve as a presentation tool by means of which the designer can explain to the client how the programme will work and can provide a "programme map" for the production team.

From the structural diagram the designer will derive lists of the media requirements for the entire programme, specifying the number of frames for stills, animations, video etc and the amount of storage available for data, text and audio tracks. This information will form the basis of the production schedule, from which the programme budget will be developed. Using the diagram as a model, all the navigational icons for each section of the programme can be specified, and rough visuals of the proposed interface prepared for the graphic designer.

ypermedia programmes are more akin to maps than to guidebooks. The guidebook reader is content to let the guide lead him, adopting the role of passive listener/observer (tourist). With a map, the user becomes an explorer, deciding where to go and how to get there. Of course, hypermedia programmes can contain guidebooks and even guides for when you need them, but essentially what the hypermedia designer is doing is providing a map of the subject/territory to be explored. The main routes into the subject will be indicated, interesting diversions will be marked, as will the availability of background and

Bob Cotton: structural sketches

Early development work on "Sight & Sound". The original programme concept is deconstructed and all the necessary components are worked out in some detail before the overall structure can be defined.

programme structure

Programme Overview

Copland: The Tenderland. Co/Design schematic/

Bob Cotton: Flowchart for Grand Tour

Overviews like this act as "interactive storyboards" for the production. Each element in the overview is described in full detail in additional diagrams and flowcharts, but starting with a simplified overview makes it much easier for those involved in the production to share the mental picture that the designer/director has developed.

Bob Cotton: structural sketches for Grand Tour.

The sketchbook is not only an immediately practical necessity - it also allows the designer to build up a repository of ideas for future development. Creative thinking on one project can lead to new ideas for programmes, and the sketchbook becomes a reference sourcebook.

Bob Cotton: flowchart for The Tenderland

The overall structure of the programme is the responsibility of the interactive designer or programme director. Flowcharts like this are a convenient way of representing the different programme sections and their inter-relationship. Detailed schematics of each part of the programme are related back to this "overview" flowchart.

Bob Cotton: Detail of The Tenderland programme design

Each decision frame is constructed to show the function and approximate layout of all the graphic components and buttons. Layouts like this are produced in a page make-up program in preparation for a presentation to the client, and for the briefing of programmers and graphic designers.

"Grand Tour" was designed by the authors as a pan-European cultural quiz game, and these flowcharts and working drawings show how the structure of the programme was developed. Users can choose from a variety of subjects and have to answer questions related to the country or city they have selected previously. Answering correctly lets them choose another venue. The winner is the first to complete the Grand Tour, linking all the European community countries together.

"The Tenderland" is a "music plus" title, offering users documentary information on the opera, the composer, orchestra and performers, as well as the ability to choose acts and scenes they wish to hear, and to view sheet music and libretto while they watch video sequences from the opera.

Button with script window

In Supercard, any object on the card can contain a script - a computer program written in simple commands - which determines what happens when the mouse pointer is over the object and the mouse button is clicked. Object scripts can be edited easily in the attached "script window".

Asif Choudhary: Script from DTP Index

Hypertalk scripts are the programming language of Hypercard. Simple Hypertalk scripts can be easily written by non-programmers, and scripting is an excellent introduction to programming. Professional programmers like Asif Choudhary can write elegant programs for on-card animations such as this, which uses Hypercard's painting tools to create drawings in real-time.

The central technology in hypermedia is the microprocessor. It is this tiny slice of doped silicon, with its myriad of logic gates, that integrates the digital signals that encode the pictures, text, video and animation of the programme. Precisely how it performs this task is the responsibility of the programmer.

The programmer is one of the core members of the production team, and works directly with the programme designer, developing the means by which all the programme components are made to appear at the right time under the control of the user. To do this, the programmer must understand how the processor works in conjunction with the storage media (memory), the display monitor, the controlling devices, and the various co-processors that are responsible for audio and video compression. Further crucial knowledge must cover storage of the programme data, how the different types of data are separated (so that for example audio data is directed through digital-analogue converters and amplifiers to the speakers, and video data is sent to the monitor screen), and what the limitations of the system are in terms of storage, speed of delivery, screen resolutions and degree of user control.

The designer's ideas are assessed by the programmer in the light of this knowledge of the system, and algorithmic solutions are suggested; in effect, the designer's ideas are restated into a logical form that can then be translated into an application program. This program controls the entire media matrix.

Apart from orchestrating the retrieval and display of the images and audio, the control program will include code that monitors the user's input from keyboard, mouse and infra-red controller, and may include custom software such as painting or word-processing applications. The processing power of the system can be harnessed to allow the user to control simulations (such as flight or driving simulators, for instance, or crisis

management simulators) or to build digital "models" of complex, multivariate problems (such as manufacturing processes, distribution network or route planning). It can also provide the user with tools such as spreadsheets, project management and idea-generation software to assess the results of these models.

Of course the programmer will assess the cost implications of developing such sophisticated software (expressed in man days of programming time needed) and will advise the designer and producer on the best strategies for achieving the maximum functionality with the minimum of cost. Hypermedia programmes can be "programmed" in a number of ways - the simplest method is to buy a user-friendly toolkit of software routines that have already been prepared especially for the system you have chosen. These toolkits, called "Authoring" packages, are designed specifically for subject experts and designers who may have no programming expertise at all, though this can make them somewhat limited in scope.

The second level of programming is "scripting", in which the designer uses simple, very "high level" (almost plain English) commands to control sets of prepared routines and programs. Hypercard and Supercard use this approach. The advantage of scripting packages is that they can be used by non-programmers with only a minimum of training, and they can be customized or "extended" by professional programmers to allow for all kinds of special applications, such as controlling external hardware (like slide or videobeam projectors), or calling up other software packages.

Lastly, the system can be programmed using a variety of high level programming languages and then "compiled" (converted into binary code suitable for the intended system) ready for use. Programming at this level is an art as well as a science, and programmers pride themselves in getting the best results from the system with the minimum of code.

programming

```
-- script for DTP Index Inkjet
on mouseUp  -- when mouse button is released
hide card field id 5       -- hide help text
save                       -- save current state
set pattern to 12          -- set spray pattern
repeat with i = 1 to 9     -- starts repeat cycle
  spray 175,150 + i * 10   -- spray the dots, left edge of 'N'
end repeat                 -- ends repeat cycle
repeat with i = 0 to 6
  shift 165 + i*5          -- spray the dots, diagonal bar of 'N'
  spray 180+i*5,170+i*10
end repeat
shift 200
repeat with i = 1 to 9
  spray 215,150 + i * 10   -- spray the dots, right edge of 'N'
end repeat
wait 3 secs
revert                     -- revert to current state
choose browse tool         -- selects the 'finger' mouse pointer
end mouseUp                -- terminator
```

```
-- subroutine 'spray'
on spray x,y                     -- spray a single dot at position x,y
choose brush tool
set brush to 31                  -- selects brush style
play "spray"                     -- play spray sound
drag from x-1,y-1 to x-24,y-24   -- spray lines
set brush to 5                   -- new brush style
click at x-36,y-36               -- paint dot
lock screen                      -- disable screen updates
choose select tool               -- selects rectangular marquee
drag from x,y to x+13,y+13       -- selects this area
cut                              -- cuts this area
drag from x-21,y-21 to x+13,y+13 -- selects this area
unlock screen                    -- update screen
end spray

-- subroutine 'shift val'
on shift val
lock screen
choose select tool
drag from val,140 to val+72,370
drag from val + 1,141 to val+6,141  -- move print head right 6 pixels
choose browse tool
unlock screen
end shift val
```

```
-- script for DTP Index Frisk Film'
on mouseUp  -- when mouse button is released
hide card field id 6      -- hide help text
save                      -- save current state
choose spray tool         -- uses Supercard's paint spray tool
set pattern to 12         -- set spray pattern
set dragspeed to 2        -- sets speed of spray action
drag from 250,145 to 150,145  -- spray line from x,y to x1,y1
choose bucket tool        -- uses Supercard's paint fill tool
click at 140,147          -- fill letter R
wait 2 seconds
revert                    -- displays the finished result for 2 secs
choose browse tool        -- revert to saved state
end mouseUp               -- selects the 'finger' mouse pointer
                          -- terminator
```

Inkjet printer

Pressureless (non impact) printing device

PRINT HEAD

Jet Control Signals

Pressurised Ink

Inkjet printer

Pressureless (non impact) printing device

PRINT HEAD

Jet Control Signals

Pressurised Ink

Frisk film

line board with outline drawing

frisk film overlay with stencil cutout

Frisk film

line board with outline drawing

frisk film overlay with stencil cutout

T

The television that we are all familiar with today is just a foretaste of what it will become over the next decade, when it enters its second generation. It will progress to being a two-way device that encourages dialogue between broadcasters and an audience of active participants, and new types of interactive programme will be available alongside broadcast, linear TV programmes.

The television set will become the focal point of a "home information/entertainment centre" that will incorporate stereo hi-fi, VCR, Interactive CD player, personal computer and telecommunications. The television will be very large in scale, high-definition (at around 1200 lines, at least twice the resolution now available on conventional sets), and will utilize the digital storage and processing currently associated with personal computers. From the ideal "home entertainment system" we will be able not only to access all broadcast and narrowcast television from terrestrial, satellite and cable networks, but also to order films and videos from an easy-to-use multimedia catalogue, or through specialist guides. We will be able to "train" our home entertainment system to sift and sort programmes for us, by using "intelligent interface" software that "knows" about our tastes and preferences, and that will compile daily "menus" of broadcast programmes, news features and films, and new hypermedia publications.

If this high-definition television becomes the main unit for "family" viewing, it will be the small-scale "Dynabook"-style personal

Westminster Cable: Interactive Metrotext menu

Cable TV receivers in London use remote control pads to operate this Metrotext guide to community information, programme guide and listing of leisure and home shopping services. Apart from giving local information, this interactive text service allows subscribers to link to British Telecom's Prestel videotext systems, with their wide range of local and national services. Unlike Teletext, which uses a carousel of information frames sent in sequence, Metrotext is an instant view-data system, with no delay between request and display.

```
METROTEXT              1a
TEXT  -METRO-  TEXT

1  Westminster Now!
2  Community Information
3  Leisure
4  Home Shopping
5  Programme Guide
6  Customer Services
7  Linking to Prestel

8  Euro Quiz

GOOD AFTERNOON
WELCOME TO WESTMINSTER CABLE
       Press TV for Channel Choice
```

Westminster Cable: Home Shopping Services

Cable subscribers can use these home shopping services to browse through items and special offers in some of London's big stores, choose the items they need, confirm the order and be assured of delivery by the next working day.

```
WESTMINSTER CABLE TV        4013a
Selfridges    Food Hall
Select category to view. When finished,
confirm your order by keying 9.
11 Entertaining      27 Fruit & Veg
12 Ready Meals
13 Mid East Savoury  28 Chocolates
14 Mid East Sweets
15 Mid East Nuts     29 Gift Lines
16 Delicatessen
18 Kosher            31 Wine / Spirit
19 Japanese Foods       Gift Lines
21 Meat
22 Fish
23 Bacon
24 Cheese            32 Household
25 Wines / Spirits    9 CONFIRM ORDER
26 Grocery
0 Index
```

Empruve: Cornucopia System

Consumer hypermedia systems are radically changing the way we perceive computers. While we shall still have desktop systems, which are desk bound, there will be an increasing variety of notebooks, palmtops and laptop multimedia machines. Empruve have developed a highly ergonomic multimedia system that can be used in a variety of locations.

hypermedia system that caters for the individual. A dominant trend in the computing, electronic information media and telecommunications fields is towards the provision of an information system that is both personal and global, allowing us to survey, locate and store information in whatever form we want (whether this be words, pictures, numbers, films, music, voice, simulations, games, maps, schematics, models, animations, diagrams, slide shows, lectures, fireside chats, stories, drama, poetry, myth or even virtual environments), and at the same time enabling us to see the people we talk to on the phone.

entertainment and information system. The variety will be enormous. Entertainment will range from games, through simulations, to interactive drama; reference and information programmes will include dictionaries, encyclopedias and atlases; "infotainment" and education will feature quizzes, interactive documentaries, "adventure learning" and "surrogate travel"; and "home shopping" and other forms of interactive advertising and "distance retailing" will be available, alongside legal, financial, travel, health, ticket agencies, and other specialist services.

In the corporate sector, hypermedia products will continue to be developed for training, point of information and point of sale. These products, and relatively new developments such as geographical information systems and multimedia emergency response systems, are likely to continue to be market leaders in the use of the latest technologies. Simulation is already widely used for commercial airplane and weapon systems training, while voice-activated interfaces, gestural interfaces and virtual reality simulations are next in line for commercial application.

Much of the work discussed in this section is indicative of the style of future interactive programmes accessible through such a home

5

hypermedia
applications
making use of the media

education

T he impact of hypermedia in education is likely to be the most controversial of all the application areas we examine. In the other areas the success of hypermedia will be settled on pragmatic grounds: it will depend on whether or not it solves practical problems or answers consumer desires. In education, on the other hand, there may be complications, since, as well as offering a promise of positive change that will improve the quality of education for all, hypermedia also represents a threat to the traditions, values and practices that have grown up over the years.

The first aspect of this threat is the nature of the medium itself. For centuries the written word has had a central authority in society. Indeed, it could be strongly argued that our notions of rationality and valid argument are all bound up with modes of thought that are derived from writing as a medium. The only real challenge to the primacy of the written word has come from its more esoteric cousin, the mathematical expression. Both these media are extremely abstract and their mastery takes many years of education and training. While most people in modern society can read, write

and handle simple mathematics, the greatest concentration of mastery in these media is found in the elite professions, and is the source of some of their power and much of their authority.

The development of hypermedia represents a return to richer, pre-print modalities of expression, as if we are "coming to our senses" after the anaesthetic of monochrome words. The opportunity it offers to reason, to think, to speculate, to debate and to learn in more concrete, multi-sensory terms may have a deep significance in terms of what we are able to think about. Indeed, a move away from a reliance on the peculiar abstraction of written or mathematical expression may be the only way we can tackle the

complexities of the modern world. But the use of hypermedia for learning traditional subjects may well be seen by many as trivializing or debasing. Those who owe their position and status to the mastery of the written word are those who may have the greatest difficulty in "writing" and "reading" in this new medium, and will resist most strongly this threat to the primacy of the written word.

This resistance is likely to be reinforced by two further aspects of hypermedia. One is the threat to jobs in education, where the major expenditure (over 80 per cent) is in salaries for teachers and lecturers. Hypermedia is the first educational technology that is likely to become a really effective means of learning. Increasingly, as this is demonstrated, there will be a strong temptation for those administering education to shift expenditure away from people, who are relatively

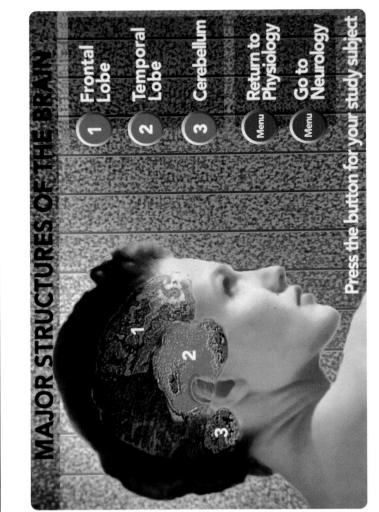

MAJOR STRUCTURES OF THE BRAIN

1 Frontal Lobe

2 Temporal Lobe

3 Cerebellum

Menu Return to Physiology

Menu Go to Neurology

Press the button for your study subject

Bank Street College: Palenque

This is a Digital Video Interactive (DVI) programme that allows children to explore an ancient Maya site interactively. "Palenque" uses surrogate travel techniques to present motion video and stills of the site, and users can explore as though they were actually present, looking at maps, taking pictures (which they can store in an album and use later to illustrate a report on their visit), asking for help from expert guides, and visiting a museum to find out more about the area.

expensive, to technology, which (if adopted on a mass scale) is relatively cheap. In many ways, however, yielding to this temptation may be an error. A more appropriate strategy would be to accept a change in the role of the teachers away from being a deliverer of content (which in many cases will be more effectively carried out by hypermedia) towards the role of "facilitator" or "manager" of learning. Nevertheless, the temptation to see hypermedia technologies as a means of saving money, rather than as a means of improving the quality of education, will be strong.

The other threat is to traditional educational institutions. If hypermedia is going to be as powerful a medium for learning as it appears, it is also going to be available in the home and in the workplace. It is highly probable that its adoption there will be considerably quicker than it is within educational institutions, and that learning will be done more effectively at home or at work. The function of schools, colleges and universities will then naturally be questioned.

These issues are important ones that we should begin to consider seriously. We still have time to think them through, since the medium is still in its infancy. Hypermedia could offer our schools, colleges and universities a powerful means of enriching the educational experience of their students when (and if) its proper place in the formal educational process can be established.

EuroSampler colour

Currency

Italian lira (LIT)
(plural lire)

1 LIT	=	0.000652 ECU
1 ECU	=	1533.662 LIT
1 LIT	=	0.007787 US$
1 US$	=	1271.107 LIT

Source:
Financial
Times

27
October
1991

EuroSampler colour

Population
Labour market
Unemployment
GDP
Agriculture
Manufacturing
Services
Tourism

Education
Energy
Transport
Language
Geography
Government
Currency
History

A-Z

EC

Ellis Partners: Major Structures in the Brain

Professional videographics can really make a difference to educational applications. The crispness and clarity of high-resolution graphics produced on a video paintbox deliver screens that are comparable in quality to broadcast television.

EuroSampler colour

Rail map
(UK)

Lancaster

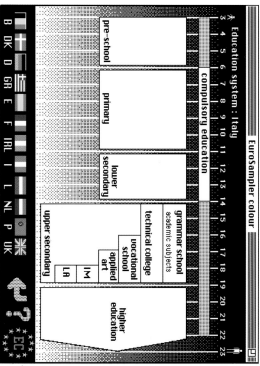

EuroSampler colour

Education system : Italy

pre-school

primary

compulsory education

lower secondary

grammar school
academic subjects

technical college

vocational school

upper secondary

applied art

IM

LA

higher education

3 4 5 6 7 8 9 10 11 12 13 14 15 16 17 18 19 20 21 22 23

B DK D GR E F IRL I L NL P UK

EC

The Hypercard interface features an icon bar along the bottom of the cards. Icons change according to the current section of the programme: for example, within the Country information, the user can select which Community language he or she wishes to use. General "navigation" icons are always present: " go back ", " help " and the " EC " symbol, which returns them to the beginning of the programme.

Vocational technologies: Europe in the Round

EuroSampler colour

A CDROM information system covering education, training and work opportunities in the 12 member states of the European Community. Available in versions for the Apple Mac or MSDOS computers, " Europe in the Round" includes a large database of background information, including maps of Europe, a gazetteer of 12 countries and 333 cities, information on the member states of the EC, and demographic statistics.

education

Position-finding and other simulations require the practice of arithmetic, which must nevertheless be accurately performed to avoid disaster for the team.

The CDTV version can be used by a group or by an individual, in the classroom or at home.

Your supplies arrive as requested.

high frequency
infra red
from the
Sun

low frequency
infra red
absorbed by CO2

The Greenhouse Effect is caused by certain pollutant gases (carbon dioxide from car exhaust and burning coal is the most important) which absorb long wave infra red escaping to space.

North Pole

ALERT

Date = 8 May

2 days pass without incident.

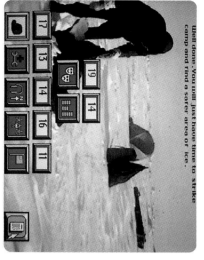

Well done. You will just have time to strike camp and find a safer area of ice.

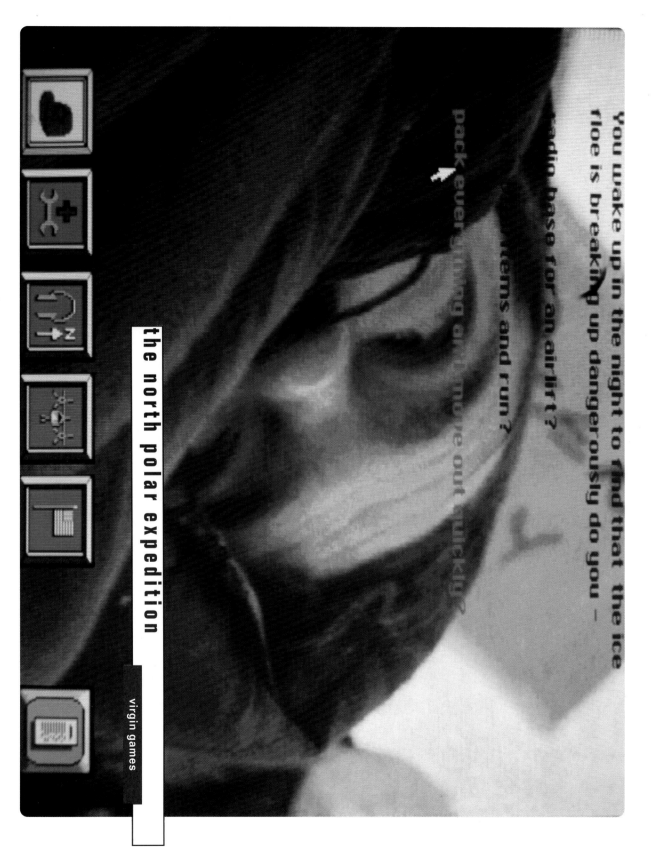

You wake up in the night to find that the ice floe is breaking up dangerously do you –

radio base for an airlift?

...items and run ?

pack everything and move out quickly?

the north polar expedition

virgin games

To provide realism and reusability, the programme includes photographic footage taken during the actual expedition led by Sir Ranulph Fiennes, together with an innovative software program and interactive database which throws up problems at random, as well as presenting difficult situations that arise out of previous decisions.

This Virgin Games programme exemplifies the new approach to educational programme-making, packaging educational source material as a multi-role adventure/simulation. Designed for classroom use, and available in laserdisc, CDROM and CDTV formats, "North Polar Expedition" presents the problems of planning a voyage across the polar ice cap as a combination of interactive quizzes and an audio-visual database of video footage and graphics. Key decisions as to routes, weather windows, equipment and supplies are made jointly by a small group of students, each of whom enacts the role of an expedition team member.

Decisions involve the disciplines of geography, arithmetic, meteorology, social sciences, logistics and interpersonal relationships, all of which are presented as problems to be tackled by the team. The teacher acts as an arbiter and guide.

*Shakespeare's
Twelfth Night
or
What You Will*

education

An important landmark in the creation of educational multimedia software, Art of Memory's "Twelfth Night" demonstrates how any meaningful text can become the locus of multi-disciplinary learning. The central feature of this programme is of course the play itself, divided into acts and scenes, each of which is introduced by a critical commentary. The entire text of the play is supplemented by an on-line glossary and a "character bar" of the dramatis personae. Clicking on any character gives a description of his or her role and a list of significant appearances, which can be used to follow the character through the play.

Art of Memory have integrated all these components within a seamless interface that allows a wide variety of user interaction, from panoramic vistas of Renaissance London (which can be scrolled horizontally to reveal labels and buttons to related topics), to the witty use of woodcuts and prints in the interactive pictures of life in an Elizabethan town. The programme makes full use of high-quality graphics, sounds, animation and text to produce an exciting and informative introduction to the play and to a wealth of associated material. It is available on CDROM for the Apple Macintosh.

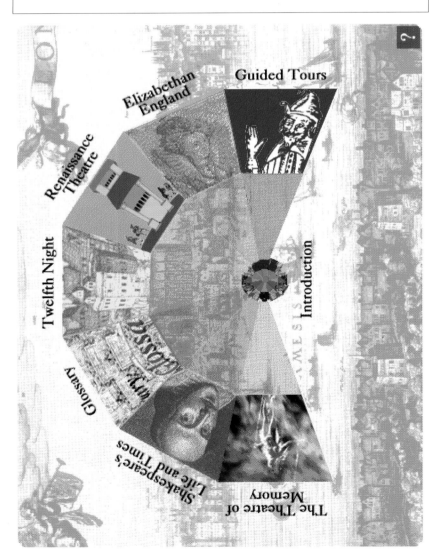

Elizabethan England
Guided Tours
Renaissance Theatre
Twelfth Night
Introduction
Glossary
Shakespeare's Life and Times
The Theatre of Memory

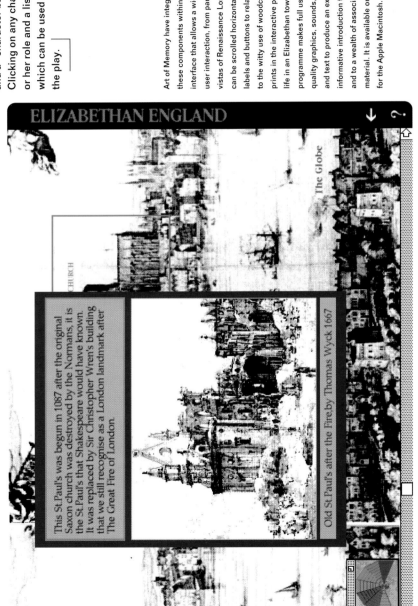

ELIZABETHAN ENGLAND

The Globe

CHURCH

This St Paul's was begun in 1087 after the original Saxon church was destroyed by the Normans, it is the St.Paul's that Shakespeare would have known. It was replaced by Sir Christopher Wren's building that we still recognise as a London landmark after The Great Fire of London.

Old St Paul's after the Fire,by Thomas Wyck 1667

shakespeare's twelfth night

A wide variety of associated material is also available through the innovative "amphitheatre" icon, which reminds the user of his or her current position within the programme. Based on Elizabethan ideas of the Memory Theatre, this icon expands, filling a larger screen window to give an overview of the disc contents and their inter-relationships. Six other major sections can be accessed through the amphitheatre icon: Renaissance Theatre, Elizabethan England, the Theatre of Memory, Shakespeare's Life and Times, Glossary, and Guided tours. The tours cover contemporary topics such as life in an Elizabethan town, playgoing, the plague, and Shakespeare's contemporaries.

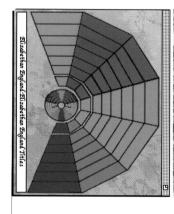

Elizabethan England/Elizabethan England Titles

An Elizabethan Town

Long View of London

The Armada

Mappery

The Plague

Executions

? ↑

ELIZABETHAN ENGLAND

Home
Garden
School
Church
Hospital
Theatre
Hostelry

An Elizabethan Town

? ↑

ELIZABETHAN ENGLAND

This programme plots the evolution of Perpetua, one of the best-known typefaces produced by Eric Gill. Mark Bowey has designed a multidimensional programme in which the user can explore several contiguous strands of information, including a biography of Gill, the chronological development of Perpetua. Gill's relationships with Stanley Morison of Monotype, Edward Johnston and Robert Gibbings, and parallel developments in typeface design. These components of the programme are made available to the user through a technique Bowey calls "textured informational layering", which is the superimposition of windows of information that are related to each other. The richness of Bowey's graphic backgrounds and button designs demonstrates a sophistication of approach that will undoubtedly influence the design of consumer programmes.

gill: the genesis of perpetua

mark bowey

Bowey is an example of the first generation of graphic designers to have grown up with the new technologies of desktop graphic design. The totality of his control over the entire production process (which includes hypermedia design, editorial writing, image retouching, graphic layout, typographic design and animation) would not have been possible much before 1990. The suite of software developed for the Macintosh system includes sophisticated tools for all these tasks, and puts these tools directly in the hands of the designer.

The "chronofile" of Gill's career can be addressed through a calendar "menu" that calls up text and picture frames for a particular year. These can be viewed consecutively as running text, or called up at random.

The layering of information within each frame adds to the multidimensional style developed by Bowey. Every component is designed to complement the subject matter. Eric Gill's typefaces are used for the text panels, captions and titles, while fragments of Gill's type and illustration work appear within the button icons.

This window explores the Genesis of Gill's Perpetua design. Click anywhere in the left hand panel to access this window. Click the "overview" button in the bottom right of this panel to return to the main overview

Button Function
1 To next card 1
2 To concurrent type designs 2

Arts and Craft movement, yet—as a designer of letterforms for the modern mechanical age, a pioneering figure whose achievements rival the developments made by his European contemporaries. Always, Gill's life seems a complex dichotomy—his functions, beliefs and public views often (to his delight) at odds with his actions and work. To an extent, it can be argued that during the post-war years his influence has undergone significant redefinition, that his legacy lies more strongly now as the creator of some of the most popular and used typefaces in this century. This project, generated in SuperCard, is designed to allow the user to explore "The Genesis of Perpetua."

TESTIMONIALS
THIS desirable looking apparatus is considered the best for the *purpose.*

As early as 1914 Gill enlarged by sixteen times a specimen of Old Style Long Primer, drawing over the top his own variations. Robert Harling has said that "the resulting characters are strangely free from the Victorian Old Style tradition which dominated English typographical design at that time.

Naturally, these forms represent only a starting point, at this moment in Gill's own lettering style, yet already one can begin to see the rudiments of the face Morison would eventually coax out of him.

GOLDEN COCKEREL

Eric Gill
1882–1940

When Eric Gill died in 1940, he left an international reputation. Throughout the twenties and thirties he was increasingly recognised, and sought after for his talents as a sculptor, engraver, writer, monumental mason, and type designer.

Edward Johnston
1872–1944

Edward Johnston had studied medicine at Edinburgh before arriving in London, with the plan to take up art. However, on meeting Stanley Cockerell in the Manuscript Room at the British Museum, he became, at his own

johnston

gill sans

The panel shows a comparison between Johnston's Railway Type and Gill Sans. Press the blue play button to see user

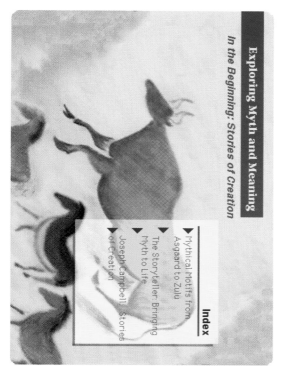

Index
- ▼ Mythical Motifs from Asgaard to Zulu
- ▼ The Storyteller: Bringing Myth to Life
- ▼ Joseph Campbell: Stories of Creation

The Interactive Media Group at Cornell has produced some of the most innovative educational multimedia applications. "Mythmaker" is a class project currently being developed under the tuition of IMG Director Geri Gay, and features "Exploring Myth and Meaning", where users can access sections on Joseph Campbell and Creation myths, mythological motifs and the role of the storyteller in bringing myth to life.

mythmaker

cornell university

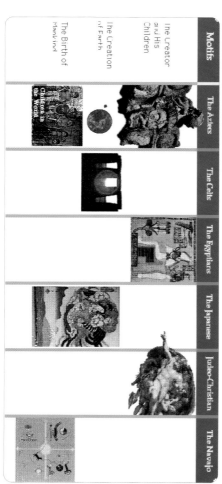

Motifs						
The Creator and His Children	The Birth of Mankind					
The Creation of Earth						
	The Aztecs	The Celts	The Egyptians	The Japanese	Judeo-Christian	The Navajo

Originally designed to help student teachers understand something of the variety of different ways that computers can be used to support learning, Anglia Polytechnic's "Xploratorium Workrooms" has expanded into an integrated suite of programmes for young learners. The aim is to offer activities that introduce children to the strategies and ideas that they will later need to solve much harder problems with more sophisticated tools such as word processors, spreadsheets and databases. The "Workrooms" menu is presented as a house, with each room representing a different activity.

"Workrooms" demonstrates just how effective educational hypermedia programmes can be in black and white. Despite its plain exterior, "Workrooms" incorporates a wealth of innovative approaches to learning with computers. The designers have produced learning tools that provide challenge, support collaborative work, offer some continuity and progression, help to build users' self esteem, leave a clear role for the teacher, and importantly, are enjoyable. "Workrooms" runs on any Apple Mac that is able to run the Hypercard 2 program.

Xploratorium workrooms

anglia polytechnic

Broken calculator

OFF · scientific · simple · Mend · Options · Why? · Break

this is a comma · multiple dra... · text up to 999 point · Built-in clip art

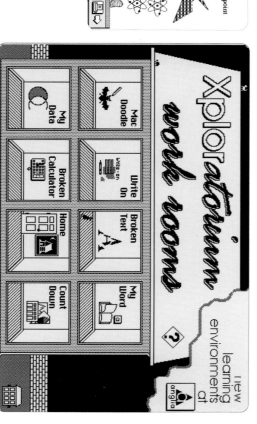

Xploratorium work rooms

- My Data
- Mac Doodle
- Broken Calculator
- Write On
- Home
- Broken Text
- My Word
- Count Down

new learning environments at anglia

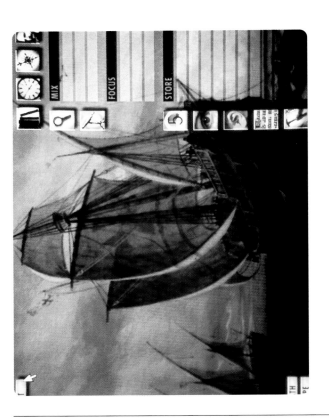

A lavish showcase for IBM multimedia and CDROM capabilities, "Columbus" offers around 180 hours of interactive instruction, and can be used by individual students or in group or classroom presentations. The programme designer is Bob Abel, the distinguished film and computer graphics pioneer who worked on *2001: A Space Odyssey* and *Tron.* The programme allows students to follow Columbus's voyage of exploration, reading his diaries, looking at the kind of maps he used, the current affairs of the time and the impact that world trade had on a nation's economy. Historical information is available in structured form as a "timeline". A "time tool" activates diagrams showing events that occurred during the Age of Exploration, including the rise of mercantilism, the birth of capitalism, and the growth of literacy, and extends from the point of discovery in 1492, through the founding of the United States in 1776, and on to cover events right up to the present day. "Columbus" is available as a set comprising three videodiscs (laserdiscs), two CDROMs and software. It runs on an IBM PS/2 fitted with internal CDROM drive and extra video and audio boards.

"Columbus" uses a combination of video, stills, text and audio source materials arranged as a database, and explored through a graphic interface that features photo-realistic buttons and navigation tools superimposed over a rich graphics background. With this programme, Bob Abel has demonstrated that high-quality multimedia programmes are not just the province of the Apple Macintosh.

field guide to insects & culture
cornell university

An interactive multimedia programme running on an IBM InfoWindow touchscreen and using laserdisc stills and video, this Cornell University-designed programme presents the subject of cultural entomology to students of undergraduate level. In Geri Gay's words: "The programme is intended to encourage students in their own strategies for learning, based on the premise that self-directed learning is more meaningful than learning from continually imposed guidance."

An important aspect of this programme is the fact that cultural entomology covers a very diverse range of sources, involving studies in art, music, medicine, poetry, folklore and history. Hypermedia is the ideal means by which materials from these different subject areas can be integrated within a coherent and easily accessible form.

columbus: encounter discovery and beyond

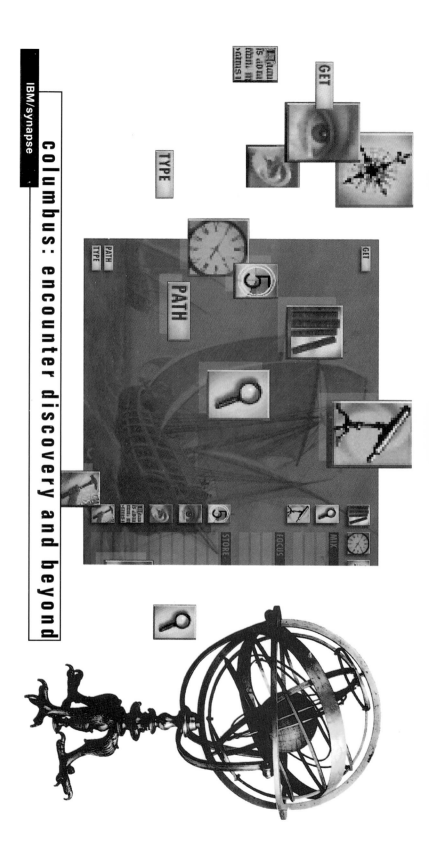

illuminated books and manuscripts

TREATISE; Declaration of Independence, by Th

LIBERTY AND INDEPENDENCE

EUROPEAN AMERICANS · ASIAN AMERICANS · SPANISH SPEAKING AMERICANS · NATIVE AMERICANS · AFRICAN AMERICANS · WOMEN

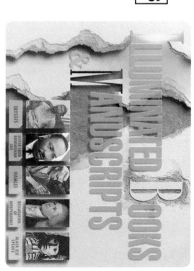

The "Illuminated Books and Manuscripts" programme offers an exploratory look at at five separate works: *The Declaration of Independence*, *Hamlet*, Tennyson's *Ulysses*, Martin Luther King's *Letter from a Birmingham Jail* and *Black Elk Speaks*. The programme runs on an IBM PS/2 computer attached to a CDROM drive and laserdisc player. Designed by AND Communications of Los Angeles, the programme features high-resolution graphics and stills, and motion-video and stereo-audio tracks, and is controlled by an elegant graphical interface. Like "Columbus", this educational programme from IBM allows students to add their own notes and images to the computer database.

Each "book" acts as a launch pad for a range of investigative approaches: to the text itself, the author's life and era, or the subject matter, as well as giving students the means to hear several different readings and examine various critical and interpretive texts.

training

The claim that hypermedia can be a powerful training medium may be treated with some scepticism by those with long memories. The cynic can point to a long list of technological innovations, from mechanical programmed learning systems to computer-based training that were supposed to revolutionize training, either making teachers or instructors redundant or requiring them to take on new roles as facilitators or managers of learning. Somehow this promised revolution has never materialized.

There are many possible explanations for the failure of technology-based training to gain the dominance predicted by its advocates, but perhaps the most crucial is the strong congruence that existed between the learning medium offered by the technology and one particular stream of learning theory, which may be loosely, if somewhat inaccurately, characterized as behaviourist. Hypermedia, by contrast, is not bound up in the embrace of one particular theoretical line.

Earlier learning technologies (because of their technological limitations) were almost bound to

be inextricably linked to particular theoretical foundations. Hypermedia, on the other hand, offers an open field capable of supporting a very wide variety of approaches underpinned by an equally wide variety of theoretical foundations. It thus embodies a breadth of possible approaches that represents a radical break with the past.

Until recently most training has been reproductive, attempting to duplicate pre-specified performances rather than providing a context for the learner to innovate or find improvements in the way a task is carried out. The aim of training has been to enable the learner to do something that someone else can already do well. While in many cases this role will continue,

another requirement is increasingly emerging: that the learner should learn to do things which no one has done before or which no one has done in quite that way before.

Hypermedia's multi-sensory capabilities and its ability to reconfigure patterns of information and experience into new patterns and relationships offers us a learning medium that is well capable of dealing with this sort of complexity. It can present traditional training material in a much richer and more interesting way than earlier attempts at educational technology.

One of hypermedia's particular strengths is that it is a superb medium for constructing simulations. This capacity for simulations can be seen to have wide implications for its role as a more general training medium. There is a sense in which all learning can be seen as simulation: it is a kind of

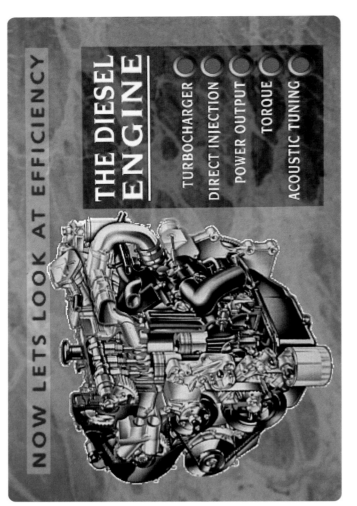

THE DIESEL ENGINE

- TURBOCHARGER
- DIRECT INJECTION
- POWER OUTPUT
- TORQUE
- ACOUSTIC TUNING

NOW LETS LOOK AT EFFICIENCY

perkins engines

ellis partners

An interactive presentation on the diesel engine, produced by The Ellis Partners for the Birmingham (UK) Motor Show on an Apple Mac using desktop video techniques. Programmes such as this can be "versioned" for presentation as linear video or as interactive hypermedia. Ellis have shown a consistently high regard for design and top-quality graphic imagery.

rehearsal for later performance, a safe context in which to practise, to explore and to develop. Real theatrical or musical rehearsals do not always work to achieve a prespecified performance, but to develop the nature of the performance as part of the rehearsal process itself.

And hypermedia appears to offer a "rehearsal medium" that can be used to construct contexts where the learner can anticipate the future. It is a medium that exploits our ability as a species to manage, organize and manipulate complexity by relating multi-sensory elements into patterns of relationship, which can themselves be changed until something new emerges. It may be that in the long term hypermedia's real significance as a training medium lies in the realm of its potential for training for innovation, rather than training as reproduction.

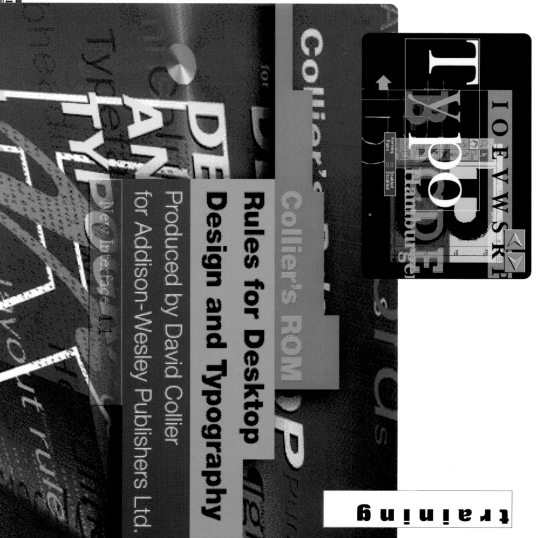

Rules for Desktop Design and Typography

Produced by David Collier for Addison-Wesley Publishers Ltd.

collier's rules

david collier

David Collier has produced an exciting hypermedia/CDROM programme based on his book *Collier's Rules of Typography*. Like the "DTP Graphic Design Mentor", Collier's CDROM incorporates an interactive glossary of technical terms as well as sections on typeface design, grids and layout. The use of multiple overlapping windows encourages cross-referencing between different elements of the programme, which features much original typography and full-colour hybrid graphics. David Collier is one of a new generation of graphic designers who works almost exclusively in electronic media, exploring the synaesthetic potential of the Macintosh, and of systems such as Philips' Compact Disc Interactive (CDI).

training

The prototype was produced in Supercard on CDROM, and comprised some 800 different information frames, which typically included text, hypertext, interactive illustration and animations, and high resolution colour and greyscale images.

The Mentor CDROM is designed as an interactive, multimedia help system for trainee DTP designers. The Mac Multifinder is used to alternate between Pagemaker and the Mentor help screens, allowing users to access design help at every level of their page makeup activity. Mentor was conceived, designed and produced by CGW personnel Richard Oliver, Asif Choudhary and Bob Cotton, and funded by the Learning Technology Unit of the Training Agency as a leading edge project. This £160,000 production took 18 months to complete, and involved research, origination and editing of content material, as well as the design and production of the interactive software itself.

training

the DTP graphic design mentor

computer graphics workshop

The brief was to produce a prototype system on CDROM. This comprised a number of modules: a menu-driven online help system, using the same menu items as Pagemaker; a "design school" module that offered sets of tutorials in ideas generation, typography, layout, colour, artwork, repro and print processes complete with interactive question and answer frames; an interactive, illustrated and animated glossary of graphics and print terminology; a section entitled "Desktop Plus" encompassing pre-DTP stages of briefing, research, design, production planning and budgeting; a collection of sample designs by professional graphic designers that could be "deconstructed" by the user to examine the design thinking (concept, choice of typefaces, colours and layout etc); and finally a module offering specific production and design help on a variety of design jobs – from simple letterheads to complete stationery ranges.

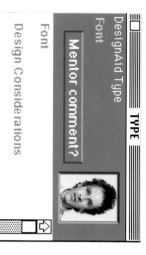

DesignAid Type

Font

TYPE

Mentor comment?

Font

Design Considerations

• Choosing a **font** or **typeface** is one of the key decisions in any DTP design. The font (or possibly fonts) you choose will, to a very large extent, determine the look and feel of your design.

• Different type of the same **point** size may look considerably bigger than another:

Avant Garde 12 point.
Times 12 point.

(This is because some typefaces have longer ascenders and descenders than others).

newsletter
master index
g
gatefold
report
reports components

Design in Action
Super Index
Super Index
Super Index
Design in Action
Design in Action

The concept of context sensitive "guides" was explored, and video animation techniques were developed to give the user a "talking head" mentor offering advice, tips and hints at various stages during the user's progress through Mentor. In the finished product, the user will be able to choose from a range of several guides – each modelled on an "experienced amateur" DTP user – to find a guide that best fits their own gender, work experience, background, type of job, and so on.

The problem of becoming "lost in hyperspace" was tackled in two ways: by recording the track or route that users take through Mentor, and providing this information in a navigation window. This list of frames can be scrolled backwards, and the required frame double-clicked instantly to return the user to that part of the programme. A second related feature called "Status" allows users instantly to see how much of the whole Mentor programme they have explored, how much of the particular subject area they have covered, and how much of the current frame they have used.

training

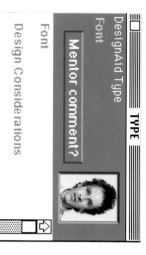

F1 for help
S to start

TRAIN DRIVING SIMULATOR

Developed for British Rail with funding from the training, enterprise and education directorate (Employment Department, UK)
Copyright (c) HMSO controller, UK 1991

train driving simulator

hodos

This DVI (Digital Video Interactive) system is designed for the training of locomotive drivers. The system uses actual control mechanisms from a locomotive cab, linked to a monitor screen which displays the view through the driver's window. The trainee driver receives voice-over comment while responding to signals on the trackside. The simulator can use wide-angle screens or videobeam projections for greater realism, but the basic system is prized for being highly portable.

Cab controls in the simulator include brake-pressure meters, a speedometer, brake-valve controls, an automatic warning system (which the trainee driver must operate whenever the train passes through an amber or red signal) and the power handle itself. DVI systems like this provide the realism necessary for effective training at a fraction of the cost of flight-simulator technology. The restricted environment of the track means that only one perspective has to be presented to the trainee.

La famille des Cartes bancaires

point of information

Point of information" (POI) and "Point of sale" (POS) applications of hypermedia are the trailblazers in the development and public acceptance of this new medium. Because both POI and POS are high-profile applications, often with large budgets attached, and because "ease of use" is a major priority here, some very innovative work with correspondingly high production values is already underway. Already applications such as the hypermedia "Micro Gallery" at London's National Gallery have been a great popular success. Museums and galleries in the United States have had similar successes, and the POI system being developed for the Barcelona Olympics in 1992 will have focused still more public attention on the potential of hypermedia.

Two wider trends make it even more likely to be a key area of development, attracting some of the most talented and innovative hypermedia developers. The first of these is mass customization. The history of industrialization has until recently been characterized by standardization and mass production. More recently, in part because of the capabilities of information technology, in part because of other changes in manufacturing technology often referred to as "lean manufacturing", it has become as easy and as inexpensive to produce a

small quantity of a product as to produce a large quantity. The logic of this process is that very soon the customer will be able to have an individual, tailor-made product for a similar price to that of a mass-produced item.

In a sense, the Micro Gallery is an early example of the mass customizing of a service. Visitors, who may be unsure of what is on offer, no longer have to join a group to be taken around the gallery by a guide, but can use the Micro Gallery to explore what is on offer and be given their own unique route around the pictures they have chosen to see.

Hypermedia, with its ability to allow associative exploration, provides an

ideal medium for the consumer to examine the possible configurations of a product or service, and to describe and specify a particular requirement. The question of where this is done is going to be one of the most interesting issues of retailing over the next few years. Is it going to be at home or is there still going to be a place for the shop or showroom? Museum and gallery custodians are already well aware that it is possible to convert POI applications into self-contained programmes for the consumer market, thereby creating extra revenue. Mail-order firms have already experimented with laserdisc and are only waiting for a suitable consumer multimedia technology to appear before they too begin to use the dynamic showcase of hypermedia for their catalogues. POI and POS applications may well open up the "home shopping" market, especially when orders can be placed electronically by simply connecting the

cash and credit card information system
banque nationale de paris

Banks have been in the vanguard in their adoption of multimedia technology for providing extra information and services to their customers. Point of information systems have a public relations role here, taking some of the strain off the human tellers, shortening queues and generally improving customer relations.

hypermedia system to a telephone. Home shopping will eventually affect the whole of high-street retailing, which will need to stress the unique advantages of "personal" service and the fact that shopping can be an enjoyable social occasion in order to survive. Wherever people shop, the link between the consumer and producer of a product or services seems certain to become more direct.

This shortening of the line between producer and consumer has been given the name of "disintermediation". This is the second wider trend that is likely to speed the adoption of hypermedia in POI and POS. Just as the history of industrialization is a story of increasing standardization, so too it was characterized by an

ever growing number of layers of intermediaries between the original producer and final consumer.

Production companies have already taken advantage of disintermediation, designing and manufacturing high quality products and selling them directly by mail order to their users. The attraction to consumers is that they do not have to pay for the costs and "mark-ups" of all the people layered between them and the producer. The producer, on the other hand, can sell a high quality product or service at a lower price and still make a good profit.

Hypermedia, with its ability to present information in multisensory modes, to enable associative

exploration of that information and, potentially, to provide direct interactive communication between producer and consumer, will allow these two trends of mass customization and disintermediation to accelerate. Because hypermedia will provide the link between consumer and producer, heavy investment in hypermedia POI and POS systems will be seen as having direct measurable value and it is in these areas that the new rhetoric of hypermedia will develop most rapidly.

holiday destination system

mediavision

Travel agents have to cope with a wide variety of general queries, as well as dealing with customers who already know where they want to go. POI systems can provide a valuable in-shop resource, effectively providing an additional "member of staff" to handle these queries. Ease of use is an absolute necessity in POI hypermedia. This system was designed by Mediavision for Arke Travel in the Netherlands.

salespoint console

M&MT

Point of information consoles are designed to provide attractive and robust units that effectively "frame" the system software. Many consoles feature touchscreens or pressure-sensitive pads for user input and control. Consoles can be especially designed to reflect the styling of the programme graphics, or else standard units can be customized with corporate colours and logotype. This is the "IQ Salespoint" console from M&MT.

Music & Entertainment

12	15	More?
11	14 (ELECTRIC AND MUSICAL INDUSTRIES LIMITED)	Calendar
10 (Scheherazade)	13 (HIS MASTER'S VOICE)	Menu
16 (EMI)		

sight and sound

fitvision/RAM

A pictorial menu features numbers that identify the actual exhibits. Selecting one calls up linear sequences of related information. These may include archive movie clips, stills, pop videos, television idents, newsreel footage and sound tracks.

The "dataframes" feature an image (some digitized in 8-bit colour, some delivered "live" from videodisc), a title panel and a text panel. The calendar and menu frames can be accessed from all dataframes. More information is available if the "more" button is flashing.

point of information

Thorn EMI's Sight and Sound exhibition, on permanent display at their Central Research Laboratories, covers all their major contributions to television, entertainments, radio, sound, lighting, radar, computer-aided tomography and security systems. The interactive exhibition catalogue allows visitors to find out more about the exhibits by calling up text, stills, CD audio tracks and motion video clips. The programme also includes a "calendar" (chronofile) section, that enables users to access information in chronological order (by decade), along with "pages" of contemporary current affairs items.

The hypermedia catalogue uses seven Mac IIsi computers linked to Sony laserdisc players. A CD player is also attached for the music clips in the entertainment section. The programme was developed in Supercard, and is driven by a custom-designed pressure-sensitive keypad, which echoes the graphic style of the interface buttons layout. Point of information systems like this add tremendous value to a static exhibition by encompassing a wide variety of contextual multimedia information.

Music & Entertainment

		More?
		Calendar
Menu		

Controls are simple, mainly because of the ergonomics of the exhibition display, and are kept as easy and as "idiot-proof" as possible. Replacing the mouse with a pressure-sensitive pad that echoes the screen interface design solves both these problems.

Music & Entertainment

1980-1989

CURRENT AFFAIRS		
1980	2	More?
0	1	Calendar
PMI (PICTURE MUSIC INT'L) 3		
Menu		

multimedia 91 exhibition guide

david collier

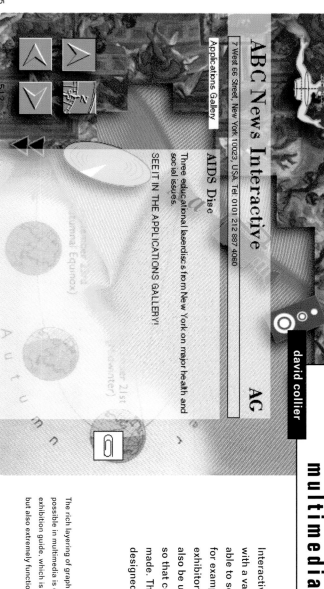

ABC News Interactive

AG

7 West 66 Street, New York 10023, USA. Tel: 0101 212 887 4060

Applications Gallery

AIDS Disc

Three educational laserdiscs from New York on major health and social issues.

SEE IT IN THE APPLICATIONS GALLERY!

512

Interactive exhibition guides like this provide users with a variety of "search" mechanisms which are able to search by company/exhibitor, or by product, for example. Such systems must indicate where the exhibitor's stand is and how to get there, but may also be used to provide lists of exhibitors by category so that comparative product assessments can be made. The Multimedia 91 exhibition guide was designed by David Collier/Decode design.

The rich layering of graphic images and text that is possible in multimedia is evident in Decode's exhibition guide, which is not only good-looking but also extremely functional and user-friendly.

Categories

Dealer or VAR
Publisher
PC/Workstation mfr
Production/Consultancy
Video Equipment
Authoring software

505

MULTiMEDiA 91

Floor Plan

Exhibitors A-Z

Categories

Applications Gallery

Conferences

About this guide

point of information

hong kong airport

interoptica

This trilingual (English/Chinese/German) programme on CDROM for the Hong Kong Government is designed to inform the public about plans for the new airport at Chek Lap Kok. Maps and plans show the site, and extra details, artists' impressions and photos of the area can be called up through this hypermedia programme, which was developed in Macromind Director 2.0. The delivery system comprises Mac IIcx computers with touchscreens, RasterOps 364 video cards, NEC CDROM drives and Pioneer videodisc players. These have been taken around the world to trade shows and exhibitions in order to promote the idea of the new airport, and to "inspire confidence in the future of Hong Kong". InterOptica was founded in 1990 to author and publish CDROM titles for both Mac and personal computer platforms for the educational and consumer markets.

东涌及赤鱲角南貌

1/3

There is a simple touchscreen on which to choose the language for the presentations, and then to access a main menu of options. This offers a short film about the airport project, textual information, or a help sequence to guide user through the programme.

The "Information" option lets users choose from a range of who?, what?, when?, where?, why? and how?-type questions. This is the Chinese language version.

Users can choose from any of the ten key projects (each with six individual categories). The different ways of "interrogating" the system (options such as who?, what?, how?) are presented along the bottom of the screen.

point of information

NG
PAINTING
CATALOGUE

'The Rokeby Venus'

Venetian Source

Cupid
Cupid is the god of Love; in Latin he is called Amor, and in Greek, Eros. The god is usually shown as a male, winged child who is seen as the son of Venus. His attributes are a bow, arrow and quiver. The arrows are fired at those who will become lovers.

He often does not play an active part when pictorially represented, but is included to signify the importance of love to the major narrative shown.

The motif of *Cupid [...] such pictures in mirror for Venus der[...] [R]oyal Collection. the Venetian traditio[...] [coll]ected works by Venetians also paint[...] [reclini]ng mythologies full-length reclining [...] [Venus and] Adonis.

Velázquez has not used the *classical proportions of Italian figures, but has adopted Venetian colouring and Titian's fluid handling of paint.

The Rokeby Venus

☐ *Venus and Adonis* TITIAN (NG)

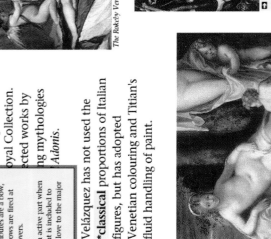

☐ *Nymphs and Children in a Landscape*

Venus with Cupid TITIAN
Thyssen Collection, Lugano

HELP PRINT TOUR

NG
PAINTING
CATALOGUE

'The Rokeby Venus'

VELÁZQUEZ
Probably 1647-51

Full title "The Toilet of Venus"
Canvas, 122.5 x 177 cm
No. 2057, Presented by
the N.A.C.F. 1906.

This is the only suviving example of a female nude by Velázquez. It was a rare subject in Spain because it met with the disapproval of the *Inquisition.

The Rokeby Venus is first recorded in June 1651 in the collection of the Marquis del Carpio, son of the First Minister of Spain. It was probably made for him; the commission must have come from someone near the King to have avoided censure.

It is known as 'The Rokeby Venus' because it was in the Morritt Collection at Rokeby Hall in Yorkshire before its acquisition.

Room 29

NEXT PAGES... *Commission and Pendant;*
Venetian Sources; Influence on Goya;
The Mirror; Paintings of Women.

The interface design uses plenty of white space to frame the paintings, and elegant typography for the text panels and captions. Linking buttons (marked on screen with a small arrow) connect users with related paintings and text, and a "pop-up" glossary is available on words marked by an asterisk.

the micro gallery

cognitive applications

The Micro Gallery, part of the London National Gallery's Sainsbury Wing opened in 1991, allows visitors to explore information on over 2200 paintings, and to devise a personal "tour" around the gallery to see the actual paintings they are interested in. The Micro Gallery itself consists of full-colour reproductions of the paintings, over 1000 secondary illustrations, dozens of animations, and some 300,000 words of supporting text. The material is displayed on special high-resolution 19-inch colour monitors with touchscreens that allow people with no experience of computers to explore easily and naturally the information contained in the programme. The Micro Gallery took three years to develop, employing a full-time team of research, editorial, layout and image-processing staff based in the Education Department of the National Gallery, working with Cognitive Applications Ltd who provided production management, software design and construction.

Ancient Myth and History

These pictures are derived from ancient Greek and Latin sources. They depict fiction - mythical events like the encounter of Apollo and Daphne - and events told by historians, such as *Trajan and the Widow*.

This type of painting became very popular in 15th century Italian art for domestic decoration, on panelling, bedheads, chests, etc.

From about 1500 the same themes are increasingly depicted on the scale of life, whether mainly for private enjoyment ☐ **Titian's** *Bacchus and Ariadne*) or persuasion and edification (☐ **Veronese's** *Family of Darius*).

point of information

Micro Gallery demonstrates that book-quality, full-colour graphics can work well in point of information systems. The graphic designers have produced screen graphics in keeping with the National Gallery's high standard of printed catalogues and guides.

The system supports a range of 256 colours. Slides of the original paintings were scanned and saved digitally, and considerable ingenuity was used to develop a colour palette that was consistent for all the paintings. (If images in systems like this do not share a single palette of colours, unsightly colour changes can occur as screens are changed.)

Diego VELAZQUEZ

1599 - 1660
Spain

Detail of self-portrait
from *Las Meninas*
VELAZQUEZ
The Prado, Madrid

Velázquez was the greatest Spanish painter, and a major figure in European art. Prized in his own time, his work has influenced artists up to the present day. ☐ **Manet** called him 'The painter of painters'.

His ***technique*** evolved from the tightly painted *Christ in the House of Martha and Mary* to the loosely brushed mature works such as *Philip IV in Brown and Silver*.

ARTISTS A - Z

☐ *Christ in the House of Martha and Mary*
VELAZQUEZ
probably 1618

☐ *Christ after the Flagellation*
VELAZQUEZ
probably 1630-1

☐ *Christ in the House*
VELAZQUEZ
probably 1618

☐ *Archbishop Fernando de Valdés*
VELAZQUEZ
painted 1640-5

☐ *Philip IV of Spain in Brown and Silver*
VELAZQUEZ
about 1631-5

☐ *St John the Evangelist on Patmos*
VELAZQUEZ
about 1618

☐ *The Toilet of Venus*
VELAZQUEZ
probably 1647-51

☐ *Philip IV of Spain*
VELAZQUEZ
probably 1655-60

☐ *The Immaculate Conception*
VELAZQUEZ
about 1618

☐ *Philip IV hunting Wild Boar*
VELAZQUEZ
about 1656

HELP | PRINT | GO BACK | NEXT PAGE → | SEE ALSO | INDEX

1 of 3 pages on VELAZUEZ
Artists A to Z

the tate gallery

bit 32

sculpture interactive

Conceived as an educational tool for making works of modern sculpture more accessible to the general public, "Sculpture Interactive" was devised by the Tate Gallery in Liverpool and Martin Wright of the BBC Open University production centre. The interface, programming and programme structure were designed and produced by Roy Stringer of Bit32.

Generally, works of modern sculpture are presented in galleries with little or no explanation or historical reference, and many people find it difficult to relate to them. "Sculpture Interactive" addresses this problem by providing a multimedia learning environment in which the user can explore a series of audio-visual "essays" incorporating vocal and written explanations by curators, artists and art historians, offering a range of contextual material to inform the user. The intention is to enrich visitors' experience of the gallery by providing information that will help people increase their understanding of "Modernist" sculpture. The result is a programme that is easy to use, and that also allows further "essays" to be written and added by gallery staff.

Hypermedia point of information systems can be extremely effective without the extra media resources of laserdisc or CDROM, but when hi-fi stereo audio and near-broadcast-quality video and stills are added, programmes can become dynamic information carriers, combining ease of use with multiple perspectives.

Running on a Macintosh computer attached to a laserdisc player and touchscreen video monitor, "Sculpture Interactive" comprises a hypermedia programme (prepared in Hypercard and then developed in Supercard) containing text and graphics, through which the user can access the 6000 stills and stills sequences, 28 minutes of video sequences and 70 minutes of radio (audio) material stored on laserdisc.

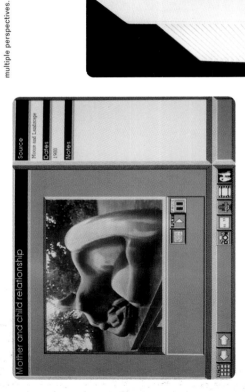

Visitors to the Tate Gallery in Liverpool use "Sculpture Interactive" before seeing the real sculptures on display. Using the "surrogate travel" techniques available within the programme, they can "walk" around Henry Moore's studio, view the sculptures from a variety of perspectives, look at the artist's working sketches, maquettes and drawings, listen to recorded interviews with the artist, and watch excerpts from television interviews.

Three Points — Artist: Henry Moore — Dates: 1939–40 — Material: Bronze 140 x 190

Black Crab — Artist: Bernard Meadows — 1952 — Materials / Size: Bronze 425 x 340 x 241 mm — Notes

Mother and child relationship — Source: Moore and Landscape — Dates: 1988 — Notes

point of information

3T productions

windsor safari park

Giraffes are to be found in wooded grassland, south of the Sahara Desert, in Africa.

Visitors need lots of time to explore large theme parks. Those whose visits are limited need to know quickly what is on offer and how to get there. Windsor Safari Park goes one step further with this 3T Productions programme for their Education Centre. Visitors can access a wide range of audio-visual information on the animals to be found in the Park, and test their knowledge with a pictorial quiz. Designed to run on an Acorn Archimedes computer, this POI system uses laserdisc and touchscreen monitors.

Accessing information on holiday resorts should be easy and intuitive, and this format offers a sort of atlas of possibilities. Users select a country, then a region of that country, and finally a resort area. Hotels are previewed with stills of the location, rooms and facilities, as well as information on the local area, the price range of rooms, and booking procedures. This simplified "surrogate travel" approach allows users quickly to survey what is on offer, before getting more detail from the programme's "information icon".

world at your fingertips

leigh cole

This award-winning student project designed by Leigh Cole encompasses some innovative ideas for holiday planning. Designed to be used both in POI and at home, the programme allows users to browse through holiday options that can be tailored to fit their own interests and favoured activities. Such a system could be extended in a POI location to include on-line access to current prices, allowing users to select the amount of money they wish to spend, and then to preview those holiday packages that fall within the selected price range.

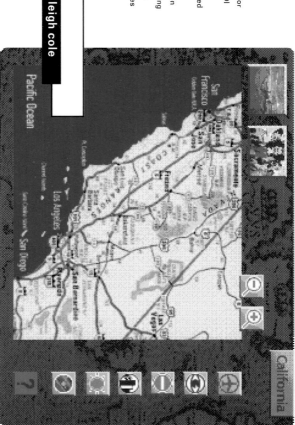

holiday information system [prototype]

This prototype was developed in seven days (using Aldus Supercard) for a client presentation illustrating the potential of point of information products in the travel agency business. From a map of Europe, the user can select a country, then a region within that country, and can then survey a range of hotels in the area, checking prices throughout the season, looking at typical rooms and leisure facilities, and accessing general information about the resorts featured. Presentations like this can crystallize an idea in a way that no other media can, providing the client with a working model of the kind of programme that is being discussed, and building a bridge across the gap between concept and actuality.

point of information

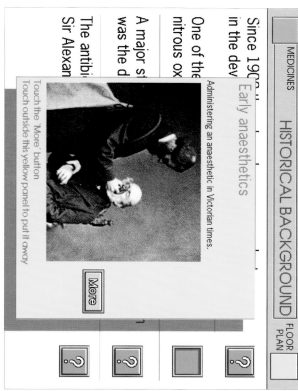

HISTORICAL BACKGROUND

MEDICINES

FLOOR PLAN

Early anaesthetics

Since 190...
in the dev

One of the
nitrous ox

A major s
was the d

The antibi
Sir Alexan

Administering an anaesthetic in Victorian times.

Touch the 'More' button
Touch outside this yellow panel to put it away

More

WHAT THEY ARE USED FOR

SOLAR PANELS

FLOOR PLAN

◁))) Photovoltaic cells can be used in many ways

Solar powered vehicles

Pumping water

Lighting systems

Leisure

Electric networks in isolated areas

Solar powered refrigerators

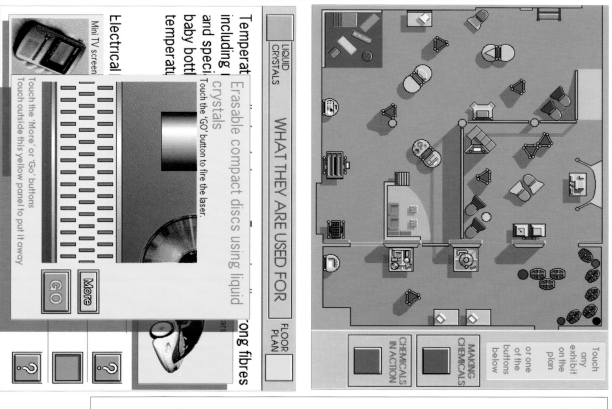

WHAT THEY ARE USED FOR

LIQUID CRYSTALS

FLOOR PLAN

Electrical

Mini TV screen

Temperat
including
crystals
and speci
baby bott
temperat

Erasable compact discs using liquid

Touch the 'Go' button to fire the laser.

Touch the 'More' or 'Go' buttons
Touch outside this yellow panel to put it away

GO

More

...ong fibres

Touch any exhibit on the plan
or one of the buttons below

MAKING CHEMICALS

CHEMICALS IN ACTION

catalyst

cognitive applications

With its mix of graphics, images, sounds and text, hypermedia provides a perfect tool for point of information. This programme from Cognitive Applications demonstrates how even complex subjects, such as chemistry, can be explained using a colourful, informative and easy-to-use interface. Designed for the Museum of the Chemical Industry in Cheshire, England, this programme covers many aspects related to the manufacture and use of chemicals.

point of information

corporate information

Hypermedia is both an adaptable communications medium and a tool for managing complexity that allows the assembly and manipulation of a mass of disparate multisensory information.

These key factors underlie the development of hypermedia systems for corporations, simply because information is becoming a critical resource for competitive advantage. In the corporate context information can be described as anything that alerts us to the need for action and gives us the facts we need to respond intelligently. Thus "information" (the facts and figures we can act upon) can be distinguished from "data" (the raw material that only becomes "information" when it has been processed and edited, and presented in a form that is relevant for the decision maker).

Over the past two decades the time scale in which corporations operate has changed dramatically. Decisions have to be made more frequently and more quickly than in the past, because the corporate environment has become more volatile and complex. At the same time the volume and rate of flow of data has increased several fold. Managers talk of the problems of

PGM encyclopedia

A leading international precious metals company, Johnson Matthey, specializes in platinum group metals (PGM), and over the years has built up a valuable resource of research information. The PGM Encyclopedia was designed as an interactive multimedia publication to disseminate this information to the company's operating divisions in a user-friendly form.

Running on a PC with Windows 3.0, the Encyclopedia uses Asymetrix's ToolBook (a hypermedia program that runs on both Apple Macs and PCs). The system incorporates entries on hundreds of material properties, elements, alloys and products. Entries can contain a variety of text, graphics, diagrams, data tables and pictures, which are comprehensively cross-referenced. These entries are stored with source reference information for quality control and audit purposes. The system is also used by Johnson Matthey's client representatives to "check material properties, calculate quantities, volumes and prices, compare material performance and select materials that meet a given specification".

The PGM Encyclopedia was developed by Johnson Matthey's research centre together with Cognitive Applications Ltd. and is edited by the Platinum Materials Group. The system provides an elegant example of how functional and easy-to-use databases of technical information can be.

corporate information

"information overload", meaning, in most cases, that they are being swamped with different media types, while providing the editorial control necessary for the tailoring of presentations to different audiences.

By making the "language" of hypermedia more familiar (and less of a culture shock), its use as a presentation medium within the corporate context should ease the adoption of more complex

data. Hypermedia, with its capacity to use more of our senses, and its ability to allow us to move freely among apparently disparate material, may prove the crucial element in transforming data into information at the speed now required.

The shrinking time frame in which today's corporations now operate can be turned to competitive advantage if information technology is used to increase the information content presented to decision makers instead of drowning them with data. It is this imperative that is likely to motivate the development of very sophisticated hypermedia communications and management systems for corporate use.

But the first widespread application of hypermedia in the corporate sector is likely to be simply as a presentation medium. Depending on the size of and importance of the audience, these presentations will either be produced by media professionals or by the corporate presenters themselves, using hypermedia "kits". Such kits will provide easy to

use tools for the assembly and integration of hypermedia communication, and management systems. There are a number of communication, database and management information systems (employing a variety of multimedia techniques) that are already in use on a day-to-day basis in research laboratories around the world. The major obstacles to their adoption in corporate life are cultural and social rather than technical.

In the early 90s, newspapers and periodicals began to publish annual editions of their publication in database form on CDROM, providing their readers, and professional writers and researchers, with the information contents of an entire year's issues in a convenient, portable and easily searchable form. CDROMs like this can be accessed through a personal computer. ZapFactor's programme provides the user with a database of business and finance graphics from the *Financial Times*, that can be searched by subject, type of graphic (diagram, map, bar chart etc), or by keyword. The graphics are copyright free, and are stored in Postscript form, so they can be edited and customized by the user.

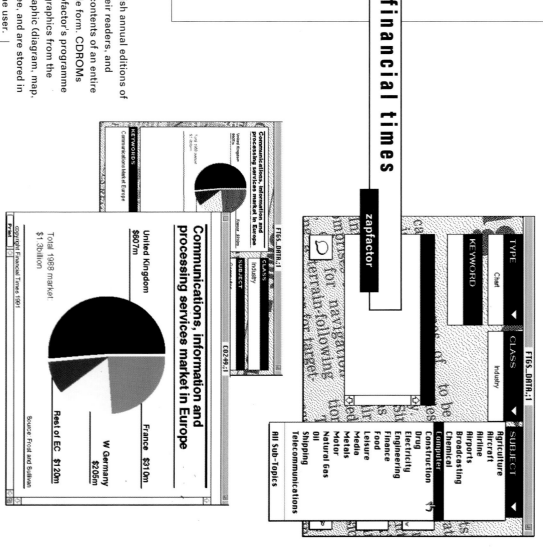

focus

joe gillespie/pixel productions

This elegant programme by Joe Gillespie for Pixel Productions, is for use in Apple dealerships, to assist staff in dealing with customer requirements. For example, customers with a fixed budget can be shown the variety of systems and software configurations that will meet their needs. The programme allows users to enter their total budget, select items that they want, and check the balance as the prices mount up. The interface is clean and uncluttered, and still manages to contain a wealth of features that not only assist the dealer but also impress the customer with what can be produced on the computer. Joe Gillespie, a graduate of the Royal College of Art, London, worked as a graphic designer in advertising before concentrating on electronic media. He combines design and programming skills to produce hypermedia programmes and applications for clients such as Apple and Videologic.

Selecting "Desktop Publishing" accesses this frame, where page composition applications for the Apple Mac can be compared for features and price. The features panel on the left lists features, and the arrows indicate which are available in the product highlighted in the centre screen panel (Quark Xpress in this case). Note that all the salient information is immediately to hand, including the minimum specification of computer processor and random access memory that will run the program. The budget panel shows the total budget and balance after items have been selected.

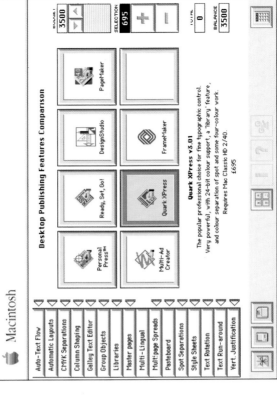

corporate information

european business guide

philips

Portable computers, telephones and CDROM drives open up opportunities for extending the range of information facilities that have previously been confined to the office. CDROMs provide individual access to very large databases at a fraction of the cost of on-line connections. With the memory resources of a mainframe containable in a briefcase, many information-retrieval operations become possible on remote sites. This European Business Guide by Philips offers immediate access to demographic data, economic statistics and other business information on the member countries of the European Community.

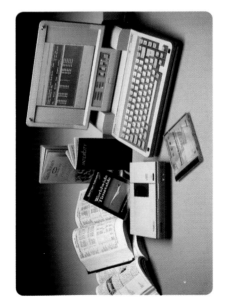

Emergency Response systems take several forms. This one is map-based and features full-colour, high-resolution frames of Admiralty charts and Ordnance Survey maps at a variety of nested scales. Designed by Peter Burnell for Synergy, the system offers a multimedia interface, capable of displaying motion and still video, photographs, satellite images, pipeline schematics and terminal layouts as well as windows of database information.

In the "Sullum Voe" prototype system, the user is able to locate and "zoom" into the required location at the required scale within one or two seconds (two or three mouse clicks from a "control" map covering northwest Europe). The map and chart images are stored as broadcast-quality analogue frames on a 30cm laserdisc. Also stored on the laserdisc are 3d computer-model animations, hundreds of still photographs, plans, drawings and chartlets, and several sequences of live-action video shot from a helicopter, giving an aerial view of the coastline of the Shetlands adjacent to the Sullum Voe terminal.

The prototype system was designed to offer emergency control officers instant access to map and picture information pertaining to the Sullum Voe terminal itself, and the surrounding coastline of the Shetlands. Access to required map information is less than two seconds (compared with several minutes for retrieval of relevant paper charts, information, pictures etc). The prototype system interface was configured to include "windows" for telecoms (a "viewphone" system), network access, "blast effect" simulation/modelling software and a projected set of tidal-flow animations for oil slick tracking/prediction.

SULLUM VOE ERS

VIDEO DIAGRAM STILLS

sullum voe emergency response [prototype]

synergy multimedia

SULLUM VOE ERS

corporate information

Apple computer service engineers require quick and easy access to reference diagrams of machine parts and parts numbers. The APLS system (designed by Cognitive Applications) provides several ways of of identifying and locating the required part: by free-text search (typing in the word you wish to look for), through diagrams, by category and by assembly. These methods are interlinked, so that a part identified by one search can be confirmed by another, for instance by a photograph or diagram of the part in situ.

The APLS system covers over 1800 components in more than 40 machines, with around 800 image screens and over 4000 "hyperlinks" between items. The system is updated every quarter, and is designed to allow for a high degree of automation in the updating process, which can often take as little as 10 days.

APLS is distributed on CDROM, and Cognitive Applications point out that "this form of electronic publication is extremely cost-effective for the distributor and time-saving for the end-user".

apple parts locator system [apls]

Presentation

Sonja Garsvo
Apple Computer U.K. Ltd

Help Contents

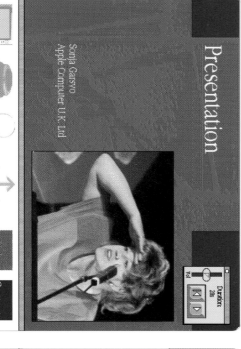

Duration
20s

Editorial
Written by Carey Green

This newsletter is intended not just as a reminder for the 300 people who were lucky enough to attend the 1989 Apple Europe Management Meeting, but also as an easy to read account of the conference highlights for the remaining 700 employees of Apple Europe who did not get to Munich.

By presenting the information in the form of a newsletter we hope you will find it interesting and informative. We also hope that, for those who did not attend, that you will get a flavour of what happened at the meeting, and that by the time you have finished reading this newsletter you will feel as inspired as those who did attend.

Communication among employees is something Apple Europe is currently striving to improve, and something which was discussed

Help Contents

future uses of
hypermedia/CDROM systems

munich 89

working knowledge transfer

Working Knowledge Transfer, together with Graham Howard and Rob Bevan, devised this programme in response to a request from Apple Computers for a method of disseminating the proceedings of their 1989 company conference to employees who could not attend personally. The hypermedia programme is embodied on both CDROM and Laserdisc, which are used side by side and controlled from a Mac. The entire conference was recorded on video, and the programme allows the user to access the video sessions alongside text transcripts of the papers, and background information on the company, it's strategy and the speakers themselves.

CDROM is especially valuable in situations where access to large databases is required, but telecom connections are difficult or not available. Oil prospecting provides a good example: remote drilling rigs often have no immediate access to the (human) mineralogy expertise necessary to interpret their core samples. An "expert system" stored on CDROM, and combining high-resolution pictures of samples with an easy-to-use diagnostic program can provide instant, on-site guidance for the rig manager, with considerable savings of time and money. Another

example is the provision of CDROM parts catalogues for aircraft or vehicle maintenance in remote locations. Complete paper catalogues of parts for an aircraft often run to several tens of volumes of heavy and bulky documentation. CDROM can store this information on a disc weighing a few grammes, and provide quick-search tools for the retrieval of text, diagrams and photographs. The use of graphical interfaces (employing simple "point and click" techniques) in such systems means that training time is minimal, as users no longer have to learn the often complex access codes and search procedures that are a feature of on-line databases.

Arcade and coin-op games manufacturers are developing multimedia formats based on hard disc and compact disc storage, and utilizing Digital Video Interactive and similar compression/decompression technologies. If arcade game producers had focused on a broader spectrum of the market, then arcade games would be the arbiter by which future domestic hypermedia products would be judged. This is not the case, but there are lessons to be learned. So far, programmers and game designers in this area have been at the forefront of interface design, realizing that their target market is that large

proportion of the population that has no previous experience of computers. Even complex games are designed to be easy to learn and use, and continue this facility with the creative use of high quality illustration, animation and programming.

The adventurous interfaces so far explored by arcade game designers have included all the devices that form the mainstay of hypermedia programmes. These include simulation, where the user has to control a situation in which adequate decisions must be made in order to "survive", be this in a flight simulator, or driving a Formula One car in the Monte Carlo rally, or playing God in a

arcade games to infotainment

infotainment

game of manipulating genetic evolution. Other devices also challenge the user, such as the maze or the map interface, in which cartographic and topographic devices are used as a way of navigating through the game. In role playing games, the user adopts a proxy character and has to complete a quest or mission against a series of adversaries. Further to this are the quiz formats, where a variety of techniques are being developed for asking and answering questions. The multimedia methods for formulating visual, audio, textual, sensual and visceral questions, and for providing the user with a variety of multiple choice, string searching and inferential modes for answering these questions, provide a baseline from which hypermedia programme design can develop.

While there will probably always be a market for "shoot-em-ups", maze games and role-playing adventures, it is likely that as the current generation of games players mature there will be an increasing demand for software that stretches the intellect as well as the emotions. Programmes may well combine the visceral fun and excitement of videogames with the educational potential of hypermedia. Such "information leisure" programmes will blend education and entertainment, and many of the examples included here contain features which point the way towards such products. At their best, hypermedia programmes will recreate the age-old concept of interactive communication, returning us to the mode of storytelling that was illustrated dramatically with pictures, songs, poetry and gesture, and told "live" to an audience free to interrupt, to ask questions, and to engage in dialogue with the story teller.

virtual egypt

black dog productions

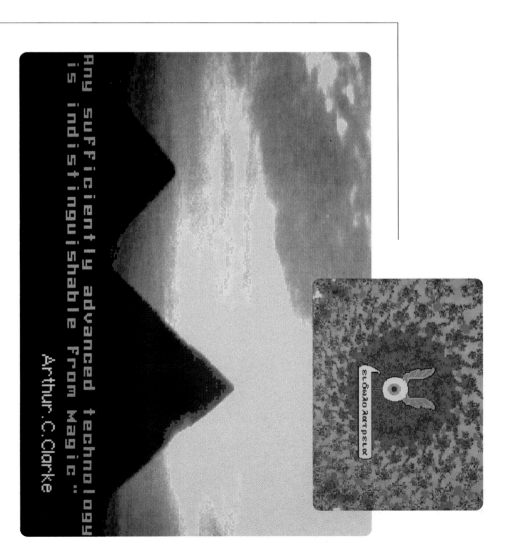

"Any sufficiently advanced technology is indistinguishable from magic."

Arthur.C.Clarke

A programme supplied by Black Dog Productions, a small production company that specialises in audio-visual media and interactive software, "Virtual Egypt" combines surrogate travel with excursions into the mythology of ancient Egypt.

INDEX

desert storm

warner new media

the first draft of history

infotainment

This CDROM features all the articles produced by *Time* magazine on the war in the Gulf. With the "Desert Storm" format, *Time* have developed an amplification of their printed magazine into interactive multimedia. Since all the text and pictures from *Time*'s coverage were easily accommodated on less than ten per cent of the CDROM, *Time* have included a range of other features: all their correspondents' files covering the war (including unedited reports, and personal profiles of Saddam Hussein and other key figures); schematic maps of the Gulf area; a glossary of high-tech weapons; 300 photographs by prominent photojournalists, and an "active timeline" (a chronofile of the war, week by week). The programme has been produced by Warner New Media, who have combined an easy-to-use graphical interface with a style of treatment akin to that of broadcast television news coverage, with high-quality graphics and animation. The disc contains more than six thousand different screens of information, all indexed by subject-matter and by chronology.

"Desert Storm" indicates how traditional print publishers are exploring the potential of electronic publishing. Not the least remarkable aspect of this joint venture is the speed with which the project was turned round; the programme was published in April 1991, just a few weeks after the end of the war. As Dick Duncan of *Time* points out: "We published practically overnight in a medium that typically takes six months to a year to create a finished product. We assembled information chronologically since the UN's January 15th deadline, encoding it for the disc as quickly as we could."

Warners have developed a multimedia news format that brings the intimacy that people expect from a magazine such as *Time* to electronic publishing. Stan Cornyn of Warners explains: "That means layers of depth beyond the one-time experience of news. We hope this 'first draft of history' will present the news as never before."

Running on the Macintosh with a CDROM drive, "Desert Storm" is an invaluable resource for education, providing the materials not only for an analysis of the war itself, but for media studies on how that war was covered by the pre-eminent American news magazine.

The Calendar spans the eight weeks of the war. Users can step through this chronologically, or browse backwards or forwards through time to items that are of particular interest.

Week 3: January 21 to 27

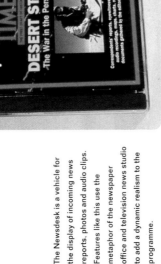

The Newsdesk is a vehicle for the display of incoming news reports, photos and audio clips. Features like this use the metaphor of the newspaper office and television news studio to add a dynamic realism to the programme.

Musicolor is a CDTV programme produced by Virgin Games, aimed primarily at younger children. It is based on the work of Candida Tobin, who has developed her system of teaching music over the last thirty years. The system utilizes colour and simple mnemonic devices to help children (or adults) learn about music and music theory in an engaging and effective manner. The accent is on having fun while you learn.

The Musicolor CDTV features a series of 15 highly interactive lessons on rhythm, pitch, chords, harmony, key signatures and time signatures. By the end of the lessons, the user should be able to compose simple tunes using the programme's built-in composition template. The programme is prefaced by a set of voice-over tutorials that guide the first-time user through a series of simple tasks (colouring a picture, moving objects around the screen etc) that introduce how the remote control is used to move the cursor, activate icons and drag on-screen images.

Designers Steve Clark and Tony Green used Hypercard to plan the programme structure, developing the contents, graphic roughs and interactive potential of each of the Musicolor lessons. The voice-overs and theme song were professionally recorded onto digital audio tape.

musicolor

virgin games

infotainment

The Church of Saint Anne in the Muslim Quarter of the Old City

Quit

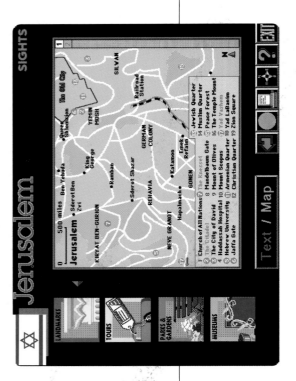

Jerusalem

SIGHTS

EXIT

Text / Map

LANDMARKS TOURS PARKS & GARDENS MUSEUMS

Jerusalem The Old City

500 miles Ben Yehuda SILWAN

YEMIN MOSH Railroad Station

Queen Shlomzion

Sderot Ben Zvi King George GERMAN COLONY

KIRYAT BEN-GURION Ramban

Sderot Shazar Emek Refaim

REHAVIA Katamon GONEN

Hapalmach

NEVE GRAMOT

1 Church of All Nations 7 The Knesset 13 Jewish Quarter
2 The Citadel 8 Mandelbaum Gate 14 Muslim Quarter
3 The City of David 9 Mount of Olives 15 Peace Forest
4 Haddassah Hospital 10 Mount Scopus 16 The Temple Mount
5 Hebrew University 11 Armenian Quarter 17 Yad Vashem
6 Jaffa Gate 12 Christian Quarter 18 Yad LaBanim
19 Zion Square

Jerusalem

ENTERTAINMENT SLIDE SHOW TRAVEL PLANNER

RESTAURANTS RECREATION SHOPPING

FAST FACTS CULTURE HOTELS
TIME CURRI

QUIZ TRANSPORT SIGHTS

EXIT

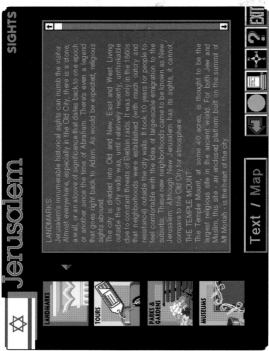

Jerusalem

SIGHTS

EXIT

Text / Map

LANDMARKS:
Jerusalem's innumerable historical sights can numb the visitor. Almost everywhere, especially in the Old City, there is a stone, a wall, or an alcove of significance that dates back to one epoch or another since the time of Abraham. There's even a legend that goes right back to Adam. As would be expected, religious sights abound.

The city is divided into Old and New, East and West. Living outside the city walls was, until relatively recently, unthinkable due to constant threats of Beduin raids. It took 10 years (or people to feel comfortable with the idea of large-scale emigration to the suburbs. These new neighborhoods came to be known as New Jerusalem. Although New Jerusalem has its sights, it cannot compare to the Old City for atmosphere.

THE TEMPLE MOUNT:
The Temple Mount, at some 40 acres, is thought to be the largest religious site in the ancient world. For both Jew and Muslim, this site -an enclosed platform built on the summit of Mt Moriah - is the heart of the city

LANDMARKS TOURS PARKS & GARDENS MUSEUMS

infotainment

A CDROM programme intended for the education and consumer markets, "Great Cities" provides a comprehensive coverage of ten of the world's major cities. Designed by InterOptica, a Hong Kong-based company developing multimedia programmes for the Apple Mac and personal computers, this disc is the second in a series of programmes comprising a Multimedia Travel Encyclopedia for the personal computer. Travel programmes are a big growth area for interactive media. People are used to maps, and the map-based interface is intuitively understandable; users can just point and click on the area of interest. Being able to "zoom" through a series of maps in progressively larger scales, right down to a street map of the city, and then choosing from the familiar "tourist map" icons to access pictures and text information on items of interest, are concepts that are grasped immediately by most people using the programme for the first time.

great cities of the world

interoptica

halliwell's interactive film guide

Well-designed hypermedia can add considerable value to print products, especially reference works such as encyclopedias and guide books. In this version of *Halliwell's Film Guide*, designed by Random Access Media with graphics by Mark Bowey, several features are available that are unique to hypermedia. The listings of film entries can be browsed through or searched in a number of different ways including, for instance, a simple "find" function for the quick retrieval of an item of interest; "browsing" by scrolling rapidly or slowly through the titles; searching using Boolean operations (where a number of search criteria can be strung together) and "associative linking" - instant searches on any of the personnel listed in the side panels of the film entries.

"Halliwell's Interactive" also features stills and publicity shots from several hundred movies, and RAM plan to produce future editions with "guided tours" featuring stars, film critics and cineastes introducing their 100 favourite movies; a chronological guide to the most significant films in the 14 or so genres featured in the Guide; extra stills, movie clips and sound-track excerpts of dialogue and music; and an audio-visual movie quiz.

RAM favour development tools such as Supercard, used in conjunction with fast, custom-built database software. In the past databases have been complicated to use, and typically deliver text-only information within an unattractive screen design. Applications such as "Halliwell's Interactive Film Guide" demonstrate that this need not be the case and that functionalism can be combined with fun.

infotainment

Hypermedia programme design is a team effort. Consider "Halliwell's" as an illustration of this. Producer Graham Fletcher and Associate Producer William Beckett had to put together a team comprising hypermedia designer, graphic designer, picture researcher, production manager, programmer, typeface designer and audio engineer. "Halliwell's Interactive" uses Supercard and a database developed based on programming tools from HyperHit.

Power Search

Wim Wenders · and Road Movies · and

Select · Cancel

title · release date · country of origin · colour process · production co · distribution · producer · star rating · awards · nominations · format · running time · director · editor · writer · photography · music · music director · special effects · cast · book · art director · production des · language

HALLIWELL'S · 1984

Paris, Texas

release
Paris Texas
release date 1984
production co /studio Palace Pictures
distribution Palace Video
country of origin W. Germany/France

HALLIWELL'S

Wild at Heart

Power Search · Movie List · Paris, Texas

HALLIWELL'S · 1990

Paris, Texas

HALLIWELL'S

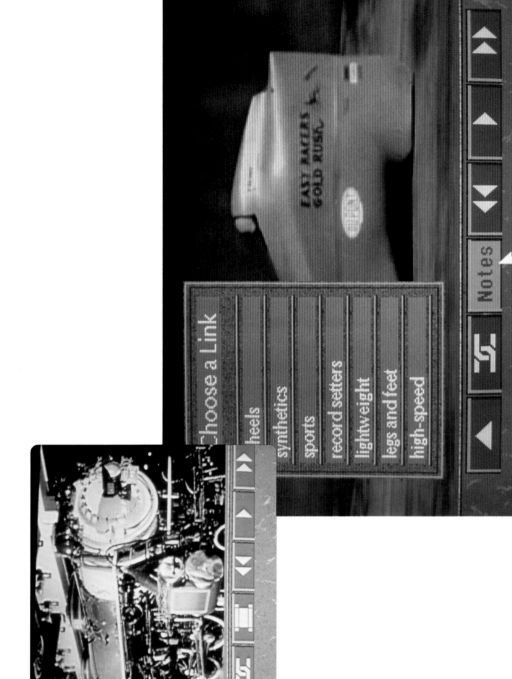

infotainment

treasures of the smithsonian

One of the first major information products for CDI, and probably the most ambitious so far, "Treasures" is an "interactive sampler" of the diversity of artefacts contained within the Smithsonian Institute's 14 museums. About 150 objects are described in short audio-visual presentations, with extra text descriptions available. Some objects have other interface features, such as offering the user the opportunity to "walk" round a sculpture, get close-ups of a painting, or "play" a musical instrument. The "treasures" can be accessed in a variety of ways: by name, category, museum and date, as well as in part of a guided tour of thematically related items.

Co-published by the Smithsonian Institute and American Interactive Media (AIM), the disc was designed and produced by Jim Hoekema, now head of Hoekema Interactive. Philips' Compact Disc Interactive (CDI) follows Commodore's CDTV system as the second multimedia system aimed at the consumer market. "Treasures of the Smithsonian" has set a benchmark by which to measure other CDI products.

quiz console

ace coin

Infotainment programmes are not confined to the home. Increasingly pubs and clubs, as well as the traditional venues of video arcades, are installing quiz games like this one from Ace Coin, who are among the first coin-op manufacturers to use Digital Video Interactive (DVI) technology. DVI allows full motion video and high-resolution images and sound to be integrated within the quiz programmes.

infotainment

bun for barney

multimedia corporation

Available in three formats (for Commodore's CDTV, Apple Mac and PC) "Bun for Barney" is an interactive programme for children that combines learning with fun as they follow the adventures of Barney through different situations. Choosing a screen display typeface that is suitable for small children is not easy. To ensure the best readability, MultiMedia Corporation created a Roman (upright) version of Rosemary Sassoon's font "Sasson", a typeface that was "carefully researched and designed specially for use in children's reading books". The type design program Font Studio was used to do this.

Because CDTV players are operated with a remote control (no mouse or keyboard are included with the basic player), MMC built an option into the CDTV version of Barney offering users the choice of watching a linear version of the story. This notion that alternative modes of viewing should be available, so that viewers can sit back and watch as well as choosing to interact with the programme, is one that will be seen in other CDI and CDTV programmes, as designers grapple with the problem of suspending disbelief in a narrative while at the same time offering users the choice of directing the course of action.

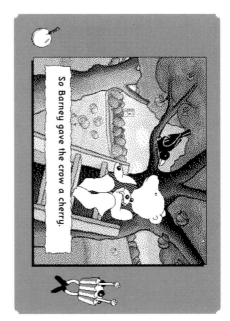

So Barney gave the crow a cherry.

So Barney gave the crow a cherry.

how things work

Tiger Media's programme enables the user to "take your appliances apart without a screwdriver", to learn how a range of everyday objects work. It answers questions such as "How does your remote control turn on the television?", "How does your CD player use lasers to play music?" and "How does an air conditioner extract heat?". Each item in "How Things Work" is accessed by clicking on an icon of the object in an overview graphic of an average house. A variety of multimedia techniques is used, including an animated, audio-visual explanation. The user can also choose from a number of related items, which may be other objects, or a feature on the underlying general principles and technologies.

Tiger Media initially developed "How Things Work" for the Fujitsu FM/Towns computer (which has an internal CDROM drive), with versions for other platforms to follow. Artwork was created entirely using the Deluxe Paint III bitmap paint program on a personal computer. Two artists worked for almost two years to create all the images needed. Voice-overs were recorded by actors in a facilities studio, then mixed with music and sound effects in Tiger Media's own sound studio.

infotainment

Many new software tools had to be developed to create the multiple interfaces and extensive animation sequences within the programme. Animations were produced using a variety of digital equivalents of traditional techniques, including cel animation as well as colour lookup table animation.

entertainment

B y the early 90s there were three main hypermedia technologies aimed at the consumer entertainment market:

Compact Disc Interactive (CDI),

Commodore Dynamic Total Vision (CDTV) and products based around Intel's Digital Video Interactive (DVI) system, such as Empruve's innovative Cornucopia. New products will undoubtedly appear on the market, many of them inspired by Alan Kay's portable "notebook" size computer, the "Dynabook", which has the huge memory storage capabilities of CDROM and can be easily linked to telephone and computer networks. These machines may combine the functions of the television, personal computer, tele/videophone, CB radio, modem and fax, and, furthermore, can be trained to recognize simple spoken commands, handwriting and gestures. Personal virtual reality systems running from personal computers are also on the horizon. The market for products that can successfully exploit the power of hypermedia is potentially vast. The

tiny, monochrome games systems from Nintendo have shown just how profitable such systems can be, and competition will be fierce.

All the competing systems will have one thing in common: they will all be digital, and they will all require innovative interactive software if they are to be successful. Manufacturers realize that a successful product must combine technically sophisticated and easy to use hardware with a wide choice of interactive programmes that capture the imagination, engage the intellect and excite the emotions.

The programmes featured here indicate the various ways in which software designers are responding to this challenge. The videogame market is already well established, and games designers have been among the first to exploit the massive storage potential of compact disc. Games machine manufacturers are developing quiz games that utilize the motion video

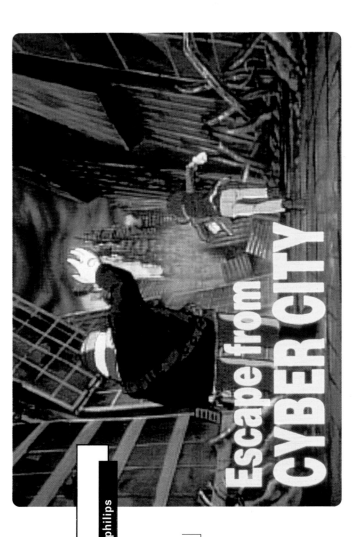

Escape from CYBER CITY

cybercity philips

Another successful application of the "graphic novel" format to interactive media. "Cybercity" was produced for Philips' CDI system.

entertainment

Interactive, and simulator and virtual reality technologies are already featured in the gaming arcades.

Simulations, mazes, maps and role playing games will all be used as devices to encourage the creative exploration of multifaceted, multiple perspective viewpoints on to any body of knowledge. The current content of videogames is less important than the potential that their formats promise for the future. Role playing games, for example, point the way towards a new form of highly interactive, user-directed hyperdrama, fusing linear narrative with interactive plot creation.

Escapist fun has been a mainstay of one of the biggest business sectors on the planet, the film business, and such programmes will also occupy a major share of the hypermedia market. Programme makers will have the task of providing engaging entertainments in which the user can suspend disbelief, while at the same time personally controlling the flow of narrative.

cartoon jukebox

philips/PIMA

In this CDI programme, children can colour the characters, then watch their coloured cartoons come alive in animation and song. CDI programmes combine computer and video software creating a new kind of home entertainment system.

sesame street

children's television workshop

Children's programmes such as "Sesame Street", with their fragmented, magazine-like structure, and opportunities for engaging children directly in activities (rather than just watching) are naturals for interactive media such as CDI. This interactive version of the popular children's series is from Philips.

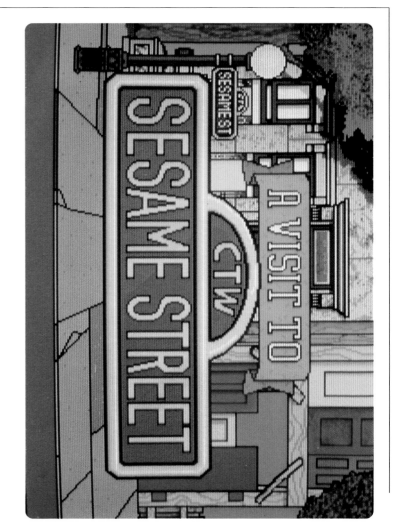

characteristics of Digital Video

entertainment

THE CASE OF THE CAUTIOUS CONDOR

AIRWAVE ADVENTURE

TOSHIBA EMI

tiger media

Drawings were made in pencil, then "inked" as in traditional comic strip production, before being digitized and coloured on the computer. A branching flowchart or "interactive storyboard" of the thousands of possible routes through the programme enabled the producers to fit each of the scenes together into a coherent and entertaining story.

"Condor" uses some seven hundred original illustrations and audio sequences that feature "radio play"-style dialogue, music and sound effects. Because there are a large number of possible routes through the programme, and each route delivers particular clues to help the user solve the mystery, the programme contents must be thoroughly explored before the murderer can be identified.

the case of the cautious condor

tiger media

This interactive 1930s-style "murder-mystery drama" was first conceived in 1987. By 1991, Tiger Media had released versions of Condor for the FM/Towns CDROM computer, for Sun Microsystem's SPARCstations, for Tandy's 2500XL computer with CDROM, and for Commodore's CDTV system. The programme exemplifies the "interactive graphic novel" approach to hypermedia programme design, combining the styles of classic radio drama and popular detective comics. The user can "eavesdrop" on characters and conversations that take place in the many different cabins of a trans-Atlantic airliner, and must piece the evidence together to find the murderer.

Tiger Media's is a successful "multi-platform" approach to hypermedia production, using a "safe subset" of all the programme components so that different versions can be cost-effectively produced for different delivery platforms, such as different personal computer/ CDROM configurations and multimedia systems such as CDTV and CDI.

entertainment

In this interactive horoscope, users select their favourite colour, pet and star sign. The sum of these choices results in personalized illustration and animation sequences framing a spoken horoscope prediction. Jeanne Verdoux developed this programme while she was a student at the Royal College of Art, London. Working with programmer Richard Turnnidge, Verdoux shows something of the variety of different illustration and graphics approaches that are possible in hypermedia programmes. Hand-painted images can be mixed with sketches, drawings and photographic collages, and enriched with animations, digital sound recordings and clever programming to produce highly professional programmes. Verdoux and Turnnidge worked in Supercard and Macromind Director on a Mac IIcx, and "Madame Soleil" was first shown at the RCA degree show in 1990.

entertainment

madame soleil's horoscope

jeanne verdoux

"Logic Bomb" is a graphic novel developed by Decode for the comic *2000 AD*, and the intention is to produce an interactive version on CDROM. Decode uses a combination of videographics, computer modelling and desktop graphic techniques to produce the frames for "Logic Bomb". The "environment" for the strip is produced in a 3d modelling program ("InfiniD") and retouched in Photoshop. The "actors" are shot on video against a chromakey (ie "invisible" on video) blue backdrop in the studio, and then combined with the computer-generated background images. The interactive graphic novel looks set to become one of the most popular genres of interactive entertainment, largely because hypermedia can offer the combination of videogame-style interaction, TV-style images, audio, and extra branching narratives, and can still be produced on the desktop by individual artists or by small studio teams. Decode appears to be in the forefront in developing techniques for what may be the most successful of the consumer interactive entertainment formats.

The poster for "Logic Bomb" shows how the video image of the actor is combined with the computer-generated model. The possibilities for the application of these techniques (developed originally for film and television, special effects) to print, as well as to hypermedia, are enormous. The virtual reality entertainment programmes of the near future will use similar techniques to integrate both the user, and the cast of characters featured in the entertainment in the same virtual space.

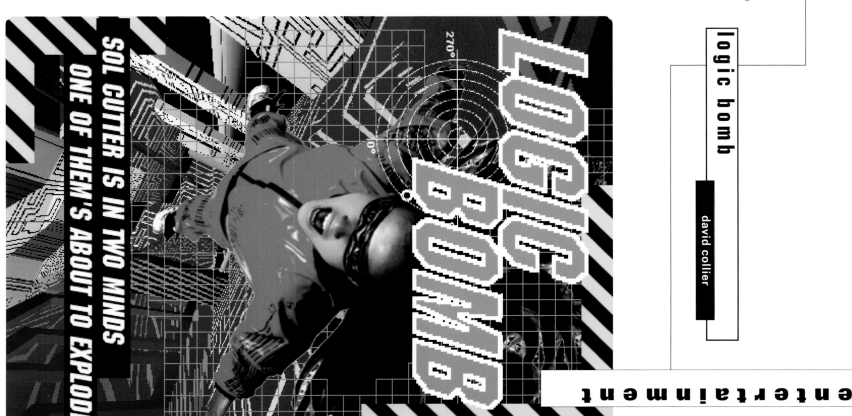

logic bomb

david collier

entertainment

LOGIC BOMB

270°

0°

SOL CUTTER IS IN TWO MINDS
ONE OF THEM'S ABOUT TO EXPLODE

great british golf

philips

Philips aim to provide a range of programmes for CDI that will appeal to every member of the family. Unlike videogame golf simulations which suffer from low-resolution images, the "Great British Golf" CDI is tantamount to a professional simulator, with high-resolution stills and motion clips, and hi-fi sound.

trivial pursuits

domark

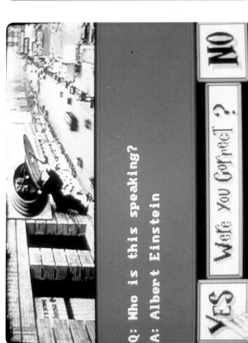

Domark have produced a CDTV version of the popular quiz game, using all the multimedia attributes of the Commodore system. Designers of such games can opt for one of two main strategies: with the metaphor of the board game, a variety of audio-visual techniques used to present the questions (as Domark have done here); or recasting the game more in the mode of a television quiz show. There is considerable debate over which of these formats is best suited for interactive media.

knightmare

anglia TV

This broadcast television programme featured participants interacting with a studio audience, and with a "virtual" set generated by a combination of computer graphic and composite video images. Knightmare pointed the way to sophisticated games shows and adventure programmes that use virtual reality systems in a vicarious interactive setting.

utopia

gremlin

The central idea of this game (which is becoming a genre in itself, following the tradition of videogames like "Populous" and "Powermonger") is to create a virtual utopia for the bitmapped denizens of the user's own world. Published by Gremlin, the idea is to create the "greatest happiness of the greatest number", but "Utopia" throws up all kinds of problems for the would-be utopian. "Arcade strategy" games like this point the way towards possibly more "educational" products that force the user to think through the implications of political and socio-economic policies. The grandest scheme of all was the "World Game" devised by Buckminster Fuller, where rival politicians and economists were to be invited to test their policies on a 200-foot-diameter computer-controlled "geosphere" of the Earth, with the results projected as demographic charts for all to see.

lotus esprit turbo challenge II

gremlin

Not just a racing car simulator, "Lotus Turbo" by Gremlin/Magnetic fields challenges the user to race across an entire continent, in stages that feature different weather conditions and driving environments. These are ingeniously reflected in the way the cars handle on the road. For example, in snowy conditions, the steering becomes very light, and the driver's vision is partly obscured. At different stages within the game, drivers must cope with special problems such as lightning strikes, night driving, snow and rain, and smoking tyres. Individual users enjoy the whole-screen graphics, and a split screen is available for two players.

As well as providing new art forms that offer an alternative form of dialogue with the artist or author, hypermedia will also provide the complete "system environment" through which all media, both linear and interactive, can be readily accessed.

The beginnings of this hybrid media hardware are used already in the form of video cassette recorders (VCRs) used interactively alongside broadcast television. Hypermedia technology is gradually being adopted in the home in much the same way, with an integrated CDROM/ personal computer joining the VCR alongside the television. With the introduction of high-definition "intelligent" television (HDTV), and an expansion of satellite and cable data services, we will increasingly operate the information technology in our homes through the kind of soft (on screen) controls that characterise the hypermedia interface.

For personal use, a wide range of portable information/entertainment systems is being developed: machines that will provide processing power, storage and telecommunication facilities. Unlike the "black boxes" of the VCR look-alikes CDI and CDTV, these portable machines explore the territory mapped out over 20 years ago by Alan Kay: the idea of the "Dynabook" (see Hypermedia Innovators). Both domestic and personal hypermedia systems use some form of random access storage such as memory cards or CDROMs as well as including access to telecoms/cable networks.

Currently the cheapest and most efficient means of distributing hypermedia programmes is the compact disc. The "read only" format is being replaced by read/write discs. CDROM (read only memory) is the standard form of mass distribution for software that exceeds about 20 megabytes (floppy disks and

The compact disc was a spin-off development from Philip's Laservision videodisc, which is

The first CD-based multimedia product for the consumer market is Commodore Dynamic Total Vision (CDTV), launched in 1991. The CDTV player is a modified Amiga 500 personal computer with an internal CDROM drive specially configured to deliver synchronised sounds and images. Also launched in 1991 (in the US) was Philip's long awaited Compact Disc Interactive (CDI). The first generation of CDI players could only support quarter-screen motion video, but second generation machines use a compression technique developed by C-Cube and Philips to allow full screen, full motion video and sound.

CDROM is also used to store highly compressed video data that is decompressed as it is loaded into personal computers that have been specially equipped with Intel's digital video interactive (DVI) microchips. Compression allows around 60 minutes of motion video to be stored on a standard CDROM. DVI CDROMs have also been integrated within portable computer/readers such as Empruve's Cornucopia.

"flopticles") can be used for the limited distribution of programmes under 20 megabytes). CDROM disc drives have been configured to work with a wide range of computers, and have been integrated within portable readers such as Sony's Data Discman.

Just as the compact (audio) cassette, the VHS videotape, and compact disc became de facto world standards by capturing the consumer markets against stiff competition from rival formats, it is likely that a world standard for interactive media will emerge from the present profusion of incompatible systems. Fortunately, programme production for these incompatible media has a great deal in common, and interactive multimedia programmes produced for one medium are often converted for use in other systems. This "multiformat" approach to production is of vital importance for multimedia publishers, since they can amortise their production costs over several distinct markets, while at the same time providing the high level of production values expected by consumers.

still a popular medium for interactive programmes, as it offers "broadcast" quality (analogue) motion video, and the ability to mix together the graphics and text of hypermedia with video stills and sequences on the same monitor screen. Because the delivery hardware includes a personal computer, monitor, video board and videodisc player, an interactive video workstation is five or six times more expensive than the stand-alone CDI/CDTV players (which link to existing television sets and stereo outputs).

6

hypermedia
hardware
delivery platforms

Eden VPi386 pen-based computer

Alan Kay's idea of the Dynabook personal hypermedia computer has been an inspiration for many computer manufacturers. This elegant example from Eden is designed to use any one of several pen-based operating systems that feature "handwriting recognition" software. Users can write notes much as they would with a pen and notepad, but here the written characters are stored as ASCII characters, and files may be saved and edited in the same way as on a word processor. The pen stylus gives the user precise control through an icon-based interface. Pen-based systems like this point the way towards personal multimedia systems that incorporate massive memory storage, powerful processing, and telecommunications links.

CDTV player

Commodore's Dynamic Total Vision (CDTV), launched in 1991, was the first consumer multimedia system. The CDTV player was designed to look like the familiar VHS video cassette recorder, not like a computer. Basically an Amiga computer with a built-in CDROM drive, it is intended for use with a standard TV monitor and hi-fi system. The player is operated by an infra-red remote control pad.

My First Sony

Personal multimedia systems are taking on many different guises, from palmtops to laptops, from pocket-sized systems to wide-screen HDTV sets. And as Sony demonstrates here with this range of computers for children, multimedia machines will cease to look like "traditional" personal computers.

hardware

CDI player

Philips launched CDI in the USA in 1991. In partnership with Sony, Philips nurtured CDI through a long period of development, and succeeded in establishing a world-wide standard for interactive multimedia. CDI discs will play on CDI players anywhere in the world, regardless of national television standards. Like Commodore's CDTV, CDI players are designed to be plugged into a conventional TV and hi-fi.

Sony Data Discman

Data Discman is a natural extension of Sony's Walkman and Discman products. Highly portable and self-contained, Data Discman offers instant access to a wide variety of electronic "books" (interactive programmes and databases stored on 8cm CDROM discs) through a neat hardware interface.

Nintendo-Super Famicom
Nintendo Gameboy
Sega Megadrive
Sega Game Gear

Videogame systems manufacturers have developed innovative hardware for the storage, control and display of their games software. Games consoles from Nintendo, Sega and others will influence the style and construction of consumer multimedia systems; both Nintendo and Sega have systems with built-in CDROM storage, fast processing and full-colour displays. The trend in games machines is towards multimedia, and the current generation of videogamers will demand a much wider range of multimedia software for their favourite consoles.

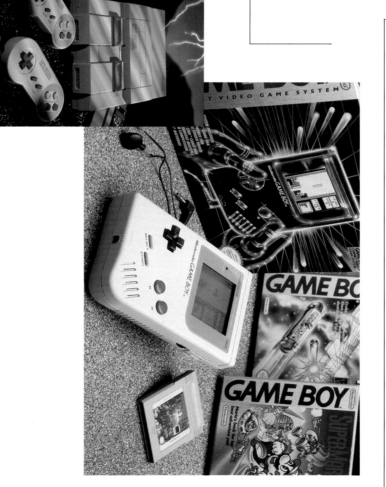

interactive "information leisure" is a radically new concept in home entertainment. Consumer electronics and communications companies are now focusing their energies on ways of establishing and developing this potentially huge market. As we have seen, the short to medium term interest is in systems that use the compact disc, which is already well established as a medium for music. Philips argue that the upgrade from CD audio to CDI is a small step for the consumer to make. The new interactive multimedia CD players will also play audio discs, so the consumer can, it is suggested, be gently introduced to the concept of interactivity. Philips' promotional strategy for CDI includes the retailing of "CDI-Ready" programmes - CDs that include graphics and pictures as well as their main music content, and can be played on ordinary CD players, but will deliver their other media contents only when the consumer upgrades to a CDI system.

Philips' initial marketing plans for CDI focused on the well to do family, with recreation and entertainment programmes to appeal to everyone, sports simulations and business information programmes for the adults, music plus product for the teenagers, and educational and games programmes for the children.

On the other hand, Commodore, which already has a large installed base of games computers, hopes that their CDTV system will initially build on this much younger market sector. Over 50 per cent of CDTV launch titles were games, ranging from electronic versions of traditional board or television games, through a large proportion of action, mystery, strategy/adventure and simulations, to music-based entertainments. The rest of Commodore's launch titles were aimed at extending market appeal to include the whole

state of the art:
hypermedia technology now

family, with a range of reference, home education, and arts and leisure programmes.

In recognition that CDI is also potentially an important games media, in 1991 Philips signed a deal with Nintendo to market their enormously successful games on CDI. With full motion video, CDI will also be a viable medium for the distribution of films and videos, which may also involve "Film Plus" interactive elements. The consumer information/leisure market is now being addressed by personal computer, games, software and consumer electronics companies such as Apple, Empruve, Microsoft, Nintendo, FM Towns, Sega (with their Megadrive CDROM) and Sony (with the Data Discman and portable CDI player).

Apple: Knowledge Navigator

This conceptual prototype demonstrates just one of the approaches that Apple has developed towards the next generation of personal hypermedia systems. With its telecommunications links and multimedia approach to information processing, the Knowledge Navigator has mapped out a set of criteria for future products. Apple are also collaborating with Sony on the production of consumer multimedia systems.

Empruve: Cornucopia System

Empruve have developed the first in a new generation of consumer multimedia/Dynabook systems. The aptly named "Cornucopia" incorporates an internal CDROM drive, 200-megabyte hard disc and both colour and monochrome screens. Cornucopia uses Intel's DVI processors to produce full-motion video and stereo sound. Technically, aesthetically and ergonomically, this machine has set the standard for future systems.

hardware

The compact disc-based systems are only the first in a rolling wave of new technologies to offer interactive multimedia to a mass audience. Within the next few years CDI and CDTV will face heavy competition: from cable networks that pipe a variety of on-line interactive information and entertainment services directly into the home; from competing systems such as Empruve's Cornucopia and new multimedia products from Sega and Nintendo; from "Dynabook"-like systems; from multimedia personal computers; and from new "virtual" media that result from developments in faster processors, solid state memory, parallel processing and virtual reality interfaces such as VPL's Dataglove and Eyephone. Far-sighted companies including VPL, W Industries, Abrams Gentile Entertainments and Rediffusion Simulation are producing or developing plans for personal simulators, "simulator cinemas", virtual reality units for game arcades, and "virtual theme parks". We are well on the road to Aldous Huxley's "feelies".

Some of the proposed High Definition Television (HDTV) systems that incorporate massive memory and processing power will allow consumers to download (record) complete linear or interactive programmes from cable or satellite sources to use, store or discard as they wish. This may eventually become the preferred method of retailing and distributing all software, whether films, video, music or databases, as well as interactive multimedia programmes.

Meanwhile, in the professional and corporate sector, Digital Video Interactive (DVI) and other video and audio-compression chip sets are becoming available for personal computers, upgrading them to the status of true multimedia systems for information management and training applications. IBM has adopted DVI, and DVI expansion boards are already available for the Apple Macintosh. Both Apple and IBM are targeting the corporate sector and look set to cooperate on producing new personal computers that combine the speed of PCs with the graphic and multimedia capabilities of the Macintosh. The recent revival of interest in laserdisc (due in part to the availability of cheaper "combi" players such as Pioneer's CLD 1500, which plays CD Audio and Laservision discs but also due to reduced pressing costs and to the success of karaoke laserdiscs in Japan) ensures that this, the first interactive video medium, will continue to be a viable option for education, training and POI applications, and could develop still further as a powerful games and entertainments medium.

millennial media: the next decade

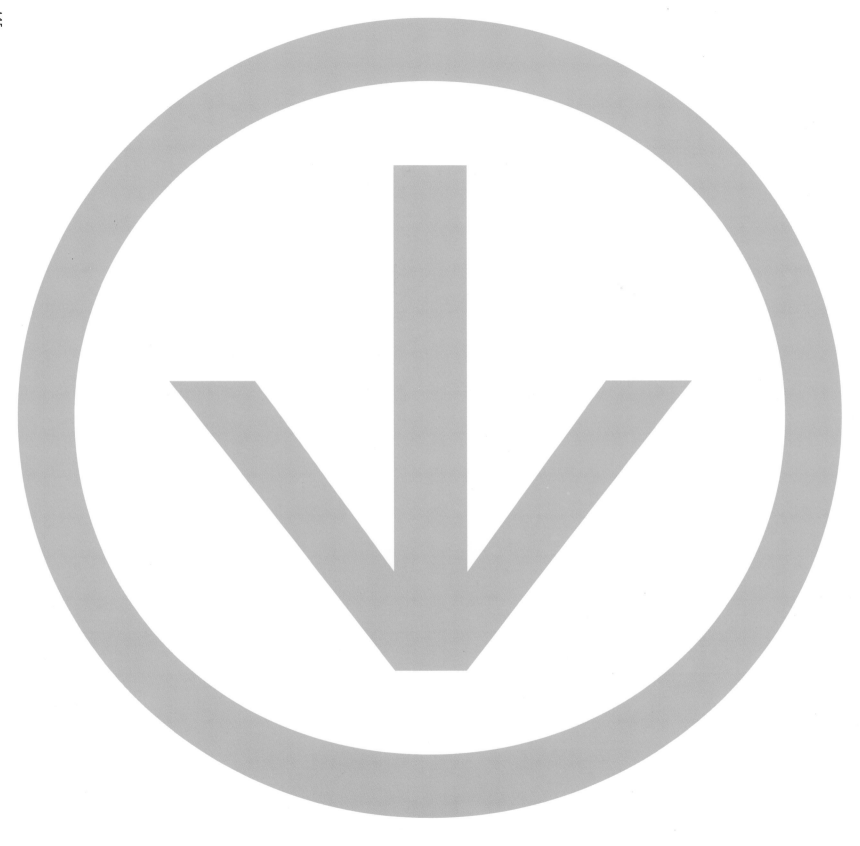

glossary

Algorithm
A procedure for solving a particular problem. Devising an algorithm basically means formulating a method by which the solution to a problem may be found. The first stage in programming or scripting is to devise an algorithm.

Alphanumeric
Letters, numbers, punctuation marks and mathematical signs.

Amigavision
A multimedia authoring program for the Commodore Amiga.

Animatics
Animations designed to demonstrate the viability of a storyboard before any live action film or video is shot.

Anti-Aliasing
Computer-graphic technique used to smooth the jagged appearance of lines and edges of graphics displayed on computer monitors. Anti-aliasing techniques include the interpolation of a neutral colour between the edge of one colour plane and another. Anti-aliased fonts and graphics are used extensively in hypermedia programmes.

Application
A computer program such as a word processor, painting or authoring program.

Arrow cursor
The standard screen cursor used on the Mac and Microsoft Windows interface. A black arrow pointing upwards to the "eleven o'clock" position, the cursor responds to movements of pointing devices such as the mouse.

ASCII
American Standard Code for Information Interchange: the industry standard for encoding alphanumeric characters, numbers, signs and symbols.

Aspect ratio
The ratio of width to height of screen images or pixels.

Associative linking
In hypermedia, words or pictures that are linked by an association in meaning or content.

Authoring
The process of designing an interactive programme.

Authorware Professional
A multimedia authoring program.

Bandwidth
The range of frequencies that can pass through a transmission channel, limiting the amount and quality of information (such as audio and video data) that can be transmitted between hardware systems. The higher the resolution (ie the more data) transmitted, the broader the bandwidth must be to accommodate the high frequencies required to convey the information.
"Bandwidth" is also used colloquially to express the transmission capacity of a system in bits per second.

Binaural
Stereo sound recording that closely approximates the way we hear natural sounds.

Bit
Binary digit: the smallest unit (valued either 0 or 1) of computer data.

Bitmap
A computer graphic image comprised of dots of colour that correspond directly to data bits stored in memory.

Bitmap editors
More commonly called "paint" programs, are the most intuitive and easy to learn of the computer graphics tools, allowing the artist control over each individual bit (represented as a screen pixel).

Branching
In interactive media, the facility to deviate from a central narrative or course structure.

Broadcast Quality
"Professional" quality video.

Browse mode
Mode in which the user may survey or peruse all or part of the contents of a hypermedia programme.

Browser
A device that allows users to peruse the contents of a hypermedia programme, generally by providing some kind of overview, such as a contents list, from which the user may choose items of interest.

Button
An area or object displayed on the screen, that reacts to some form of user input - such as the use of a pointer or the click of a mouse.

glossary

Byte
A set of bits considered as a unit of information in the computer. In personal computers a byte is normally 8 bits and can represent a single character such as a letter of the alphabet, a number from 0 to 9, or a punctuation mark.

CAD
Computer aided design: the term now used to describe virtually all design activities that incorporate the use of computers. These include the media arts of graphic design, desktop publishing, television and audio-visual graphics, as well as architectural design, engineering design, and a wide variety of environmental planning, product development, and marketing applications.

Card
A discrete unit in hypermedia and database systems that use the "cardfile" metaphor, such as Apple's Hypercard and Microsoft's Windows Cardfile, where the information contents of the programme are displayed on separate "pages" akin to the cards used in filing systems.

CD
Compact Disc: the basic 120mm digital-optical disc that can be used to carry audio (CDDA), data (CDROM) or multimedia programmes (CDROMXA, CDTV, CDI, DVICDROM). CDs have a data-storage capacity of around 640 Megabytes.

CDDA or CDAD
Compact Disc Digital Audio or Compact Digital Audio Disc. Launched in 1982 as the result of a joint development between Philips and Sony, CDDA was the first audio medium to carry digital-optical recording in a "compact" form of the 300mm laserdisc.

CDI
Compact Disc Interactive. A multimedia compact disc-based system developed jointly by Philips and Sony. CDI players are designed to be plugged into television sets and hi-fi stereo systems, and will also play compact digital audio discs.

CDI Ready
A CD format that combines CD audio with additional interactive multimedia components. Such discs can be played in a normal CD system, but the multimedia contents can only be accessed when the user upgrades to a CDI player.

CDROM
Compact Disc Read Only Memory: a compact disc that can store computer data as well as audio data.

CDROMXA
The "extended architecture" version of CDROM, that includes the ability to synchronise audio and image data.

CDTV
Commodore Dynamic Total Vision. A compact disc-based multimedia system carrying programmes that combine computer graphics and data with photographic images, text and sound.

Cel Animation
The most common form of animation, whereby individual drawings are made on transparent plastic sheets or cels each one recording the different position of a moving object. They are then photographed by a rostrum camera.

Chromakey
A system that enables two or more video images to be combined into a single, composite image using the principle of colour keying - effectively rendering one or more colours "transparent", so that other images may be displayed in their place.

CLUT
Colour Look Up Table: an array or "table" of data containing numerical values for all the colours represented in an image. CLUTs can be used to manipulate and compress colour images.

Compression ratio
The factor by which digital data, such as images and sounds, can be compressed.

Content provider
The owner or licensee of the source contents (audio, stills, video, text or data) for a multimedia programme.

Cuecon
A screen pictogram that "prompts" the user of a hypermedia programme to further exploratory action by drawing his or her attention to specific choices.

Cursor
In computer and multimedia systems, the screen symbol that represents the screen position of the pointing device (mouse, joystick, digitpad, infrared control pad etc).

Cyberspace
An expression coined by William Gibson in the novel *Neuromancer* (1984): literally "the space of cybernetics", the virtual space of computer memory and networks, global telecommunications and digital media.

Database
A collection of information that has been organized in such a form that it is retrievable through a computer system.

Data
Information stored in digital form.

Data acquisition
In multimedia, the digitizing of original (analogue) images and sounds.

DAT
Digital Audio Tape: a tape cassette that stores digital-audio data. Unlike CDs, which are "read-only", DAT tapes are "read/write" - sounds can be recorded by the user. DAT is also used to store safety copies or "backups" of other sorts of digital data.

Dataglove
A glove designed by VPL to translate the movements of the hand and fingers into code that is readable by a computer controlling a virtual reality or remote robotic system.

Data Diskman
A portable disk reader with built-in display screen manufactured by Sony.

Datasuit
A suit designed by VPL to translate body movements into digital code enabling the wearer to participate in a virtual reality system.

DCC
Digital Compact Cassette: a recordable digital audio tape format developed by Philips.

Delivery system
In hypermedia, the computer/CDROM system through which a programme is "delivered" to the end user.

Depth Cueing
A computer graphic technique for representing the effect of aerial perspective or distance.

Development platform
The computer system used for the development of hypermedia programmes.

Dialogue box

In a multimedia system or windows-based computer interface, a box or small window that asks the user to choose from a number of options or to verify an action they have taken.

Digital audio

Sounds stored in digital form.

Digitizing tablet or Digitpad

A tablet resembling a drawing board that converts a freehand drawing or tracing produced with an electronic stylus or pen into digital signals that are displayed on a monitor screen.

Digitizer

Any hardware that is used to convert analog sounds or images into digital code.

Director

Animation software. See "Macromind Director".

Diskette

"Floppy disk" with a capacity of up to around 2 Megabytes used for storage and distribution of computer data.

DVI

Digital Video Interactive. A computer microchip developed by Intel, specially designed for the compression and decompression of motion video.

Dynabook

A portable computer/hypermedia system proposed by Alan Kay in 1968. Designed to have a flat screen display and a graphic interface, it was intended to handle several Megabytes of text, and provide an easy to use programming language called "Paintbrush" - that children could use to create pictures and animate them. Kay proposed that the Dynabook would link (via telephone lines and wireless) to other Dynabooks and to library resources, and should be produced for under $500, so that it could be made available to every school pupil. The Dynabook idea has still to be implemented.

Earcon

An on-screen symbol which triggers a digital sound or soundtrack.

Edutainment

A hypermedia programme providing educational material in an entertaining way.

Electronic Mail

Messages sent via a computer network.

Electronic publishing

"Non-print" publishing, including hypermedia and database publishing on CDROM and diskette, or via telephone or cable networks.

Eyephones

A head-mounted display device developed by VPL for interfacing with a Virtual Reality system. Eyephones incorporate stereo display screens, stereo headphones and a position sensor that responds to head movements and determines the view the wearer enjoys of the virtual world.

Feedback

In hypermedia, the process by which the program or system informs users of what it is doing so that they can take appropriate action.

Fibreoptic

Glass fibre cables used to carry very large volumes of low-band signals (such as telephone calls), or limited volumes of wide band signals (such as video images). Fibre optics play an important role in the development of integrated multi-media communications systems.

Film Plus

Hypermedia programmes that elaborate or expand upon a feature film or video.

Flowchart

A schematic diagram of a hypermedia programme.

FMV

Full Motion Video: video displayed by a multimedia system at rates approaching 25 frames/sec (UK) or 30 Frames/sec (US). "Full screen full-motion video" is used to describe systems that have the necessary processing power and transmission capacity to display full-screen size images at video rates.

Fractal

Objects or patterns that reveal increasing detail as they are magnified.

Frame grabber

Also called Video Digitizer: an add-on board for a computer that allows single frames to be digitized from a tape or camera video source.

Graphical User Interface (GUI)

A method of interacting with a computer using windows, icons, menus and other graphical devices.

Guide

A hypermedia authoring program originally developed by Office Workstations Ltd (OWL).

Hardware

The equipment needed to make and run multimedia programmes, as opposed to the "software" - the actual programmes themselves. Typically, Hardware includes a computer and disc storage for the delivery platform, plus a scanner, video frame-grabber and audio digitizer for the development platform.

HDTV

High Definition TV, the generic term for television systems that boast around 1200 lines (roughly twice the resolution of current systems). In its ideal form (that is with onboard memory and processing power and with interactive networked links to satellite, cable and computer networks) HDTV could be the principal home information and entertainment system of the twenty-first century.

Human-computer interface

The way in which we interact with computer systems. (See also "Graphical User Interface".)

Hypercard

Apple's Hypercard became the first popular hypermedia authoring software, responsible for introducing many people to the joys of constructing their own hypermedia programmes.

Hypergraphics

Graphics in hypermedia programmes that are not just still images, ie graphics that are time-based, animated, linked to other graphics, three dimensional or viewable in several different perspectives.

Hyperlink

In hypermedia, the programmed links between related items of information.

Hypertext

Software that enables the user to read texts linked in a variety of linear and non-linear ways, and to create new links between words or passages of text.

glossary

glossary

Hypermedia
Interactive programmes in which information is stored in a number of different media and organized so that it can be retrieved and presented in a variety of ways that amplify meaning for the user. Hypermedia involves the presentation of information in media that most effectively communicate its content, and provides the user with the means to sequence information in ways that are most appropriate to a given task.

Icon
The pictorial representation of an object, a computer program, a feature or a function within a hypermedia programme or graphic computer interface.

Infotainment
Describes hypermedia programmes that present information in an entertaining manner, such as quiz programmes.

Infra-red controller
Remote controller for a multimedia, hi-fi, video or TV system.

Interaction
The process of control and feedback between the user and hypermedia system.

Interactive Video (IV)
A system that uses a computer (often with hypermedia software) to control the audio, stills and motion sequences stored on a videodisc or tape.

Interface
Short for "Human Computer Interface": the hardware and software through which the user interacts with a hypermedia or computer system.

ISDN
Integrated Services Data Network: the emerging standard for a global, potentially wide-band (ie multimedia) data network using fibre-optic telecommunications and integrating telephone, interactive media, fax, video conferencing, videophone and data transfer services.

Joystick
A control/pointing device for computer systems, videogames and simulators.

Kilobyte (kbyte)
1024 bytes of data.

Kodak Photo CD
A compact disc-based system compatible with CDI for storing very high resolution photographic images in digital form, so that they can be viewed on a TV set or monitor.

Laserdisc
A videodisk that is read by means of a laserbeam.

Laservision
Philips' interactive videodisc system, which can store 54,000 frames of broadcast-quality video pictures. Using a videoboard, images can be displayed in full motion or still frame within a hypermedia programme.

LCD
Liquid Crystal Display: a flat screen display technology for portable computers and personal hypermedia systems.

Links
A feature of hypermedia programmes that allow associated items of information in different parts of a programme to be linked together.

Macintosh
Apple Macintosh computers: the range of computers that introduced the graphical user interface (1984) and hypermedia (Hypercard, 1986) to the mass market.

MacroMind Director
An animation program for the Macintosh, enabling users to develop presentations and interactive hypermedia programmes that combine dynamic images, video sequences, and sound.

Megabyte (Mbyte)
1,048,576 bytes of data, just over one million bytes. Floppydisks can store up to 2.88 Mbytes, CDROMs 640 Mbytes, and Laservision (LVROMs) 1000 Mbytes (or 1 gigabyte) of data.

Menu
A range of options for the user, presented in pull-down, pop-up or static form as a list of options, or in pictorial form as a range of icons, pictures or labels from which the user can choose the most appropriate or desired action.

Menubar
The part of a graphical user interface that sits along the top of the screen and contains a choice of menu titles. Menus can be revealed by pointing and clicking or dragging the menu choices from the menubar.

Menu-driven
Computer applications and hypermedia programmes that are controlled by means of menus.

Micon
Motion icon: animated pictograms used either to attract attention, as a decorative feature, or as a way of guiding the user through a complex set of activities.

MIDI
Musical Instrument Digital interface: a global software and hardware standard that allows musical instruments such as synthesizers, keyboards and drum machines to be controlled from a computer program.

Motion Video
See FMV

Mouse
Hand-held input and pointing device: as the mouse is moved across the desktop it moves a screen cursor or "pointer".

Multimedia
Generic term for "multimedia computing" or "interactive multimedia": the use of a wide variety of media within a computer interface or hypermedia programme. Also used to describe art works that combine several different media.

Multiplex
The transmission of a number of messages simultaneously over the same communications channel.

Music Plus
Used of hypermedia programmes that add value to digital audio music tracks by providing music notation, lyrics, audio controls, and contextual information on musicians, performers, and so on.

Navigation
The process of finding one's way around the contents of a hypermedia programme.

Network
System that links computers and other information or telecoms technologies together, either by cable or by "wireless" (radio or optical) means.

glossary

Node
In any branching programme, a main decision point or menu where the user has to make a choice from two or more alternative actions.

NTSC
National Television System Committee: the TV standard used in the United States and Japan, based on a 525-line image displayed at 30 frames per second.

Paintbox
A computer graphic system designed by Quantel for professional-quality TV graphics.

Paint program
The simplest type of computer graphic program for computers: the user can colour pixels on the computer screen with a variety of digital equivalents of pencils, paintbrushes, airbrushes and so forth.

PAL
Phase Alternate Line: the television standard used in Britain, parts of Europe and the Far East. PAL is a 625-line image displayed at 25 frames per second.

PC
Personal computer: generally used to describe IBM or similar "IBM-compatible" machines.

Pixel
Picture element: the smallest unit of the computer screen. On a black and white (1-bit) screen the pixel is either white or black. On a colour (8-bit or 24-bit) monitor, pixels can be any colour from a choice of hundreds or even millions of colours depending upon the pixel "depth" (ie how many bits are available to describe the colour values at any pixel). Pixels are also the measure of resolution of a screen (as in "72 pixels/inch").

POI
Point of information: name given to systems that provide information for the visitors of museums, exhibitions, galleries, trade shows and so on.

POS
Point of sale: advertising, promotion and vending systems that are available to the public in stores, shopping malls etc.

Position sensor
Technology that tracks the location of a headset, dataglove or other object in 3d (X,Y, Z coordinate) space. Used extensively in robotics and virtual reality systems.

Program
A set of instructions produced for a computer to enable it to perform a particular activity.

Programme
In hypermedia: a completed, finished product ready for the intended end-user.

Programming
The preparation of a set of instructions that can be interpreted and enacted by a digital computer.

Quicktime
Software for image and audio compression and decompression and the integration of multiple media formats for Apple Macintosh computers, allowing motion video sequences to be displayed at real-time rates on the computer monitor screen.

RAM
Random access memory: data storage that can be written to and read from. In computers RAM is volatile, temporary storage that is used to run program applications.

Ray Tracing
Computer graphic technique used in three-dimensional modelling and rendering programs for creating transparency, reflection, refraction, shadows and similar effects.

Read/Write
Electromagnetic or optical digital storage media on which data can be written (recorded on) or read (retrieved from).

Read only
Information stored in digital form that cannot be altered, but that can only be retrieved (read) by displaying it on a monitor, or by copying it to another storage device (such as a hard disk or floppy disk).

Real-time
Computer processing that takes place instantaneously.

Realtime animation
Sequences of images generated and displayed "instantaneously" from three-dimensional model data stored in a computer, in response to the user's input. Used extensively in flight simulation and Virtual Reality systems.

Refresh rate
The time it takes for the computer or hypermedia system to display an image on the monitor screen.

Remote services
The interactive access to services that are mediated by a remote computer, such as cable TV home shopping services or automatic teller machines.

Resolution
The measure of the detail in an image or sound. Images are measured in pixels (dots) per inch, and in the number of bytes used to describe the colour values (or grey scale) at each pixel. Audio is measured in the number of samples per second (usually expressed in kiloHertz).

Scanner
Hardware for digitizing images: scanners convert analogue values to digital samples.

Screen saver
Computer graphic software: stops the monitor screen deteriorating by automatically generating moving images if, after a short period of time, no user interaction has taken place.

Scripting language
The simplest form of computer programming using nearly plain English commands. Examples are Hypertalk, Supertalk and Lingo.

Scrolling
The action of viewing text or images in a screen window that is smaller than the area covered by the text or image, by moving the image left or right, or up or down.

Sequence editor
Software that allows sequential information, such as presentations, video, or animation, to be edited and reordered.

Soft
Pertaining to ideas, information or other "software".

Software

Information such as computer programs, data and hypermedia programmes stored in digital or analogue form.

Stack

Interactive programmes produced in Apple's Hypercard; in the plural, stackware.

Storage capacity

The amount of data that a storage medium can hold. CDROMs store 640 Megabytes.

Supercard

A hypermedia development program, developed by Aldus for the Apple Macintosh.

Surrogate travel

Hypermedia programme that presents the user with travel simulations, such as being able to walk around a foreign city or venture into space.

Telematic

Remote or distant control of a computer or information system.

Texture mapping

Computer graphic technique for applying textures and images to three-dimensional models.

Touchscreen

A technology that allows users to make choices by pointing their finger at areas or "buttons" on the screen.

Trackerball

A pointing device for personal computers and hypermedia systems, in which the user's hand rotates a ball within a fixed frame, and can move a pointer or cursor around the screen.

Tree structure

The structure of a branching programme.

Tricons

Three-dimensional icons.

Videodisc

A disc that stores video images as analogue information: available in two types - for linear and for interactive programmes.

Videogame

Interactive game produced for personal computers, arcade consoles and purpose-built games machines, generally distributed on floppy disk, ROM cartridge or cassette tape.

Virtual Reality (VR)

The simulation of reality through realtime 3d animation, position tracking and stereo audio and video techniques. By immersing the user within a computer generated, simulated environment, VR systems introduce an entirely new way of interacting with multimedia information.

Virtual space

The illusion of 2d or 3d space created by the use of microprocessors, computer memory and telecommunications networks, of which the extensive "environments" that can be created within flight simulators and Virtual Reality systems are good examples.

Voice annotation

The facility for added spoken comments or memos to a hypermedia programme.

Voice recognition

Software that can interpret spoken commands and perform actions in response.

Walkthrough

Software in which animations are generated from 3d architectural models and displayed at a realtime rate equivalent to walking speed, in response to the user's choice of direction within the model.

Window

Screen area that can contain part or all of a hypermedia programme (such as a "video window" or "text window"), or computer application such as a word processor.

WORM

Write Once Read Many times. An optical disc used for storage and archiving of digital data.

Xanadu

A hypermedia storage management system devised by Ted Nelson in the early 70s for the non-linear exploration of textual and other information. In its ideal form, Xanadu would provide users with hypertext links to and between all the books in all the world's libraries and museums.

XYZ coordinates

The Cartesian system for quantifying the position of an object in three-dimensional space.

bibliography

This is a list of some of the books that the authors have found helpful in preparing this book. It is in no way an exhaustive bibliography, but does suggest some of the most useful "associative links" for further reading.

Ackerman, Diane
A Natural History of the Senses, 1990

Ambron, Sueann & Hooper, Kristina (eds)
Interactive Multimedia, 1988

Barlow, Blakemore, Weston-Smith (eds)
Images and Understanding, 1990

Baudrillard, Jean
Simulations, 1983

Berger, John
Ways of Seeing, 1972

Brand, Stewart
The Media Lab: Inventing the Future at MIT, 1987

Buckminster Fuller, Richard
I Seem to be a Verb, 1970

Davies, Bathurst and Bathurst
The Telling Image, 1990

Eames, (Office of Charles and Ray)
A Computer Perspective: Background to the Computer Age, 1990

Eisenstein, Sergei
The Film Sense, 1943

Evans, Christopher
The Mighty Micro, 1984

Floyd, Steve & Beth (eds)
Handbook of Interactive Video, 1982

Foster, Hal (ed)
PostModern Culture, 1985

Fraase, Michael
Macintosh Hypermedia, 1990

Franco, Gaston Lionel
World Communications: New Horizons, New Power, New Hope, 1984

Frutiger, Adrian
Signs and Symbols: Their Design and Meaning, 1989

Gibson, William
Neuromancer, 1984

Greenberger, Martin (ed)
On Multimedia, 1990

Greiman, April
Hybrid Imagery, 1990

Hanhardt, John (ed)
Video Culture: A Critical Investigation, 1986

Hardison, O.B.
Disappearing Through the Skylight, 1990

Helsel, Sandra & Roth, Judith (eds)
Virtual Reality: Theory & Practice, 1990

Hoffos, Signe
CDI Designers' Guide, 1991

Jones, J. Christopher
Essays in Design, 1984

Kreuger, Myron
Artificial Reality, 1983

Lambert, Steve & Ropiequet, Suzanne (eds)
CDROM: The New Papyrus, 1986

Lambert, Steve & Salas, Jane (eds)
CDI & Interactive Videodisc Technology, 1987

Laurel, Brenda (ed)
The Art of Human Computer Interface Design, 1990

Lowenstein, Otto
The Senses, 1966

McLuhan, Herbert Marshall
Counterblast, 1970
Understanding Media: The Extensions of Man, 1964
Verbi-Voco-Visual Explorations, 1967

Mellor, D.H. (ed)
Ways of Communicating, 1990

Michie, Donald and Johnston, Rory
The Creative Computer, 1984

Morton, J.A.
Organising for Innovation, 1971

Negroponte, Nicholas
The Architecture Machine, 1970

Nelson, Ted
Computer Lib/Dream Machines, 1987

Palfreman, Jon & Swade, Doron
The Dream Machine: Exploring the Computer Age, 1991

Papert, Seymour
Mindstorms: Children, Computers, and Powerful Ideas, 1982

Parsloe, Eric (ed)
Interactive Video, 1983

Preston, J.M.
Compact Disc Interactive: A Designer's Overview, 1988

Reid, T.R.
Microchip, 1985

Rheingold, Howard
Virtual Reality, 1991

Roszak, Theodore
The Cult of Information, 1988

Sculley, John
Odyssey, 1987

Sless, Peter
Learning and Visual Communication, 1977

Thackara, John (ed)
Design after Modernism, 1988

Vallee, Jacques
The Network Revolution, 1984

Wiener, Norbert
Cybernetics: or Control and Communication in the Animal and the Machine, 1948

Woodhead, Nigel
Hypertext & Hypermedia Theory and Application, 1990

Youngblood, Gene
Expanded Cinema, 1970

Zuboff, Shoshona
In the Age of the Smart Machine: The Future of Work and Power, 1988

index

Software, hardware, book and image titles appear in *italics*. Page numbers in **bold** refer to glossary definition.

A

Aaron Copland: The Tenderland, 62

Abel, Bob, 96,

Abrams Gentile Entertainments, 144

Ace Coin, 127

Agitprop, 21

Alexandria Institute, 37

algorithm, 64, **146**

algorithmic, 84

alphanumeric, 34, 52, **146**

Ambassadors, The, 48

American Interactive Media, 126

Amigavision, **146**

AND Communications, 97

Anderson, Laurie, 21

Anglia Polytechnic, 95

Anglia TV, 137

animatics, 69, **146**

animation, 8, 34, 42, 49, 52, 56, 68-71, 87

bites, 68

anti-aliasing, 54, **146**

Apple Knowledge Navigator, 143

Apple *Macintosh*, 144

Apple Parts Locator System, 118

Apple, 35, 42, 64, 65, 119, 143, 144

i n d e x

applications, 9, 41, 43, 65, 84, 102, 144, **146**
arcade games, 120
architect's plan [as metaphor], 40
arrow cursor, **146**
Art of Memory, 44, 92-93
Art of Noise, 21
artificial intelligence, 60
Artificial Reality, 29
As We May Think, 22
ASCII, **146**
aspect ratio, **146**
associative indexing, 22
associative linking, 125, **146**
Astrostack, 57
audio, 60-63
 feedback, 60
 production, 81
Audio Notes, 63
Augmentation
 project, 23
 system, 23
Augmentation of the Human Intellect, 23
authoring, 81, 84, **146**
Authorware Professional, **146**
Autoceptor Experimedia, 46, 62
autoplay, 70

B
bandwidth, **146**
Bank Street College, 88
Banque Nationale de Paris, 102
Baudrillard, Jean, 29
Bauhaus, 21
Bauhaus, 58
BBC Open University Production Centre, 110
Berger, John, 20
Bevan, Rob, 119
binaural, 8, **146**
bit, 32, 110, **146**
bitmap, **146**
bitmap editors, **146**
Black Dog Productions, 121
Bowey, Mark, 53, 54, 79, 94, 125
branching, 60, 61, **146**
Braque, Georges, 20
bricolage, 36
brief, 80

broadcast quality, 139, **146**
Broderbund, 47
Bronowski, J., 20
browse, 77
 mode, **146**
browser, **146**
browsing, 23
Brunner, John, 29
Bun for Barney, 127
Burnell, Peter, 49, 117
Bush, Vannevar, 11, 22-23, 24, 38
button, 45, **146**
byte, **147**

C
C-Cube, 65, 139
cable data services, 138
cable networks, 144
CAD [Computer Aided Design], 34, **147**
Cage, John, 21
CAI [Computer Aided Instruction], 82
calligraphy, 52
cards, **147**
Cartoon Jukebox, 131
Case of the Cautious Condor, 132-133
Cash and Credit Information System, 102
Catalyst, 113
CBT [Computer Based Training], 82
CD [Compact Disc], 8, 13, 34, **147**
CDDA [Compact Disc Digital Audio], **147**
CDI [Compact Disc Interactive], 13, 65, 78, 126, 138, 142, 144, **147**
CDI Developer's Workstation, 78
CDI player, 141
CDI Ready, 142
CDROM [Compact Disc Read Only Memory], 13, 25, 78, 119 138, **147**
CDROM Developer's Workstation, 78
CDROMXA, 13, **147**
CDTV [Commodore Dynamic Total Vision], 13, 39, 60, 78, 123, 138, 140 142, 144, **147**
CDTV player, 140
cel animation, **147**
Children's Television Workshop, 131
Choudhary, Asif, 84
chromakey, **147**
chronophotography, 12

chunk hypertext, 53
CinemaScope, 30
cinematography, 11, 12
Cinerama, **147**
Clark, Steve, 30, 60, 123
CLUT [Colour Look Up Table], **147**
 animation, 68
Cognitive Applications, 109, 113, 114, 118
Cole, Leigh, 111
collateral hypertext, 53
Collier's Rules for Desktop Design ROM, 99
Collier, David, 99, 105, 135
colour photography, 20
Columbus, 96-97
combi player, 144
Commodore, 39, 142
compression ratio, **147**
computer, 11, 13, 14-19, 22, 23, 24, 25, 30, 41, 60
 animation, 81
 as hypermedium, 41
 games, 9
Computer Graphics Workshop, 47, 51, 55, 71, 75, 100
Computer Lib/Dream Machines, 24, 28
content provider, **147**
conversation as metaphor, 60
Cooley, Mike, 34
copyright, 37-38
Cornell University, 50, 95, 96
Cornucopia, 41, 86, 143, 144
corporate information applications, 114-119
Cotton, Bob, 49, 50, 79, 82, 83
Cubism, 20
cuecon, **147**
cursor, **147**
Cybercity, 130
Cybernetic Serendipity, 26, 29
cyberpunk, 26
cyberspace, 12, 26, 29, 30, 31, 40, 57, 72, 73, **147**

D
Dada, 21
 typography, 20
DAT [Digital Audio Tape], **147**
data, 26, 29, 45, 84, 114, 115 **147**
 acquisition, 78, 80, **147**
 compression, 13, 22

Data Discman, 141, 147
databases, 13, 53, 73, 77, 115, 125, 147
Dataglove, 31, 144, 147
Datasuit, 147
DCC [Digital Compact Cassette], 147
Decode Design, 105, 135
default condition, 68, 70
delivery medium, 77, 78
platforms, 138-139
system, 147
depth cueing, 147
Desert Storm: The First Draft of History, 122
desktop publishing, 13
development platform, 147
Diablo, 59
dialogue box, 148
digital, 50, 68, 130
audio, 148
audio tape, 13
electronics, 8
media, 36
optical storage, 11
video, 13
digitizer, 148
digitizing, 50, 81
tablet, 148
Dimension International, 30, 72
Director, 53, 69, 148
disembodiment of work, 34
disintermediation, 103
diskette, 148
DM Studio, 54
Domark, 30, 72, 136
DTP [DeskTop Publishing], 13, 35
DTP Graphic Design Index, 47, 51, 84-85, 100-101
Duncan, Dick, 122
DVI [Digital Video Interactive], 65, 78, 120, 127, 139, 144, 148
DVI-CDROM, 65
Dynabook, 25, 86, 138, 140, 144, 148

E
earcon, 61, 148
Ectropy, 54
Eden pen-based computer, 140
Edison, Thomas Alva, 68
education applications, 88-97

Education Automation, 29
edutainment, 148
Einstein, Albert, 20
Eisenstein, Sergei, 21, 49
electronic mail, 13, 23, 148
electronic publishing, 122, 148
Ellis Partners, 89, 98
emergency response systems, 117
Empruve, 41, 86, 143, 144
Engelbart, Douglas, 11, 23-24, 38
entertainment applications, 130-137
ergonomics, 44, 78
Essays in Design, 41
Europe in the Round, 89
European Business Guide, 116
Evans and Sutherland, 30, 39
Event Horizon, The, 49
Expanded Cinema, 29
Experience Theatres, 30
expert guides, 77
Expo 67, 21
eyephones, 144, 148

F
Fantics, 24
feedback, 30, 42, 148
fibreoptic, 8, 148
Field Guide to Insects and Culture, A, 96
film plus, 40, 148
Film Sense, The, 21
film, 11, 12, 34, 42
Financial Times, 115
Finnegan's Wake, 21
flopticle, 139
floppy disk, 138
flight simulator, 30, 31, 70
Fit Vision, 67, 104, 125
flowcharts, 79, 82, 148
FMV, 148 see also full motion video
Focus, 46, 116
force feedback, 31
formatting, 81
Fraase, Michael, 37
fractal, 148
fractal generators, 68
frame grabber, 148
full motion video, 65

index

G
Garrett, Malcolm, 57
Gay, Geri, 96
General Theory, 38
Genesis of Perpetua, The, 53, 94
Gesamptkunstwerk, 21
Gibson, William, 26
Gillespie, Joe, 46, 57, 58, 61, 67, 116
global village, 26
Grand Tour, 83
graphic design, 42, 81
graphical user interface, 25, 56
graphics, 56-59
Great British Golf, 136
Great Cities of the World, 124
Green, Tony, 60, 123
Gremlin Graphics, 59, 74, 137
Grooves, 61
GUI, 25, 56
Guide, 148

Fuller, Richard Buckminster, 29
Futurists, 21

H
Halliwell's Interactive Film Guide, 125
hands off [interface], 60
Happenings, 21
hardware, 138-144, 148
HDTV, 73, 138, 144, 148
head-mounted display, 30
Heilig, Morton, 30
Heritage Homes, 50
High Bandwidth Panning, 55, 71, 75
Hodos, 101
Hoekema Interactive, 126
Hoekema, Jim, 126
Holbein, Hans, 48
Holiday Destination System, 103
Holiday Information System, 112
home information/entertainment, 86
Home Shopping Service, 86
home shopping, 102-103
Hong Kong Airport information system, 106-107
Hopper, Grace, 13
house style, 45

index

How Things Work, 128-129
Howard, Graham, 119
human-computer interface, 25
hyperbiography, 53
Hypercard, 35, 78, 84, **148**
hyperenvironments, 73
hypergraphics, 56, **148**
hyperlink, 77, **148**
hypermedia, **148**
 applications, 9, 41, 86-137
 artists, 7, 21
 design, 68
 designers, 7, 24, 42, 56, 82
 developers, 102
 producers, 7, 48
 production, 7, 76-81
 products, 34, 35, 78, 87, 120
 programmes, 7, 9, 40, 42, 43, 48, 53, 55, 56, 57, 61, 64, 65, 68, 70, 73, 76, 78, 82, 116, 131, 134, 138
 publishers, 7
 revolution, 23
 software, 13, 42
 systems, 8, 22, 23, 25, 60, 87, 103, 114, 115, 138
Hypertalk, 25
hypertext, 24, 52, 53, 55, 56, **149**

I Seem to be a Verb, 29
IBM, 96-97, 144
Infowindow Touchscreen, 96
icons, 61, **149**
Illuminated Books and Manuscripts, 97
image, 48-51
In the Age of the Smart Machine, 34
information, 12, 24, 36, 37, 52, 56, 73, 87, 98, 103, 114, 119
 architect, 65, 82
 design, 57
 explosion, 22
 hierarchy, 70
 leisure, 131, 142
 overload, 25, 115
 space, 52
 systems, 87, 115
 trails, 23, 48

Infotainment, **149**
 applications, 120-129
infrared controller, **149**
Institute of Contemporary Art, 29
integrated circuit, 13
Intel, 65
intellectual property, 36, 37
intelligent interface, 86
interaction, 25, 31, 50, 56, 60, 70, 76, **149**
Interactive Catalogue, 57
interactive,
 audio, 61
 advertising, 87
 documentaries, 87
 drama, 87
 encyclopedia, 40
 graphic novel, 135
 illustrations, 48
 interface, 25
 multimedia, 7, 9, 11, 122, 142, 144
 production, 50
 programmes, 12, 61, 65, 78, 87, 130, 139
 storyboards, 80
 video, 9, 65, **149**
interface, 25, 43, 44-47, **149**
InterOptica, 106, 124
intimate computing, 25
ISDN, **149**
IT [Information Technology], 34, 102, 115

J
Jones, J. Christopher, 41
joystick, 23, **149**

K
Kandinksy, Wassily, 21
Kay, Alan, 11, 25
Kelly, Kevin, 38
Kerr, Robert, 37
Keynes, Maynard, 38
Kid Pix, 47
kilobyte [kbyte], **149**
Kinetiscope, 12, 68
Knightmare, 137
knowledge processing, 37
knowledge trails, 77
Kodak Photo CD, **149**
Kreuger, Myron, 29

L
La Mancha Productions, 40
laserdisc, 65, 78, **149**
Laservision, 139, 144, **149**
LCD, **149**
Leary, Timothy, 29, 45
Life of Sir Henry Unton, The, 51
Lingo, 69
Link Trainer, 30
links, **149**
Lissitsky, El, 20
Logic Bomb, 135
Lotus Turbo Challenge, 74

M
M&MT, 103
Macintosh, 42, **149**
Macintosh Hypermedia, 37
MacroMind, 68, 69
 Director, **149**
Madame Soleil's Horoscope, 134
Magic Flute, The, 63
magic lantern, 12
Major Structures in the Brain, 89
Man with a Movie Camera, 21
managing complexity, 41
map interface, 121
mass customization, 102
maze interface, 121
McLuhan, Herbert Marshall, 20, 26, 29, 40
Mediamaker, 68
Mediavision, 103
megabyte [Mbyte], **149**
Memex, 22
menu, 43, 48, **149**
menu-driven, **149**
menubar, **149**
Metrotext, 86
micons, 68, **149**
Micro Gallery, The, 102, 108-109
microfilm, 23
microprocessor, 13, 84
MIDI, 13, **149**
Mig 29 Super Fulcrum, 72
MIT, 29
Moholy-Nagy, László, 21
montage, 21, 49

Morse, Samuel, 20
motion video, 64, **149**
mouse, 8, 23, 45, **149**
multimedia, 42, 43, **149**
 catalogue, 86
 encyclopedia, 76-77
 programmes, 96
 travel encyclopedia, 124
Multimedia '91, 105
Multimedia Corporation, 127
multiplex, **149**
Munich '89, 119
Murder Makes Strange Deadfellows, 70
music plus, 40, 61, **149**
Musicolor, 60, 123
My First Sony, 140
Mythmaker, 95

N
narrative, 64
NASA, 27, 29, 31, 75
National Gallery, 109
natural language, 60
navigation, 44, **149**
 icons, 82
Negroponte, Nicholas, 38
Nelson, Ted, 11, 24, 25, 28, 35, 38, 52-53, 55
Network, **149**
Neuromancer, 26
new rhetoric, 40
Nintendo, 141, 144
 Gameboy, 141
 Super Famicom, 141
Niven, Larry, 29
NLS, [oN Line System], 23, 24
nodes, **150**
Noise House, 62
North Polar Expedition, 90-91
notebook computers, 25
NTSC, **150**
Nu Vista, 66

O
on-line databases, 13
optical theory, 20
Oriane, 54

P
Paik, Nam June, 29
paint programs, **150**
Paintbox, **150**
Palenque, 88
PAL, **150**
parallelism, 20
Pavarotti CDI prototype, 62
PC, see personal computer
Perkins Engines, 98
personal computer, 11, 24, 130, 143, 144, **150**
personal simulators, 144
PGM Encyclopedia, 114
Philips, 65, 116, 126, 130, 136, 139
Phillips, Peter, 21
Phillips, Tom, 20
Picasso, Pablo, 20
Pioneer, 144
pixel, 26, **150**
Pixel Productions, 58, 61, 67, 116
Plank, Max, 20
Point of information applications, 102-113, **150**
Point of sale applications, 102-113, **150**
Polaroid stereoscopic movies, 30
position sensors, 30, **150**
pre-production planning, 80
production cycle, 78
production schedule, 82
programs, 7, 25, **150**
programme, 7, **150**
 budget, 82
 construction, 81
 map, 82
 structure, 76-77
programmer, 84
programming, 76-77, 84, **150**
prototyping, 78

Q
Quantel, 56
Quicktime, 64, 65, **150**
quiz console, 127

R
radio, 13, 42, 61
RAM, [Random Access Memory] **150**
Random Access Media, 8, 40, 50, 62, 67, 83, 104, 112, 125
random access, 8, 64, 76
Ray Base, 48
ray tracing, **150**
read only, 34-35, **150**
read/write, 35, **150**
Reality Built for Two, 29
realtime, **150**
realtime animation, **150**
Rediffusion Simulation, 30, 144
refresh rate, **150**
Reichardt, Jascia, 26, 29
remote services, **150**
resolution, 86, **150**
Retros, 62
Ringworld, 29
rooms metaphor, 73
Royal College of Art, 134
Rucker, Rudy, 29

S
S curve of innovation, 32, 35
Salespoint console, 103
sampling, 36
scanner, **150**
Schlemmer, Oskar, 21
screen saver, **150**
scripting, 84
scrolling, **150**
Sculpture Interactive, 110
Sega, 141, 144
 Gamegear, 141
 Megadrive, 141
semantic compression, 38
Sensorama, 30
Sesame Street, 131
Shakespeare's Twelfth Night or What you Will, 44, 92-93
Shannon, Claude, 13
share-right, 38
Shockwave Rider, 29
Sight and Sound, 67, 104
simulation, 29, 120
simulator cinemas, 144
sketchbooks, 79

index

Smalltalk, 25
Smirke, Sir Robert, 40
soft, 45, 56, 73, **150**
software, 29, **151**
 agents, 25
 piracy, 36, 37
Sony, 141
sound recording, 42
Space Glove, 31
speech recognition, 60
stack, 35, **151**
Stand on Zanzibar, 29
Sterling, Bruce, 29
storage capacity, **151**
storytelling, 64
Stringer, Roy, 110
structural diagrams, 82
structural metaphors, 41
Studio DM, 59
Studiomaster Professional, 66
Success and Failure of Picasso, The, 20
Sullum Voe Emergency Response system, 117
Super Virtualities, 24
Supercard, 35, 53, 84, 125, **151**
Superscape, 30
surrogate travel, **151**
Sutherland, Ivan, 30
synaesthesia, 21
Synapse, 96-97
Synergy Multimedia, 117

T
Tate Gallery of Liverpool, 110
Taylor, Colin, 54
technology-based training, 98
teleconferencing, 23
telegraph, 12
Telematic, **151**
telephone, 12
teletext, 13
television, 11, 13, 35, 73, 86, 130
Tenderland, The, 83
testing and debugging, 81
text, 52-55
texture mapping, **151**
Thinkertoys, 24
Thorn EMI, 48, 67

3T Productions, 111
Tigermedia, 70, 128-129, 132-133
Time Magazine, 122
touchscreen, 8, **151**
trackerball, **151**
Train Driving Simulator, 101
training applications, 98-101
transistor, 13
transitional effects, 68, 70
Treasures of the Smithsonian, 126
tree structure, **151**
tricons, **151**
Trivial Pursuits, 136
Turnridge, Richard, 134
typography, 52-55, 56

u
Understanding Media, 20
USCO, 21
user illusion, 44
Utopia, 137

v
Van der Beek, Stan, 29
VCR (Video Cassette Recorder), 8, 138
Verdoux, Jeanne, 79, 134
Vertov, Dziga, 21
video and film production, 81
video, 8, 42, 64-67
videodisc, 13, **151**
videogames, 42, 70, 131, **151**
videographics, 56
Videologic Control Software, 67
videotape, 13
Virgin Games, 60, 90-91, 123
Virtual Egypt, 121
virtual,
 environments, 57
 interface, 75
 jukebox, 45
 reality, 8, 29, 30, 31, 57, 65, 73, 131, 144, **151**
 space, 26, 72-75, **151**
 theme parks, 144
 world, 8
Virtuality, 27, 29, 31, 72
Visette, 27
Vocational Technologies, 89

voice annotation, **151**
voice recognition
VPL, 144, 29, 31
VR see Virtual Reality

w
W Industries, 27, 29, 31, 144
Wagner, Richard, 21
wait state, 70
walkthrough, **151**
Warhol, Andy, 21
Warner New Media, 63, 122
Weiner, Norbert, 13, 29
Westminster Cable, 35, 86
Whistler, James McNeil, 21
Whitney brothers, 29
Whole Earth Review, 38
windows, 23, 43, 73, **151**
 metaphor, 73
Windsor Safari Park information system, 111
Working Knowledge Transfer, 119
World at your Fingertips, 111
WORM, 13, **151**
Worthington, Mike, 54
Wright, Martin, 110
WW2 Interactive, 40

x
x-ray photography, 20
Xanadu, 24, 53, 55, **151**
Xerox PARC, 25, 73
Xploratorium Workrooms, 95
XYZ coordinates, **151**

y
Youngblood, Gene, 29

z
ZAPfactor, 115
Zaumgadgets, 46, 62
Zubof, Shoshana, 34